MW00560881

DRESSING THE PART

ALSO BY HAL RUBENSTEIN

100 Unforgettable Dresses

The Looks of Love

The Gentry Man

Paisley Goes with Nothing

Walls of Change: The Story of Wynwood Walls

The Eccentrics

DRESSING THE PART

TELEVISION'S MOST STYLISH SHOWS

HAL RUBENSTEIN

HARPER

An Imprint of HarperCollins*Publishers*

DRESSING THE PART. Copyright © 2023 by Hal Rubenstein. All rights reserved. Printed in Malaysia. No part of this book may be used or reproduced in any manner whatsoever without written permission except in the case of brief quotations embodied in critical articles and reviews. For information, address Harper Design, 195 Broadway, New York, NY 10007.

HarperCollins books may be purchased for educational, business, or sales promotional use. For information, please email the Special Markets Department at SPsales@harpercollins.com.

FIRST EDITION

Designed by Raphael Geroni

Library of Congress Cataloging-in-Publication Data has been applied for.

ISBN 978-0-06-327259-0

Library of Congress Control Number: 2023934355

23 24 25 26 27 IMAGO 10 9 8 7 6 5 4 3 2 1

To DEBRA,

I still love Lucy, but I've always loved you more.

Contents

INTRODUCTION

O N THE NICOLLET MALL IN MINNEAPOLIS, IT'S NOT UNUSUAL TO spot someone walking down one of its sidewalks, and at the 7th Street intersection, suddenly flinging his or her hat into the air. This has been going on for fifty years. If you ever get the chance to visit the mall, the reason for these spontaneous tossings will be obvious: at that corner stands an eight-foot-tall bronze statue by Gwendolyn Gillen of Mary Tyler Moore casting her crocheted blue beret airborne, just as she did every week at the end of the intro to *The Mary Tyler Moore Show*. In 2002, when the statue was dedicated, Moore was joined by three thousand beret-clad men and women in a group toss. Two decades later, the statue is still one of the city's major tourist attractions.[1]

There's no denying how readily TikTok, Facebook, YouTube, Instagram, IMAX, and your near–surgically attached smartphone can influence style and behavior. But no medium impacts our lives as thoroughly and consistently as television. As we were reminded when housebound for months during the pandemic, television still reigns as our most accessible and immediate portal for discovering culture, instigating trends, arousing wanderlust, shaping our perceptions, decorating our homes, redefining how we envision romance, even prodding us to dance when no one is watching.

However, television's most effective provocation, since it became the focal point of our living rooms in the mid-1950s, has been showing us how we dress, how others dress, and what we should aspire to wear. TV has been our in-house, pro bono stylist, cajoling and inspiring us to choose wardrobes for work, being at home, going on a date, taking a vacation, getting ready for a big night out, making a condolence call, or engaging in domestic combat.

Dressing the Part: Television's Most Stylish Shows is a celebration of the medium's ingratiating power over us. It's not necessarily focused on the finest drama, comedy, and entertainment television has offered. *The Sopranos*; *M*A*S*H*; *Breaking Bad*; *Roots*; *The Wire*; *Seinfeld*; *Six Feet Under*; *The West Wing*; *All in the Family*; *I, Claudius*; *Game of Thrones*; every Ken Burns documentary; and *The Great British Baking Show* indisputably rank among my favorites. None of them are in this book.

Rather, what I hail and explore in the following pages are certain key series that over the past seventy-five years have wielded the greatest sway over what we've zipped up the back, buttoned down the front, pulled over, wrapped around, stepped into, and tied up—as well as what we've done in front of the mirror to get it together, and how we've acted when we finally put it all out there.

Dressing the Part is a geyser of high style and sartorial inspiration, gushing with facts, backstory, cultural context, gossip, deliberate ingenuity, and happy accidents about these fifty productions and how they coerced our sense of couture, helped establish our markers for beauty, and advised us on what outfits and getups might be most attractive to those we live, work, and sleep with.

As with all entertainment, character always comes first. *Dressing the Part* revels in the undeniable impact we felt and the judgment calls we made while riveted by charismatic

figures like Tom Selleck and his mustache, Donna Reed making dinner in a crinolined shirtwaist, Ally McBeal before the court in a thigh-high mini, Don Johnson crime-fighting in a pale pink linen blazer, Robert Conrad sharpshooting while poured into ridiculously tight pants, Farrah Fawcett in a red bathing suit that made the entire male population of the planet drool, what life might be like as Cher.

Several shows did far more than highlight what to wear. *Sex and the City* was instrumental in reshaping and elevating the image of the world's most exciting town. Fonzie on *Happy Days* domesticated Marlon Brando's motorcycle jacket. An entire city embarked on a civic renaissance to satisfy the image promised by *Miami Vice*. *The Avengers* (there were two of them long before Marvel's expansive platoon) introduced us to S&M before most of us knew what the initials meant. The languorous grunge attire adopted by Angela Chase and her classmates in *My So-Called Life* altered the high school wardrobes of a generation. And *Empire's* unfettered flamboyance proved there is no point in walking into a room if you're not going to make an entrance.

It's been a treat to delve into these shows' histories, but my greatest delight in creating the book has been in amassing personal photos and sketches gleaned from more than two dozen of the medium's finest costume designers, showrunners, writers, and costars, and in conducting interviews with them: their lucid stories, sly insights, and meticulous research skills are liable to have you racing for the remote to rewatch their memorable work on their respective series. *Dressing the Part* is an opportunity to marvel at the ingenuity and talent of artists like Donna Zakowska, who glorified the rapturous silhouettes of the '50s for *The Marvelous Mrs. Maisel*; discover how Lyn Paolo's sartorial choices for Kerry Washington helped define her gladiatorial Olivia Pope in *Scandal*; savor how costumer Salvador Perez convinced Mindy Kaling that she was beautiful; be awed by the clever ways Ellen Mirojnick of *Bridgerton* reinterpreted early nineteenth-century corsets, shirred Empire-waist gowns, and men's military jackets into next season's must-haves; learn how *Project Runway* affected designer Michael Kors's perception of the catwalk, or how much it cost designer Nolan Miller to glitz everyone up on *Dynasty*; and giggle at producer Andy Cohen's unabashed affection for his favorite *Real Housewives*.

The shows in *Dressing the Part* were not selected by any survey. They were curated by me. After three decades of discerning, chronicling, photographing, criticizing, and championing fashion and pop culture's landmarks as fashion director of *InStyle* and Men's Style Editor of the *New York Times*, plus a lifetime of wearing Mickey Mouse ears, sporting a Selleck mustache, improving my dance moves by watching *Soul Train*, sweating to get a bod half as buff as Robert Conrad's on *The Wild Wild West*, and assembling a wardrobe that harmoniously fuses those of Rob Petrie (*The Dick Van Dyke Show*), Illya Kuryakin (*The Man from U.N.C.L.E.*), Don Draper (*Mad Men*), and Neal Caffrey (*White Collar*), I trust my eye and television's hand in assembling what's hanging in my closet. It's been so much fun I could just throw my beret into the air, except I never wear hats. I hope you agree.

Proper Attire Required

PERIOD DRAMAS

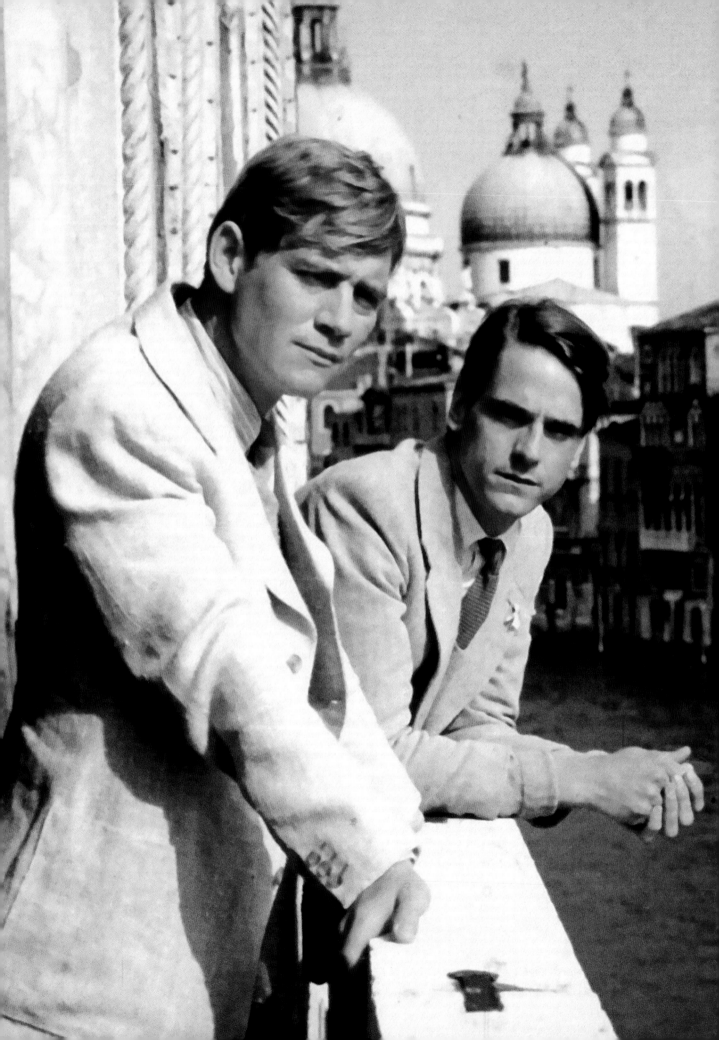

Brideshead Revisited

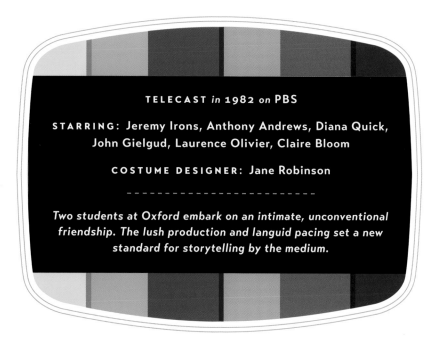

TELECAST *in* 1982 *on* PBS

STARRING: Jeremy Irons, Anthony Andrews, Diana Quick, John Gielgud, Laurence Olivier, Claire Bloom

COSTUME DESIGNER: Jane Robinson

Two students at Oxford embark on an intimate, unconventional friendship. The lush production and languid pacing set a new standard for storytelling by the medium.

THANKS TO EASY ACCESS TO NEARLY AS many streaming services as we have Facebook friends, with budgets to rival Tom Cruise's take-home pay from the latest *Top Gun*, we take for granted television's narrative possibilities. But forty years ago, when the top dramas in the United States—*Dallas, Magnum P.I., Dynasty,* and *Falcon Crest*—had us convinced that wealth was meant to be brandished with crass panache, a radically different series from Great Britain snuck in almost unnoticed as a stowaway on public broadcasting. It caught us completely by surprise, stunned us with a visual sumptuousness we didn't know was possible, introduced us to the self-satisfied resolve of those to the manor born, and most fascinating of all, made us aware, by way of a hypnotic tale of epic yearning and dissolute abandon, that television could be our most compelling medium for storytelling.

Brideshead Revisited was a magnificent achievement, an eleven-hour adaptation of Evelyn Waugh's imagined memories at Oxford, set against a splendiferous panorama of aristocratic splendor we are too young a nation to match. In production for more than two years with a budget of $20 million, *Brideshead* had the audacity to unfold its story languidly, luxuriating over every gesture, passing glance, meal, outfit, and escapade. We watch a young and beautiful Jeremy Irons, as the reserved Charles Ryder, become infatuated with the even more beautiful Anthony Andrews, as the passionately self-indulgent Sebastian Flyte, and discover that a life of privilege alters the rules of behavior to suit one's whims.

Brideshead's disconcerting but enthralling homoeroticism was another first for television during an era when just the mention of homosexuality normally would send censors into a panic. Instead, the inference is subtly, but

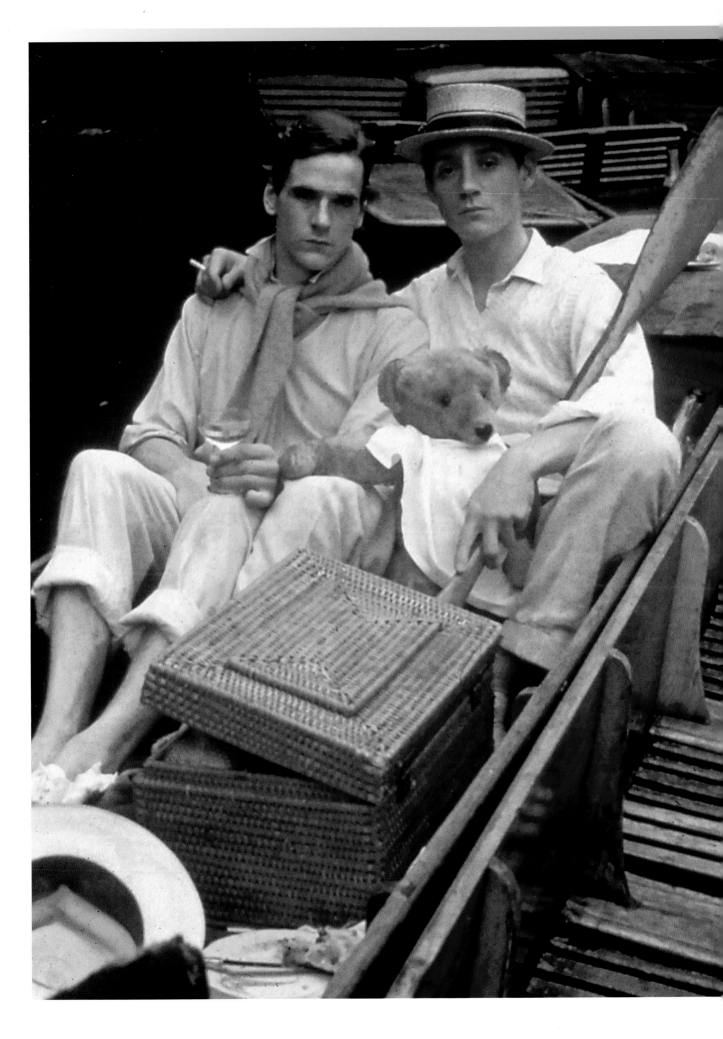

steadily woven into Charles's encounter with Sebastian's rarefied, dazzling world.

Fifty minutes into the first episode, the first sight of Brideshead, Sebastian's ancestral home, is jaw-dropping. Castle Howard, its location, was built in the eighteenth century and designed by John Vanbrugh, who later oversaw the construction of Blenheim Palace. Its 145 rooms are set on 8,800 acres (ten times the size of New York's Central Park); its domed entrance foyer soars to a height of nearly seventy feet. Like Charles, we are all the more agog because Sebastian regards Brideshead's grandeur and the high drama his family generates whenever they are in residence as a given, which could explain why Sebastian's natural state of being—which Charles describes as "conspicuous by reason of his beauty, which was arresting"—is a bizarre yet seductive form of performance art.

Sebastian's clothes are an integral part of his show, as calculated as they are ravishing. He pairs a houndstooth jacket so thick it must be stifling in the summer heat, with a Fair Isle sweater as intricate as lace, or tosses a chocolate brown cashmere topcoat casually round the shoulders over a cream-colored wool suit, accessorized with a rakishly tied foulard, a matching cream fedora, and an ivory-handled cane. Tweed suits with two-tone bucks are what he wears to class, banded white tennis sweaters are for sporty weekends, and navy blazers with white piping accented by a silk cravat are perfect for a picnic of lobster thermidor by the river at Brideshead, with a place always set for Aloysius, Sebastian's white-bibbed teddy bear.

It can't be mere coincidence that *Brideshead* premiered, with 60 percent of Americans tuning into it on PBS, in the same year that Ralph Lauren commissioned photographer Bruce Weber to help him create fashion's first multipage advertorial, in which the designer offered an extensive Oxford-ready wardrobe that promised the illusion of being listed in *Burke's Peerage* to an aspiring demographic of first-generation Americans.

The *New York Times* claimed that *Brideshead Revisited* "constituted the biggest British invasion since the Beatles."[2] Bloomingdale's devoted windows and a new section of its men's department to English tailoring. Geoffrey Burgon's lush score featuring a wistful oboe became a popular wedding processional. No one was available for dinner on Monday nights unless you were willing to serve beef Wellington on TV trays. Teddy bears became an all-too-common, unfortunate accessory.

After a decade that started with love beads left over from Woodstock and ended with polyester disco duds, *Brideshead* reminded us that a return to elegance was a worthy destination, that true élan involves taking one's time, and that the medium that delivered this message had powers yet to be tapped. We had been trained to consume television greedily. Now, we were shown a way it could be savored.

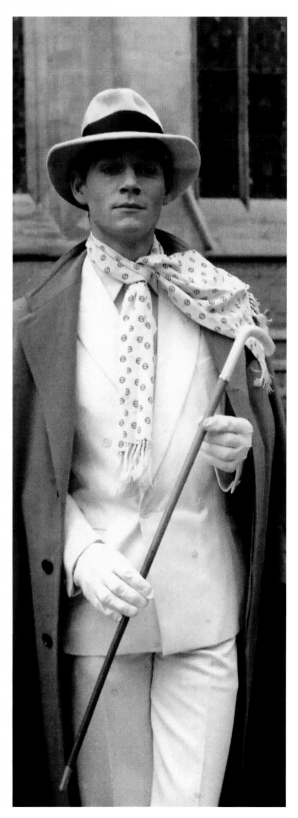

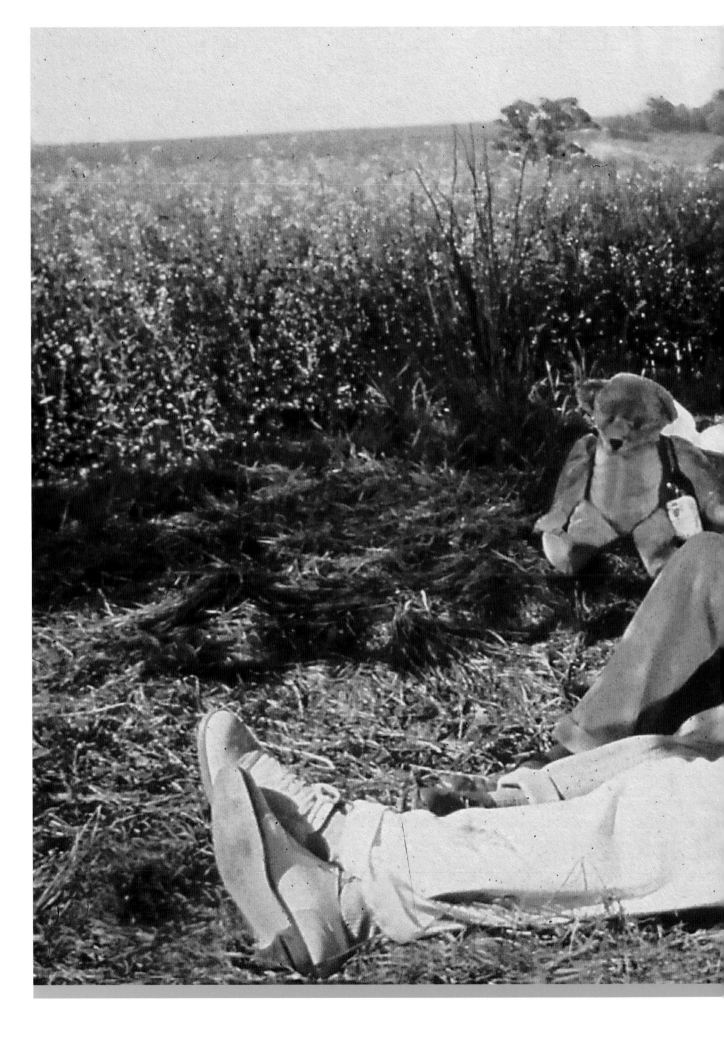

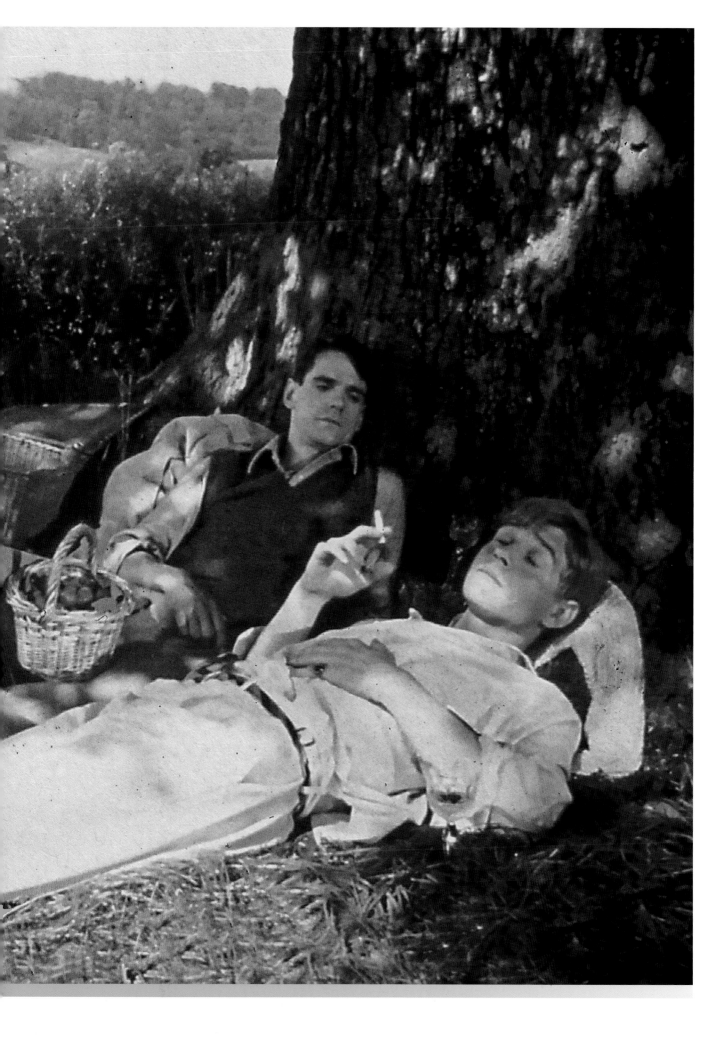

Mad Men

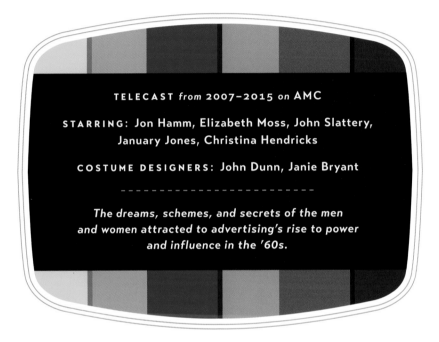

TELECAST *from* 2007–2015 *on* AMC

STARRING: Jon Hamm, Elizabeth Moss, John Slattery, January Jones, Christina Hendricks

COSTUME DESIGNERS: John Dunn, Janie Bryant

- -

The dreams, schemes, and secrets of the men and women attracted to advertising's rise to power and influence in the '60s.

MAD MEN WAS AN UNRELENTING but welcome celebration of one man's case of obsessive-compulsive disorder. Though Matthew Weiner created a sweeping urban tapestry in his brilliant construction of the intersecting paths of upwardly mobile ambition, the show's maestro was also a visual miniaturist. Week after week, I would hit pause at least half a dozen times during the hour, sometimes to check out the new lamp on Roger Sterling's desk, or mark the precise way Peggy would display her storyboards, but more often to focus on department-store heiress Rachel Menken's pink-feathered hat, Harry Crane's new argyle sweater, the narrowed lapel of Pete Campbell's newest blue suit, or to marvel at the voluminous folds encircling Betty Draper's sensational pink, black, and white paneled gown.

No doubt Weiner intended the crisp silhouettes that defined American style when we still believed in Camelot,

the glamour of a two-door hardtop, and the sensuality of a lit cigarette to be a driving force in *Mad Men*'s landscape, but at times the clothes were so sharp and informative that they threatened to upstage every ad pitch at Sterling Cooper. *Mad Men*'s clothes amplified each principal's story.

"When Matthew approached me about the project while we were both working on *The Sopranos*, I immediately thought about those hard-edged movies about New York in the '50s, like the *Sweet Smell of Success* and *What Makes Sammy Run?*" said John Dunn, who designed the clothes for *Mad Men*'s pilot episode. "No one had seriously tapped into that era on TV, when the city still had rough edges, women coming into the workforce caused confusion, and men realized that their clothes could help them make a strong impression. Matthew agreed. He wanted the look to be hot, sexy, gritty, and distinct."[3]

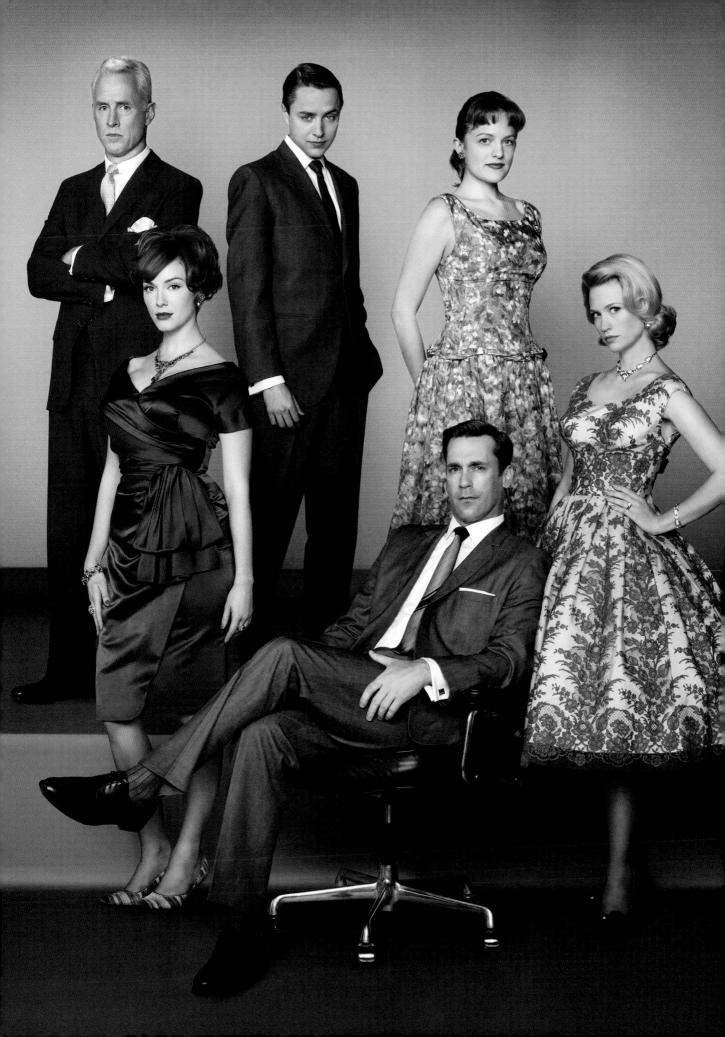

Mad Men
Roger Sterling

Mad Men
Season III

Joan

costume
for
Bonnett Teller

Purple Raw Silk
Sailor Collar
Tie
Princess Seams
Waist Band

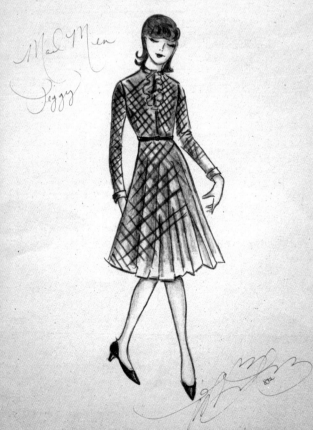

Mad Men
Peggy

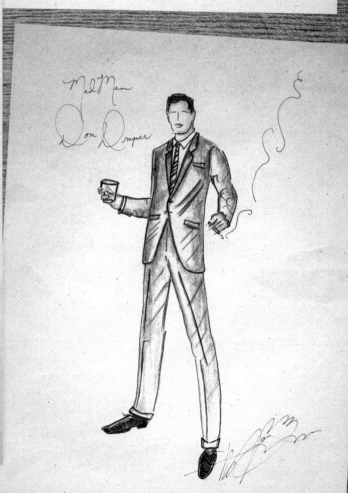

Mad Men
Don Draper

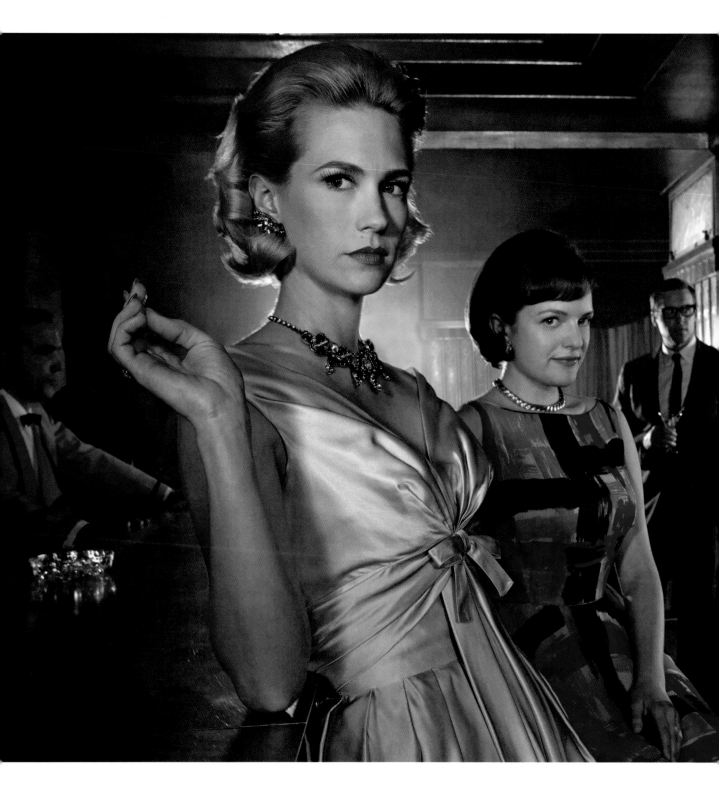

Once filming began, Weiner moved production to the West Coast, and costume designer Janie Bryant expanded and evolved Dunn's sartorial template over the series' seven seasons. With characters so specifically drawn, Bryant found it easy to draw stylistic lanes and avoid any crossover, starting with show's central figure.

"Don Draper's armor is his gray suits," says Bryant. "His life is a myth, his reality shrouded in mystery and secrecy. He finds protection in a neutral palette because it allows him to create an easily recognizable facade of always being in charge. What an onlooker sees is incredibly handsome and impeccable, but inside he is broken."[4]

Roger Sterling, Draper's superior at the ad agency, dresses to be acknowledged. Bryant "started him rooted in the classic shapes of manhood—double-breasted and

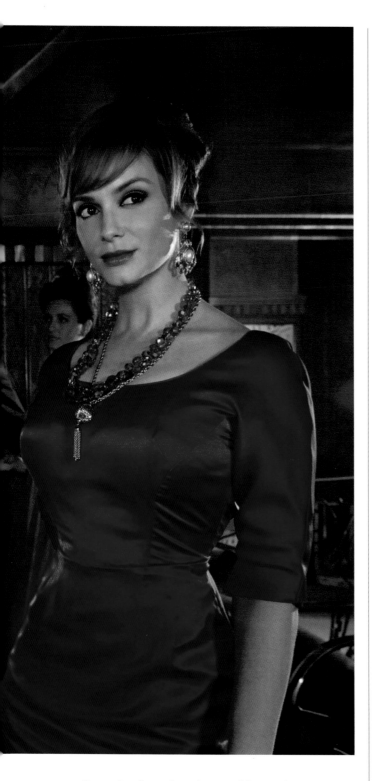

character because, though gay, he has to remain closeted in the office. "And yet, he doesn't put on a uniform," Bryant notes. "It's not natural for him, so he reaches for meticulous separates as a celebration of getting dressed every day. He can't help himself."[7]

For the men, Bryant sourced vintage suitings, scoured costume houses, pulled furnishings from Brooks Brothers, and built a full-time tailor shop on site. Later she developed a men's retail collection with Brooks Brothers and three successive ones with Banana Republic. All of them sold out.

The four main female characters exhibited a more drastic opposition of styles because each woman was on a different mission. Betty went from trying to be the perfect housewife to a woman angry enough to rebel. Joan knew that her curves were her calling card and secret weapon. Megan, Don's young second wife, was daring enough to scare him. Peggy took the most complicated journey of anyone on *Mad Men*, at first subjugating her femininity to succeed in a man's arena, until success made her realize that her female perspective was what made her special. Bryant found that "dressing the women was exciting because it became obvious that the '60s was such a watershed of design, it will always be in style. It's why mid-century modern furniture and architecture never lose their appeal. The florals and brocades that became available just as women were embracing their curves and accentuating their waists gave us so many options for our women to shine. We created three women's collections with Banana Republic, and they also sold out. I don't think it's possible to do a period film without injecting a modern sensibility, and that made these looks easily relatable."[8]

Bryant correctly asserts that "the menswear industry changed dramatically because of *Mad Men*."[9] The slim suit struck a chord (and not just in America) because the cut is youthful, enhances a fit physique, and its simplicity makes you feel modern. Recently, ready-to-wear collections and even forward-thinking fast-fashion brands like Zara are trying to coax men back into clothing with more volume, presenting unstructured jackets that slouch, and pants with double pleats, but the reversal isn't gaining much traction beyond those who don't list fashion on their calling card.

Matt Bomer's more recent wardrobe for *White Collar* is proof that the slim silhouette is tough to beat. Recalling Matthew Weiner's obsessive eye for detail, the slim silhouette is even sharper if you can pointedly add a skinny tie clip. Recalling Matthew Weiner's obsessive antihero, it also helps if you have nothing to hide.

three-piece bespoke suits—until he winds up grasping for his youth in a classic midlife crisis: growing his sideburns, wearing brighter colors, stepping into zip-up boots, leaving his wife for his secretary."[5]

Bryant enjoyed dressing Pete Campbell "because he was such an obvious brown-nosing social climber. His bright blue suits were all about his easily bruised ego."[6] Salvatore Romano is probably the most complex male

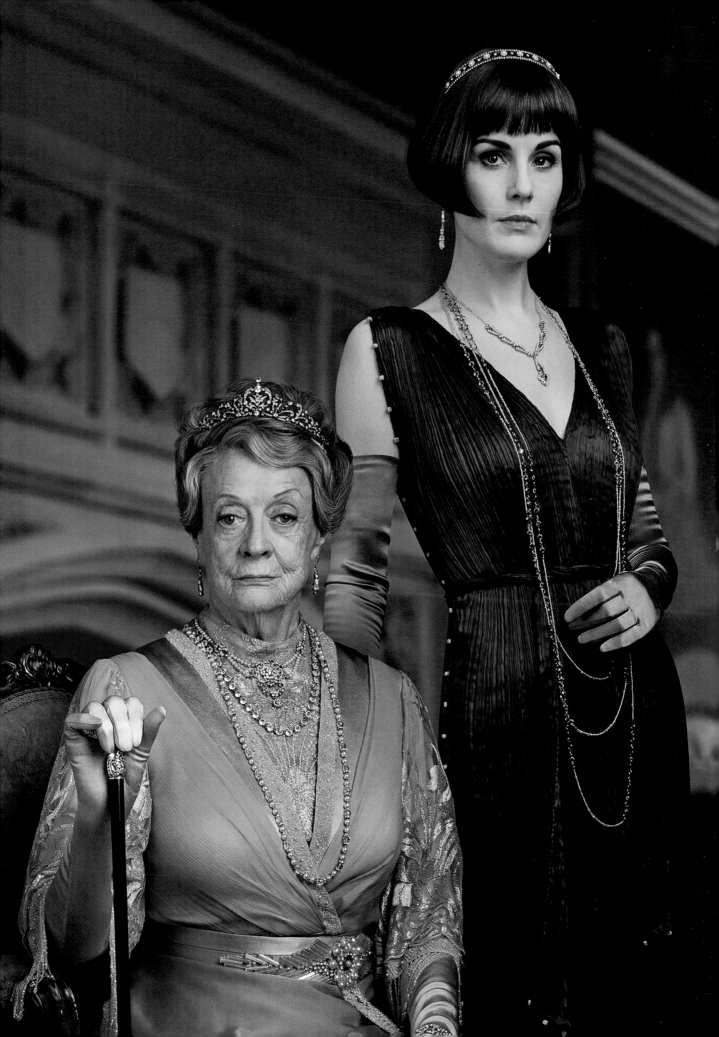

Downton Abbey

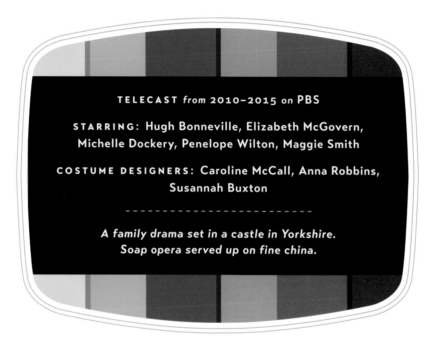

TELECAST *from* 2010–2015 *on* PBS

STARRING: Hugh Bonneville, Elizabeth McGovern, Michelle Dockery, Penelope Wilton, Maggie Smith

COSTUME DESIGNERS: Caroline McCall, Anna Robbins, Susannah Buxton

- -

*A family drama set in a castle in Yorkshire.
Soap opera served up on fine china.*

F YOUR IDEA OF SPENDING A NIGHT AT HOME includes favorite sweats, sushi by way of Grubhub, and figuring out Wordle in three tries, then congrats on being easy to please. But watching *Downton Abbey* makes me want to dress for dinner, sip brandy from a warm snifter, go for a drive in a 1924 Sunbeam limousine, Viennese waltz in the ballroom, give aspic one more try, and daydream about getting invited there for a weekend, a week, a month, or however long it takes to make Maggie Smith's Dowager Countess of Grantham laugh.

Unlike television's other grand bastions of affluence, *Downton*'s Abbey (in real life Highclere Castle) was never the site of an epic catfight, an inheritance battle, an overturned dinner table. It is certainly more impressive than the Carrington estate on *Dynasty*, though it doesn't boast the imperial majesty of *Brideshead*'s Castle Howard location. But what Downton has that the other two residences lack is a sense that, for all its trappings, you believe that a family lives comfortably within its walls.

There were conflicts, of course—after all, it is a drama in which different generations often have clashing responses to the rapidly changing times, both pre- and post-World War I. But everyone at Downton abides by established rules of decorum that apply equally to the family upstairs and servants below. Whatever the subject may have been at the grand dining table, in the drawing room, or downstairs in the kitchen's prep area, all conversation was grounded in an inherent civility toward one another, a willingness to discuss rather than shout, and an openness to showing affection that grew gradually as the show went on. Never a passionate embrace, mind you. But a knowing gaze did nicely.

Dinner demanded men in white ties and waistcoats and women in micropleated jewel-tone gowns by Fortuny

and chiffon florals that cascaded into asymmetrical hand-kerchief hems, but it wasn't devotion to all things posh that made millions fall so madly in love with *Downton* that it became the most watched show ever on PBS. The magic of this series is the warmth and loyalty that remained at the core of every story line Julian Fellowes, the series' creator, wrote over six years. Because *Downton* premiered while both Britain and the United States were still mired in a postrecession economy following Wall Street's collapse in 2008, one might assume that watching wealthy people struggle to adjust to a modernizing world might be the last thing that would engage our sympathies and interest. But with Fellowes loading up the story lines with sibling rivalry, blackmail, romance between a lady of the manor and her chauffeur, a secret heir, a child out of wedlock, closeted homosexuality, rape, a shattering auto accident, potential financial ruin, and Lady Mary losing her virginity to one hell of a hot guy who drops dead in her bed once he's done, it was easy to get distracted. And we welcomed that.

Besides, *Downton* was not meant to be rooted in historical realism. While the plotline doesn't ignore the outside forces that were changing life in England, this is soap opera on a grand scale, deliberately softening the rigid British class structure. Had it been more accurate, communication between lord and valet, lady and maid, probably would have been more brittle. Visually

the series was far more accurate: the women affecting pale matte makeup, donning gowns in dusty hues, and wearing corsets underneath in the show's early seasons, while in the next decade the women discarded all of the above, adding color to cheekbones and bolder hues to more sinuous, less constricting garb. Lord Grantham even dares to wear the "new" formal wear—black tie—to dinner one night. The Dowager lets her son know that she almost mistook him for a waiter.

"A corset can help you get into character very quickly," says Virginia Bates, who used to own the most resplendent vintage clothing store in London's Notting Hill. "You must pick your head up. You must stand straight. Slouching is impossible. You feel like someone else. You *become* someone else. You certainly become a lot more flirtatious when your boobs are raised up and out."[10]

According to Bates, John Galliano used to buy "inspiration pieces" from her "when he was doing all those marvelous bias-cut gowns at Dior." Bates also sold pieces to *Downton*'s designers. "The dresses were the real deal. Fortuny silks, panne velvet with drop waists. You do have to cheat a little when it comes to the twenties dressing, though, because while women were throwing their corsets away, there is nothing sexy about flapper dresses from the twenties—they only work if you are skinny and have no

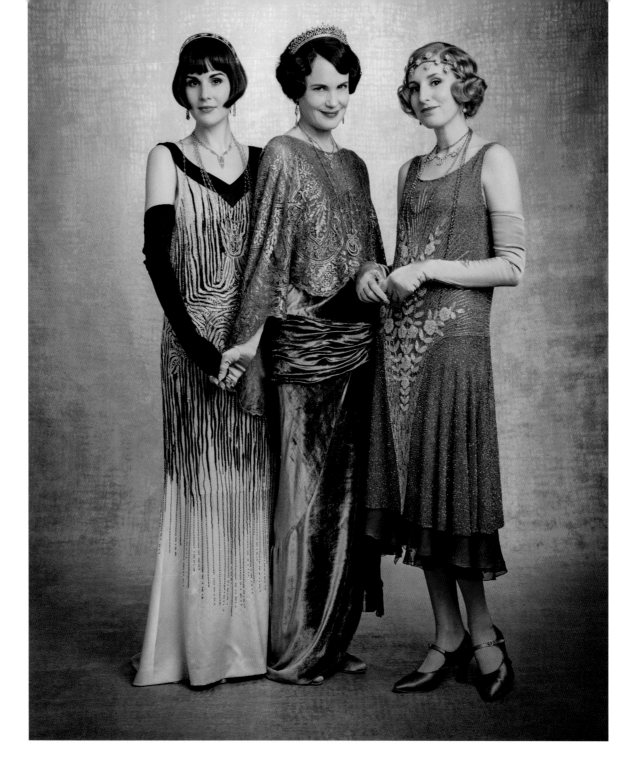

breasts. I recommended finessing dresses from the thirties, when they were cut on the bias and much more flattering for anyone with curves. Lady Mary had a stunning, deep sapphire Fortuny gown that was simply delicious."[11]

It's worth noting that the neckline of Michelle Dockery's gown was cut much lower than Fortuny's classic boat-neck neckline. But as Janie Bryant said, in reference to designing *Mad Men* (see page 23), even when doing a period drama, it's essential to maintain a modern sensibility.

Other successful TV shows have had new life on the big screen, but except for the two messy, unsatisfying *Sex and the City* films, most movie versions—for example, *Miami Vice*, *21 Jump Street*, and *Charlie's Angels*—have used entirely different casts and plots that were only tangentially related to the original program. *Downton's* two subsequent, highly successful films kept the cast intact and carefully extended the story, but maintained the series' deliberate pace and deliberately calibrated dynamics, ultimately reaching a logical and satisfying conclusion, to the delight of its stalwart fans.

There are more than forty bedrooms at *Downton's* Highclere Castle. One of them has to have my name on it.

The Crown

TELECAST *from* **2016–2023** *on* **NETFLIX**

STARRING: Claire Foy, Olivia Colman, Imelda Staunton, Matt Smith, Tobias Menzies, Jonathan Pryce, Vanessa Kirby, Helena Bonham Carter, Josh O'Connor, Emma Corrin

COSTUME DESIGNERS: Michele Clapton, Jane Petrie, Amy Roberts

A meticulously imagined chronicle of life with the British royal family under Queen Elizabeth II.

Elizabeth the Second, by the Grace of God, of the United Kingdom of Great Britain and Northern Ireland, and of Her other Realms and Territories, Queen, Head of the Commonwealth, Defender of the Faith, and Sovereign of the Most Noble Order of the Garter was the most famous woman in the world. Anyone who suspected that her renown was due more to her wealth and titles than to the impact of her steadfast resolve and forthright optimism was schooled otherwise during the third weekend of September in 2022, when hundreds of thousands waited up to twenty-four hours on a line that stretched six miles from the Great West Door of Westminster Abbey to pay their last respects.[12]

What's most remarkable is that the queen's stature as an object of universal curiosity (it is estimated that more than four billion people watched the funeral[13])
grew stronger as she got older, because in a culture where nearly everyone—including those famous, or hoping to be—freely post their opinions and the minutiae of their day on social media, the queen was a closed book. She never gave an interview in her life. She may have been the last person left on earth with any mystique. And mystique is the ultimate tantalizer, the very reason that audiences on both sides of the Atlantic have breathlessly waited for each new season of *The Crown*. Queen Elizabeth's withholding seduced us all into becoming voyeurs.

We wish we knew what went on, but Peter Morgan's well-researched yet still speculative scripts are as close as we're ever going to get. And what eggs us on—there was such an uproar when Morgan said *The Crown* would end after season five, that he succumbed to adding a season six—is an unspoken but satisfying air of superiority in

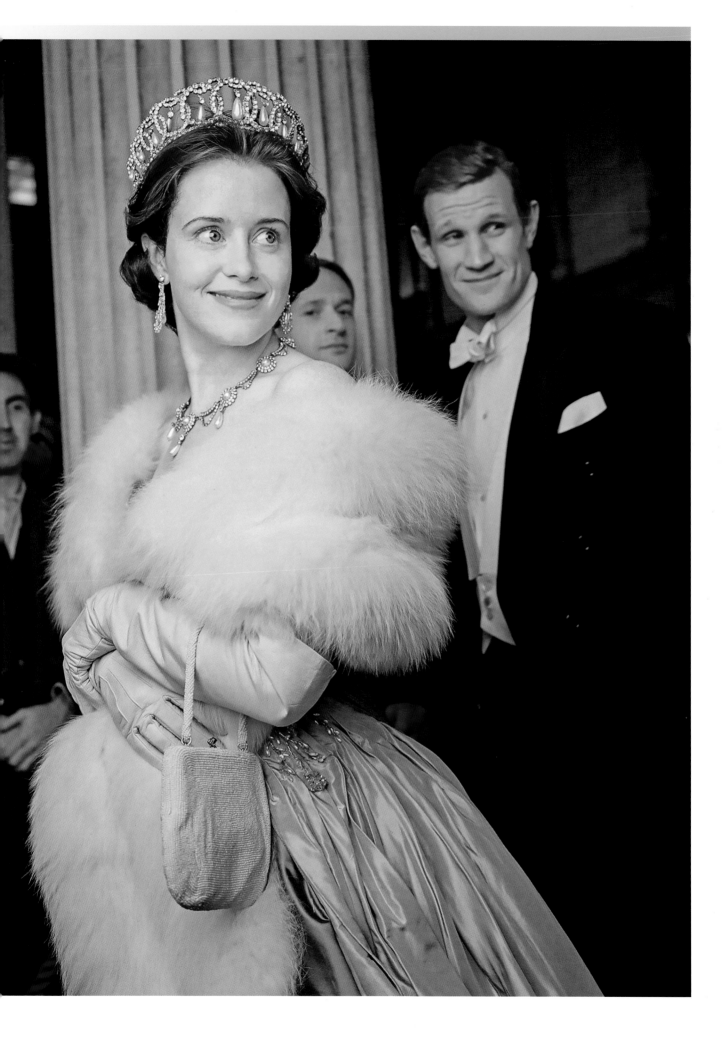

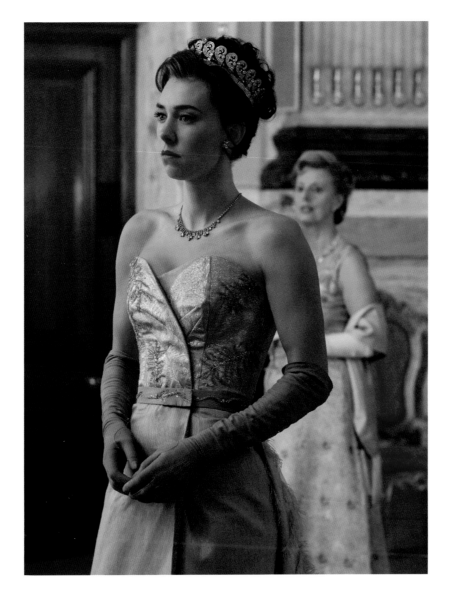

knowing that the bejeweled may be rich, but they ain't happy. As time goes on, and the rifts grow deeper, it is not unlike watching "*The Real Royals of Windsor Castle*" minus an Andy Cohen reunion.

The gates of Buckingham Palace may be ornate and imposing but backyard fence nosiness is a dominating factor in the show's appeal. There are other undeniable seductions: superlative acting; the occasional juicy scenery chewing of enviably sumptuous interiors, as well as the superlative work of *The Crown's* costume designers. Because of the scarcity of vintage clothes of superior quality that could pass for royal garb, they had to craft virtually every piece of each principal's wardrobe. Extra praise is due to Michelle Clapton, who designed the first two seasons, and whose team invested eight weeks and $37,000 to execute the young princess's wedding gown for her marriage to Prince Philip. Clapton also deftly executed the tricky task of outfitting Claire Foy and Vanessa

Kirby as two sisters who realize that, despite their youth and mutual affection, they must affect different images now that one carries a scepter as well as a purse.

There is no shortage of superior recreated looks from the series: Kirby in Margaret's butterfly gown, Foy in ruffled blue chiffon at the state dinner for President and Mrs. Kennedy, the lime green tumbleweed of a fur hat worn by Marion Bailey as the Queen Mum, Josh O'Connor in Prince Charles's trim and spiffy polo gear, and Emma Corrin as Diana in a red dotted-silk sundress.

Like her predecessor, Queen Victoria, Queen Elizabeth spent fifteen minutes before bed every night writing in a diary, a habit she started when she was fifteen. Only a few sections of Victoria's 122 volumes were ever published.[14] There is no word on when, if ever, Queen Elizabeth's will be released. Right now, you probably have a better chance of borrowing the Crown Jewels for the weekend. *The Crown* will have to suffice.

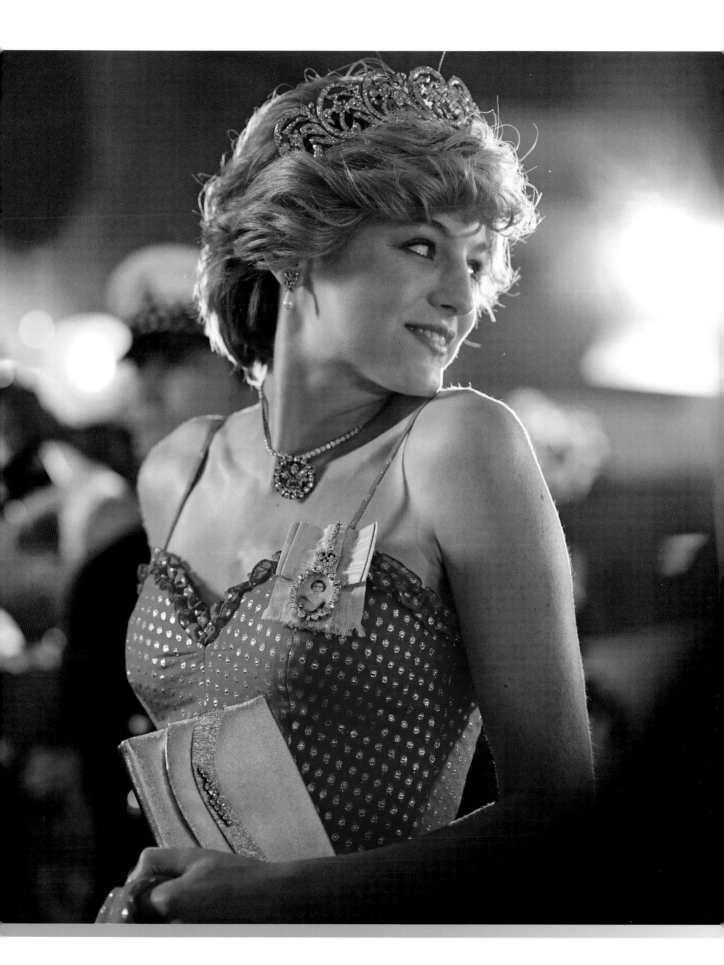

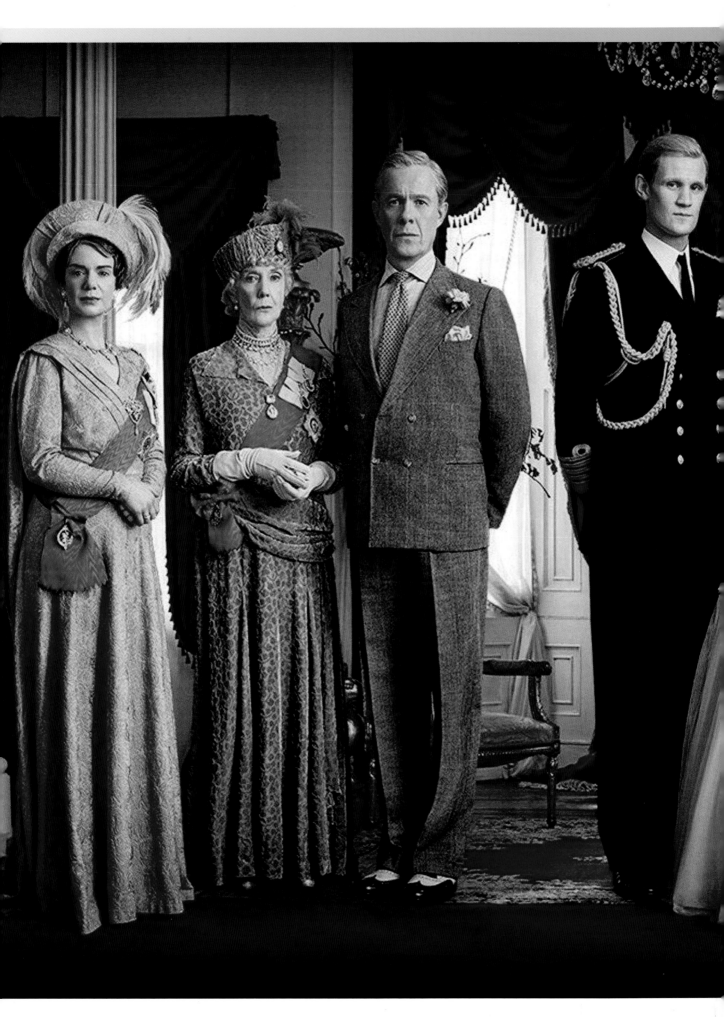

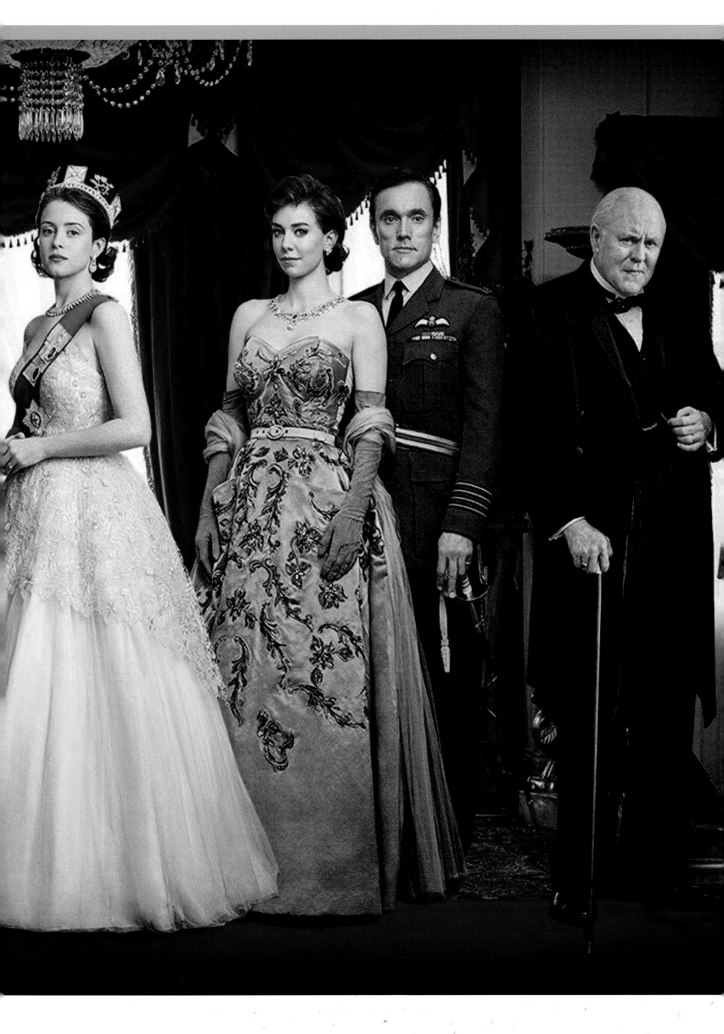

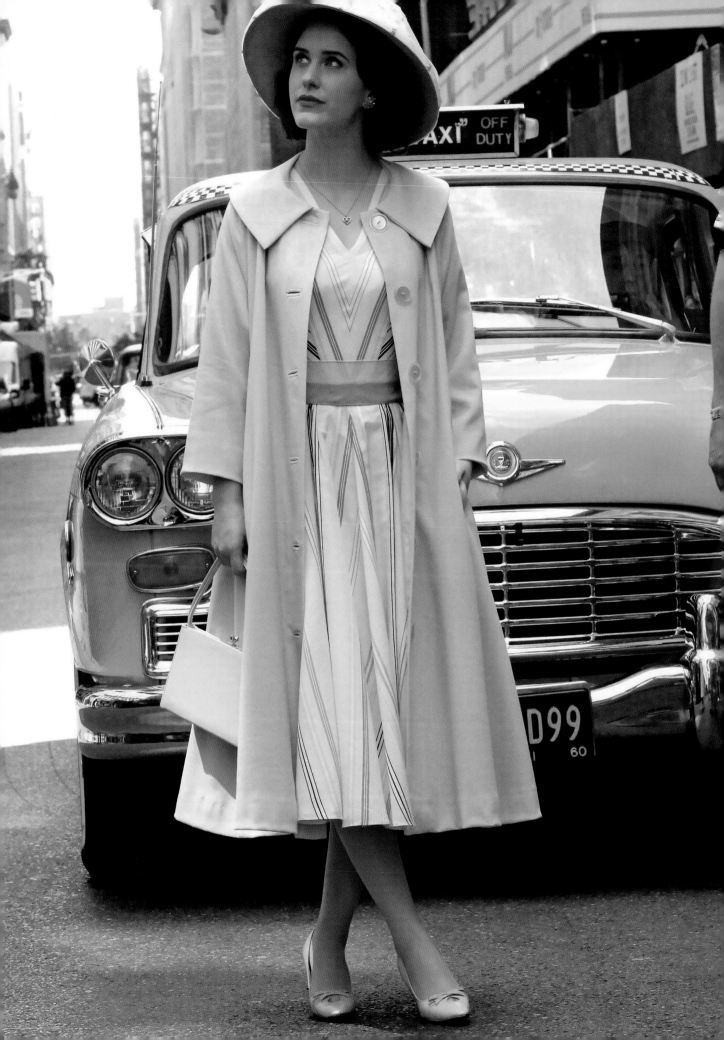

The Marvelous Mrs. Maisel

TELECAST *from* **2017–2023** *on* **AMAZON PRIME**

STARRING: Rachel Brosnahan, Alex Borstein, Marin Hinkle, Tony Shalhoub

COSTUME DESIGNERS: Donna Zakowska, Caroline McCall, Anna Robbins, and Susannah Buxton

- -

She's a sharp wit and a sharp dresser, but isn't content being an Upper West Side housewife and mother. Though it's the '50s, Midge is determined to be a stand-up comic.

SUPPOSEDLY, ACTOR EDMUND GWENN said on his deathbed, "Dying is easy, comedy is hard." Then how come Amy Sherman-Palladino makes it seem so effortless? Not since the peerless film director/screenwriter Billy Wilder (*Some Like It Hot*, *The Apartment*) has anyone captured the verbal lighting that marks the syncopated, multilayered, rapid-fire, name-dropping, this-short-of-smart-ass-saved-by-just-enough-heart speech of all-too-knowing urbanites who don't want to miss anything but never leave enough time to get there. If that isn't enviable enough, Sherman-Palladino has a romantic's eye for composition, and an archivist's passion for period detail.

The Marvelous Mrs. Maisel boasts such a shimmering vision of New York in the '50s, it's tempting to savor the show with the sound off, if only because while the sound is on, it's hard to focus on anything except what a sensational creation is Midge Maisel—even more irresistible than the spell Sherman-Palladino cast with Lauren Graham as Lorelai Gilmore on *Gilmore Girls*. And because Rachel Brosnahan has the moxie and self-possession to sell this girl-on-a-mission, you couldn't root for her more if she were your sister.

Midge propels herself down city streets, as if disappointed it's not a moving walkway, dressed in something smart, cinch-waisted, and flared, her swing coat in mid-billow as if she was five minutes late to lunch with the girls at B. Altman's Charleston Gardens—whereas in reality, she is nearly running the entire department

store's switchboard by herself, while waiting for her big break.

That could be a while. During the '50s, female stand-ups were as rare as Gentiles vacationing in the Borscht Belt. I can only think of one who was on *The Ed Sullivan Show* during the decade: Jean Carroll. (Phyllis Diller made her debut in 1960, Joan Rivers in 1966.) Making it even tougher on herself, Midge isn't listening to the advice of misogynistic club owners or future rivals, who believe she needs to take off the cocktail dress and take on a shtick. In one episode, she goes off when she's told, as she puts it, "No one will find me funny unless I do some big wackadoodle character or have a dick? Men won't find me funny if I don't look like a dump truck?"

Midge is funnier because you don't expect hilarious insight from someone who looks like she belongs behind the wheel of a Coupe de Ville. To ensure her stylishness, Sherman-Palladino gave designer Donna Zakowska the space and funds to build a costume dream factory at Steiner Studios in Brooklyn with a staff of forty seamstresses, pattern and hat makers, tailors, and embroiderers.

"Amy sold me the moment she told me comedy should be seductive and delightful," says Zakowska in her studio, its walls lined with sketches, fabric bolts, hat stands, clothing racks, and swaths of sequins. "It all started with the pink coat Midge wears at the beginning of the series, which now hangs in the Smithsonian (along with Midge's black onstage dress and her baby blue lace peignoir she wore during her first stand-up routine), that symbolizes her seeing the world and opportunity through rose-colored glasses."[15]

According to Zakowska, "there was an exuberance about the character. I never wanted her to look depressed. Midge is always capable of overcoming the odds, so her clothes follow that mindset."[16] Zakowska started with her heroine's undergarments. "The woman who built Midge's lingerie in Paris was awarded the Légion d'Honneur. I thought that was a good thing to build on."[17] A foundation like that demands follow spot-worthy fashion. Zakowska and her team "looked at magazines of the period, French and American *Vogue*. Ready-to-wear and couture used to be about making wearable clothes. The era owes a lot to Dior and Charles James, who believed that garments came out of contouring fabric onto the body. That's why we put Rachel and Marin [Hinkle, who plays Midge's very chic if delusional mother, Rose] through so many fittings."[18]

All Brosnahan's clothes are made on site, as are most of the clothes for the other principals, including the suits and even the beret for Tony Shalhoub, Midge's

intellectual and fragile dad, Abe. No synthetic fabrics are used: they weren't good enough for clothes at this level.

When Midge is onstage, however, her wardrobe is different. "She is outside herself when performing," says Zakowska. "And I didn't want her clothes to distract, so we used black and a lot of shine."[19]

For the fourth season, as the era moves into the early '60s, Zakowska notes, "The clothes get more sculptural, less full-skirt and more A-line. We narrow down the curves and extravagance and push toward Pierre Cardin's view of the modern world."[20]

The one person in Midge's world whose attitude and wardrobe never change is her caustic manager, Susie (Alex Borstein). "Her identity has never been sexual, so I didn't want to be overt, especially not during this period, but I did look at photos of a lot of lesbian bars of the era," says Zakowska, "That's where I came upon the idea for her cap. You're never sure the difference the right accessory can make until you find it—a Greek fisherman hat I found in a vintage store in Bridgehampton. It gives her stature, and that's important when you have someone who is only five feet."[21]

Midge Maisel wears hats all the time, but her stature is never in doubt. Even Lenny Bruce believes in her, as he makes clear in a disquieting speech Sherman-Palladino gives to the eerily good Luke Kirby as the scandalously sharp comedian. Who expects that something Lenny Bruce says would choke you up? The words, of course, are Sherman-Palladino's, and she believes in her girl. Actually, in all girls. As Midge asks her audience, "What if we discover one day that we were always the ones in charge, just no one told us?" I'd be more than happy to give Amy Sherman-Palladino the reins to anything she wanted to run. I just want to be there and benefit from it.

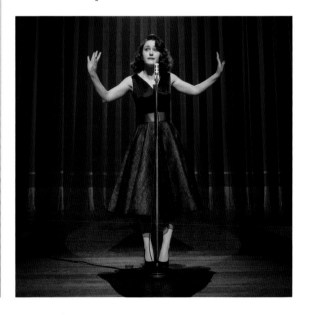

DRESSING THE PART

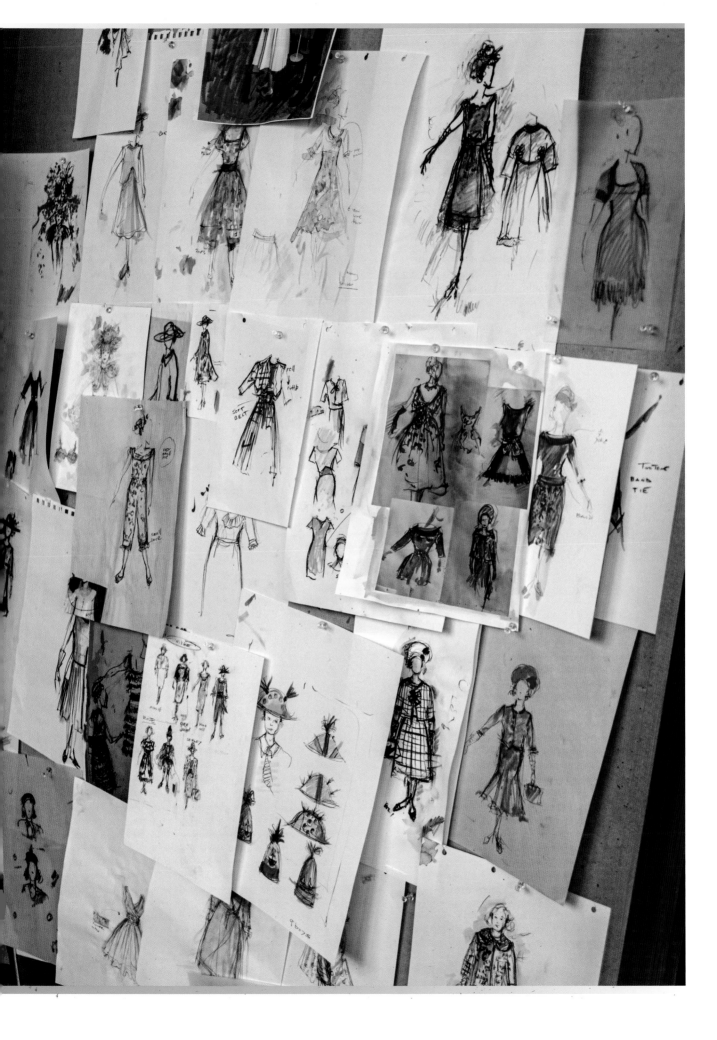

A CONVERSATION WITH DONNA ZAKOWSKA

Is there a color you haven't used on Midge? Her wardrobe is a kaleidoscope.

I was trained as a painter, so the study of color was always a part of my life. I get color visions, and that's how it begins. I have a childlike excitement about reacting to them.

How do you pass those perceptions on to Rachel Brosnahan?

Rachel is a perfect animator of clothes. She responds to the colors. I think we all do. As Midge, pink is reminiscent of her past. Red has her standing up to the male world, like when she wears a sexy red flare dress when she needs a

special favor from her ex-husband, Joel. And when I felt Midge did something heroic, I put Rachel in green. The right fabric texture can heighten that complexity even further. Like when Midge is onstage, I want her clothes bouncing light more than color.

You have more hats on MMM than we often see at Easter. Is there something more going on here than accessorizing?

Hats were a ladylike staple during the era. But once you design one hat, it becomes an addiction. You just must do more. Soon they started to enjoy a completely separate life of their own on Instagram. Suddenly, there was all this fan art with hats. People

wanted to buy them, too. It's very flattering, but I'm not a retailer. I've had enough to do dressing nine thousand extras.

Do you think clothes are as glamorous today as they were during the show's time frame?

What I've always loved about Bob Mackie's talent is that no matter how theatrical his work, he always celebrated the female body. So many clothes today don't enhance. They go over the body, but they don't grow out of the body. When you superimpose shapes on someone, you diminish them. Clothes are our way of celebrating life every day. That's why we love Midge. She's always in the throes of celebrating.[22]

Bridgerton

TELECAST *from* **2020–** *on* **NETFLIX**

STARRING: Regé-Jean Page, Phoebe Dynevor, Jonathan Bailey, Simone Ashley, Charithra Chandran, Golda Rosheuvel, Polly Walker, Nicola Coughlan, Luke Newton, Adjoa Andoh

COSTUME DESIGNERS: Ellen Mirojnick, Sophie Canale

- -

Romance, gossip, and status amongst the aristocracy in early nineteenth-century England—a history lesson that's part fantasy.

HOW DO YOU DESCRIBE A SERIES THAT ignores all the rules; flaunts dramatic license; installs women as the movers and shakers of society two centuries ago; presents men as the more emotionally mercurial sex when it comes to romance; uses music by Madonna, Rihanna, Taylor Swift, and Nirvana to underscore machinations and seductions in the early nineteenth-century court of Queen Charlotte; boasts a cast that is as colorful as colorblind; and is cheekily proud of the fact that its designated lovers are sexier with their bodices and breeches laced than most people are with their knickers off?

Julia Quinn's nine *Bridgerton* novels were published between 2000 and 2013. All are set in Regency England: a period that lasted only nine years, from 1811–1820, after King George III (you know, the one who lost the American Revolution and was snarkily portrayed by Jonathan Groff in *Hamilton*) was declared mentally unfit to rule, and his handsome son George IV (then Prince of Wales) was installed as regent. Evidently, it was a time when the aristocracy and the fine arts flourished. But none of these details even remotely indicate what a genre-busting whoopee cushion of a series producer Shonda Rhimes was about to drop on an unsuspecting, housebound public. However, some 625 million Netflix viewing hours later, we are almost thankful to have been quarantined so we could focus our full attention on an exuberantly lavish, why-not-outdo-Baz-Luhrmann costume escapade that was more tantalizing than playing Truth or Dare at a masked ball on Halloween.

Even given a $100 million development deal Netflix offered the creator of *Grey's Anatomy*, *Scandal*, and *How to Get Away with Murder*, it's pretty audacious to spend $7 million per episode on a costume drama surrounding

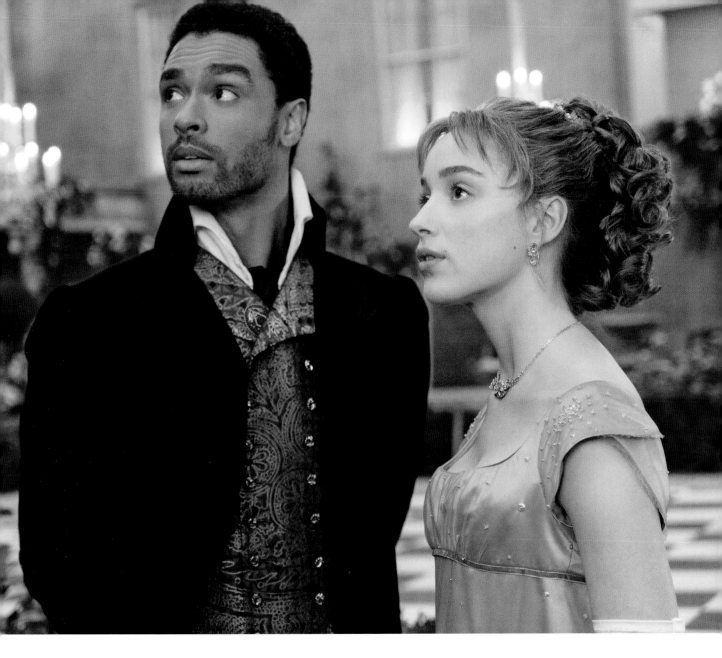

and resulting from a coming-out party held two hundred years ago.[23] In season one, Daphne Bridgerton, the eldest and wisest daughter of one of the royal court's most highly regarded families, has been dubbed this season's "diamond" by the toweringly bewigged, appropriately imperious Queen Charlotte. Complicating matters and setting an inevitable romance in motion, Daphne coerces her brother's dashing peacock of a best friend, Simon Basset, Duke of Hastings, to pretend to be her suitor to keep less appetizing creeps in cutaways from getting too close. Of course, we all know where this is going, but we've never passed such spectacular scenery on the way there. But then, how many people of color held titles and land in 1812 England, and how many balls back then featured the music of Taylor Swift and Madonna?

As soon as she read the first episode, Ellen Mirojnick, the costume designer for season one, knew that historical accuracy would not be as essential as an engaging fashion mash-up that would result in social media iconography. "There was really nothing to source, because any available clothing from the period would look too archival, plus people were smaller back then."[24] Also, the clothes needed to drive the visual banquet as well as the story. "I do look for odd sources of inspiration sometime, and I found it in illustrations by Genieve Figgis, who did ironic takes on eighteenth- and nineteenth-century aristocracy. I thought they were kind of sexy."[25] (Personally, I found this artwork bizarrely off-putting, but the color palette in Figgis's work is appropriately lush.)

"We had to build three cutting rooms in Spain, Italy, and England to handle the one thousand costumes for the principals and over six thousand for the extras, so I created a massive 'look book' to cover all aspects of the production," said Mirojnick. "We were aware that

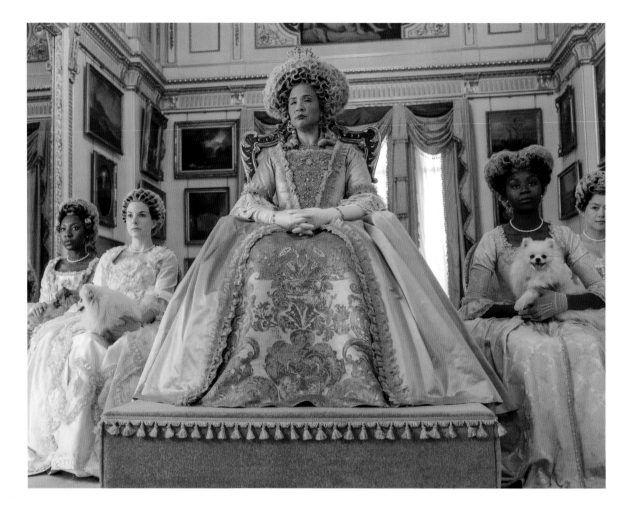

the audience for the show would be young, and they wouldn't be attuned to the era, but we felt we could attract them by presenting period dressing in such an accessible new way, that they could imagine themselves in the fantasy, especially if we never eased up on the hook of romance."[26]

There was plenty of over-the-top outrageousness: Queen Charlotte's hair and movie-screen-wide skirts, the socially ambitious and awkward Featheringtons in a riot of clashing fruity hues. Lady Danbury, who was more than a lady but less than a queen, emphatic in scarlets and crimson, punctuated by her requisite showy top hat and cane, contrasted with the Bridgertons, who uniformly reflected a softer palette of muted blues, mauves, and lavenders. To ensure that she held focus and relatability, the angelic Phoebe Dynevor as Daphne, the season's "diamond," was singularly dressed with the simplicity of an ingenue. "It was as if her entire look was layered filigree. She wears no bows, no ribbons. Whereas all the other women wear opulent jewelry, Daphne rejects a grandiosely unsubtle floral diamond necklace from a prospective royal suitor, and from then on is seen wearing one small diamond and occasional crystal ornaments.

We had more requests for that diamond drop than any other piece we showed during the season.

"The one body part of Daphne that always remains in focus is her bosom. Half-corsets crafted by Mr. Pearl, the foremost corset maker in the world, made that easy. All the women wore them. But even Daphne's gowns deliberately lack volume at first glance, to focus all initial attention on her bodice. The gown's fullness swirls around her in the back."[27]

Making the men look sexy was easy. Regency menswear coincided with the era of Beau Brummel, when every piece of tailoring was so fitted that men had no room for underwear beneath their britches. "Regé has a great body but a long neck, so we gave him really high collars, which gave us the opportunity to frame his profile in colored scarves and brooches."[28]

According to French *Vogue*, after *Bridgerton*'s first season, online searches for floral dresses went up by 146 percent, for gloves 63 percent, for corsets 71 percent, for Empire-waist dresses 150 percent, and for velvet dresses 69 percent.[29]

Rhimes continued to take big risks with *Bridgerton*'s second season. Because each of Quinn's books focuses

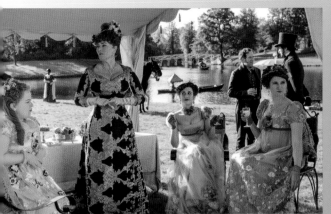
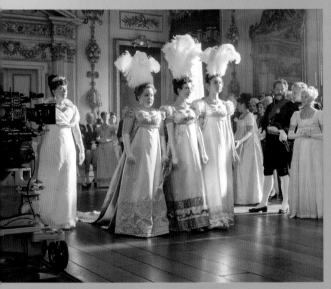

on a different member of the family, not only was Dynev-or's Daphne moved out of the spotlight, but Regé-Jean Page went completely MIA, causing major say-it-ain't-so! heartthrob deprivation panic.

But after a few weeks of readjustment, the equally pulse-quickening pairing of Jonathan Bailey as Anthony Bridgerton and Simone Ashley as Kate Sharma restored a healthy level of lust. This time, the most notable fashion moment was the color progression of Kate's wardrobe, from subdued teals and light sage, while she was still gracefully pimping out her sister to be Anthony's intended, to purple velvet and embroidered lilac as she realizes her true feelings for the man, until the tale's happy ending, when Ashley's gorgeous bru-nette mane falls on violet velvet and marigold brocade as her white-gloved hands caress Bailey's handsome

face. After that season, queries about cropped jackets increased by 96 percent, Regency dresses 84 percent, silk gloves 63 percent, military blazers 89 percent, and waistcoats 77 percent.[30] Demand for croquet sets went up by an undisclosed amount, but I was given a one-month waiting time for mine.

Filming for season three of *Bridgerton*—about the relationship between Colin Bridgerton and Penelope Featherington, aka Lady Whistledown—is underway. But Rhimes has also launched a sidebar series all about the commanding and Cinemascopically dressed Queen Charlotte. There's little doubt it will attract the same audience, but it's doubtful that it will generate the same flurry of fashion searches. Taking on Charlotte's look will be quite a challenge. Forget about calling an Uber when you're ready. You're going to need a UPS truck.

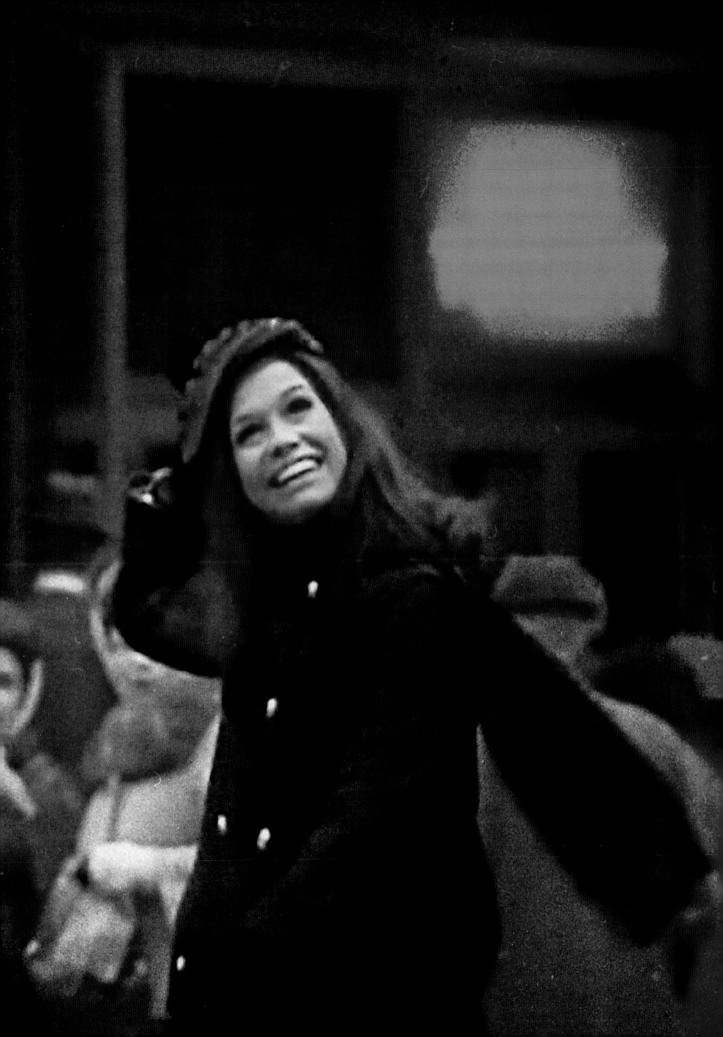

You're Gonna Make It After All

WORKING WOMEN

That Girl

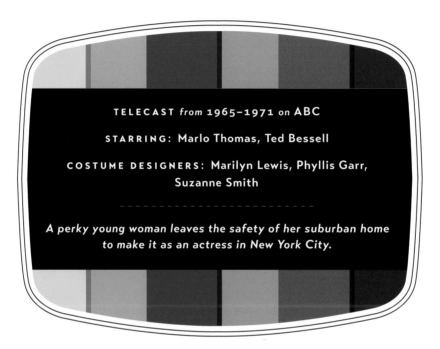

TELECAST *from* 1965–1971 *on* ABC

STARRING: Marlo Thomas, Ted Bessell

COSTUME DESIGNERS: Marilyn Lewis, Phyllis Garr, Suzanne Smith

- -

A perky young woman leaves the safety of her suburban home to make it as an actress in New York City.

W ATCH THE SHOW NOW, AND THE episodes are so plush-toy adorable they almost squeak (Marlo Thomas's voice certainly does), with friction-free plots, tidy resolutions, and not a hair out of place—I mean that literally, because Ann Marie's densely banged flip never wilts, flattens, or moves.

And yet, scroll back forty-seven years and you discover *That Girl* was benchmark television, the first time a network got behind a show about a girl who wants to experience the joy of being single. Marlo Thomas, originally wanted to call the show *Miss Independence* because that's what her father, the comedy TV star and producer Danny Thomas, used to call her.

Validating Daddy's nickname, Thomas got herself a TV show by being headstrong. She had auditioned for a different pilot on ABC (without her father's help) and didn't get

it, but Edgar Scherick, the vice president for programming at ABC, told Thomas that he believed she could be a TV star. He was so sure, the actress/producer recalled in an interview with the Television Academy in 2011, that he told her, "You already have a sponsor [Clairol]."[31]

However, reading through the scripts and pitches she'd been sent was numbing. Thomas asked Scherick, "Have you ever thought of doing a show about a young woman who is the focus of the story, as opposed to being the daughter of somebody or the wife of somebody or the secretary of somebody, but it's about her dreams. . . . How about doing a show about a girl like me—someone who graduated college as an English teacher, whose parents want her to get married, who wants to be an actress and move to the big city, [but] her father is scared she's going to lose her virginity, even though she probably already has."[32]

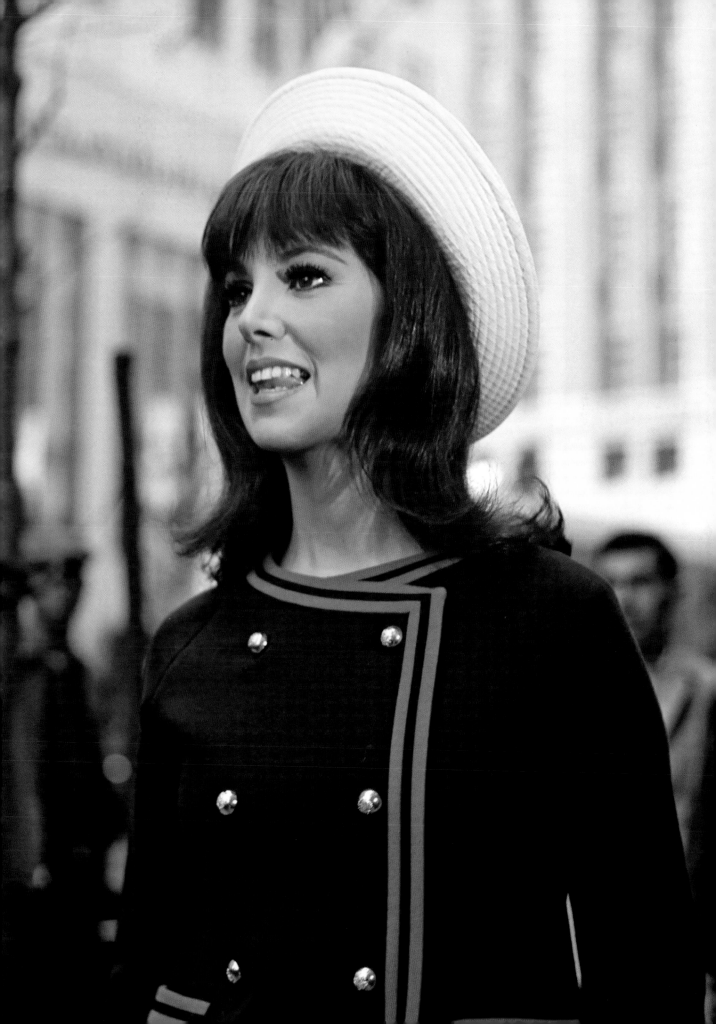

To quell Scherick's doubts, Thomas brought him a copy of *The Feminine Mystique* by Betty Friedan and urged him to read it because, she insisted, "this is what's happening in this country now. Women don't want to be their mothers anymore. They want something else. . . . I'm nothing if not a woman of my time."[33]

To his credit, Scherick not only read Friedan's revolutionary realigning of femininity, but he also greenlit the project, with Thomas as her own producer. She immediately went to veteran writers Bill Persky and Sam Denoff—who were her childhood charades partners but are probably better known for having crafted the blissful *Dick Van Dyke Show* (see page 76; the show was also produced by her dad)—and posed to them the challenge of writing for a woman for a change. They agreed.

And so, Ann Marie travels forty miles south from Brewster, New York, and moves into the big city, managing not only to rent an apartment while her taxi waits outside with the meter running but also to fully furnish it within hours. At least the chairs are mismatched, so we might assume that she's just starting out on her own.

The mid-sixties saw the first post-war "youthquake," when those under twenty-five were supposed to embrace the Age of Aquarius. Even so, certain concessions had to be made to get past TV's puritan Standards and Practices. Ann Marie and Donald "were sweethearts . . . from the '50s," she says. "The sexuality was really hidden. Here we were in the sixties and seventies, the Vietnam War, free love, women not wearing bras, this whole sexual revolution, but it wasn't happening on television."[34]

Then why did *That Girl*'s audience accept such an outmoded arrangement? Thomas believes they "went with it because everyone aspired to that morality, but no one was living it."[35] In fact, the only modern touch in their relationship was that Thomas stood firm against Clairol's insistence that the couple marry in the finale. "I can't do that to these women who have followed her for five years and say to them now that the only happy ending is a wedding."[36] Instead, Ann Marie takes Donald to a women's lib meeting.

The one area where Ann Marie was current was her wardrobe. It was astounding how this young woman, who never once held down a steady job during *That Girl*'s five-year run, appeared in a different, picture-perfect, brand-new dress or outfit in almost every scene—a sleight of hand worthy of David Copperfield.

Prior to the start of filming, Thomas had been "in London doing *Barefoot in the Park*, and this was a time of great fashion . . . Mary Quant, Twiggy, white boots, fishnet stockings, big sunglasses, big eyelashes . . . so I brought that back with me."[37] And when Thomas reckoned that most American TV was still dressed like "*The Donna Reed Show*, everything was very fifties . . . so I insisted that we do it. It was in *Vogue* magazine, but it hadn't hit the streets yet. . . . By the time we were on the air it had hit the streets, so the fashion was very with it, and girls loved it."[38] Thomas brought in clothing designer Marilyn Lewis, a West Coast designer who made her mark in a short career (1968–1977) with a bright, color-blocked, highly geometric, upscale line called Cardinali, which was quickly copied by lower-priced labels like Jonathan Logan. (My cousin saved her babysitting money and bought twenty-three Logan *That Girl* dresses when she started her new secretarial job after high school.) A costumer named Suzanne Smith pulled from Giorgio di Sant' Angelo, Halston, and Mary Quant. I don't recall Ann Marie ever earning an Equity card, yet her bottomless closet was as enviable as it was piggy-bank busting. But that's what made *That Girl*'s fashion parade so much fun.

"No, Ann Marie would never have been able to afford it," says Thomas. "I don't think *Marlo* would have been able to afford it . . . but it really worked. [The clothes] made it a hot, present show, as opposed to just another look at TV fashion, which has never been great."[39]

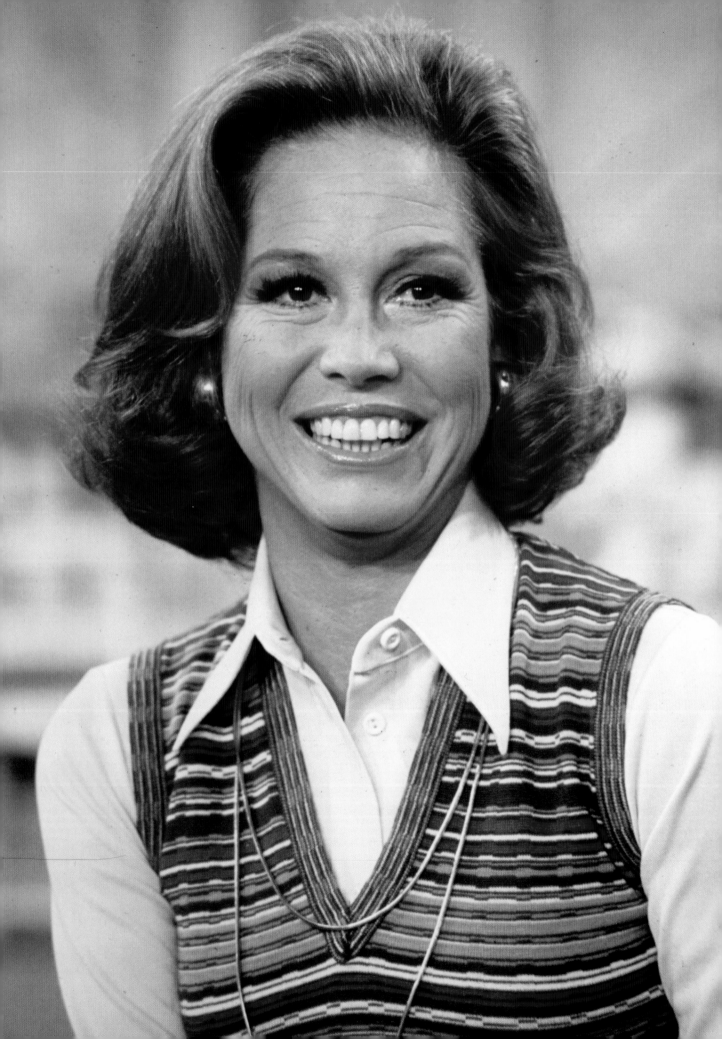

The Mary Tyler Moore Show

TELECAST *from* **1970–1977** *on* **CBS**

STARRING: Mary Tyler Moore, Valerie Harper, Cloris Leachman, Ed Asner, Gavin MacLeod, Ted Knight, Betty White, Georgia Engel

COSTUME DESIGNER: Leslie Hall

The first series to show a woman over age thirty living alone and liking it, and whose motivating purpose is building a career.

I T DIDN'T MATTER TO THEM THAT SOCIAL landscape of America was rapidly changing. In 1950, 82 percent of American women were married. By 1970, that figure had dropped to 61 percent.[40] In 1969, Woodstock changed sex, drugs, and rock and roll forever. The following year, liberated women protested in Atlantic City outside the Miss America pageant. But the moment executive producers James L. Brooks and Allan Burns pitched casting Mary Tyler Moore as a thirty-year-old divorcée who moves to the big city to start fresh, the network brass shot the concept down midsentence.

"You want to *divorce* Mary?" asked [CBS programming executive] Mike Dann, who had promised Moore her own show, incredulously."[41]

Another exec exclaimed, "The audience will think she divorced Dick Van Dyke!"[42]

Then Dann brought in the head of CBS research who declared, "American audiences won't tolerate a divorcée in a lead of a series, any more than they will tolerate Jews, people with mustaches, and people who live in New York."[43] (Don't you hope these guys—and you can be sure they were guys—lived long enough to witness the network success of *Maude, Seinfeld, Magnum P.I.,* and *Mad About You*?)

Not that CBS had much to boast about, since their once rich cultivation of kick-the-can backwoods comedies like *The Beverly Hillbillies, Green Acres,* and *Petticoat Junction* was drying up fast. Luckily a sudden regime change at the top in 1970 brought in Robert D. Wood and Perry Lafferty,

who jointly decided it was time to urbanize the network's prime-time lineup. So, Mary was in, except now she had been dumped by her boyfriend after helping to put him through medical school. To Moore, that situation was even more offensive, but it placated the men in charge. Nevertheless, Mary's independence had to be gingerly tiptoed in—to borrow an image from the now legendary MTM production company logo—on little cat feet.

According to Jennifer Keishin Armstrong's book *Mary and Lou and Rhoda and Ted*, this is how Brooks and Burns deftly positioned her in their written proposal:

> *Mary is open and nice. That's why she's in trouble. It's also why she's still single. If she had been less open, she could've maneuvered that doctor into marrying her. In the world of the seventies, openness is for national parks. . . . Lest you be left with the picture of Mary with warm apple pies cooling on her windowsill, singing duets with her pet squirrel, that's not our girl. It's just that she seems wholesome when contrasted with those around her. We'll let you in on a secret that's for your eyes only. Mary is not a virgin. This becomes a very wholesome quality when you realize that Rhoda is not a virgin many times over.*[44]

That Girl may have had Ann Marie moving to New York to be an actress, but when Mary first walked into Mr. Grant's office in her miniskirt and white go-go boots, hoping to be hired as a secretary and winding up being hired as associate producer of the six o'clock news at WJM-TV (at a lower salary), she didn't have a Donald to run home to, or a daddy stopping by unannounced to check on her virtue.

Though *TMTMS* was at first damned by faint praise—*TV Guide* initially described Mary as "desperate" and the *New York Times* dismissed her situation as "preposterous"[45]—the alchemy of spot-on actors combined with brilliantly sharp but warm humor week after week (turned out by a writing staff that, featured a then unheard-of twenty-five women) soon had the fledgling associate producer being heralded as the ideal liberated woman.

During the first season, Moore wore a long wig, hoping to distance herself from looking like Rob Petrie's wife. By the second season, the wig came off. Mary was now "making a nothing day suddenly make it all seem worthwhile," and costume designer Leslie Hall started developing Moore's refreshing and relatable sense of style. Hall had previously helped Elizabeth Montgomery discard her personal wardrobe in favor of Samantha's sleek suburban normalcy on *Bewitched* (see page 78). Moore had made her sartorial mark in capri pants on the *Van Dyke Show* (see page 77), but she and Hall agreed that they weren't an option for Mary.

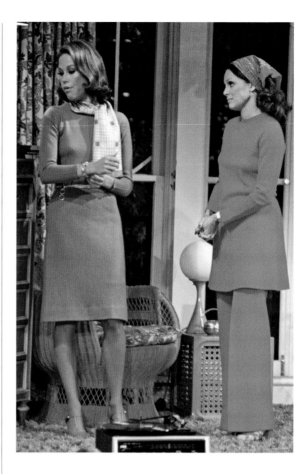

Instead, Hall came up with a novel plan: making a deal with Evan-Picone, a Seventh Avenue ready-to-wear house that specialized in both casual and work-appropriate separates, to design a complete wardrobe for the character—the first example of product placement on TV. Just as innovative was Hall's insistence that the character re-wear pieces, mixing and matching her miniskirts, and later midi-skirts, multihued sweater vests, bell-bottoms, pantsuits, long-collared blouses, shirtwaists, jumpsuits, and jewelry. (In fact, while streaming reruns of the final season, try playing a drinking game: downing a shot every time you spot Mary's striking open square metal brooch prior to its appearance on her lapel in the final episode.) Mary's wardrobe became so popular that Hall would come out each week during the Friday night taping warm-up to answer fashion questions and give style advice to the audience, though she refused when her agent tried to promote her as a potential label.

Mary's bestie was supposed to be a schlump. The problem with hiring Valerie Harper as Rhoda Morgenstern was that she was very attractive. They tried to dress her down, and Harper cannily played her as a brash, fish-out-of-water New Yorker with shaky confidence, in contrast to Cloris Leachman's ludicrously overconfident, overdressed, and overtressed Phyllis, their landlady and Rhoda's nemesis.

But during the hiatus after the first season, Harper, by her own choice, had gone on a diet, and become as trim as Moore, so it would have strained credibility to continue to dress her down. An inspired way forward came via Mary Tyler Moore's equally comely stand-in turned assistant. Though never credited, Mimi Kirk routinely glammed it up as a Cher-like hippie/gypsy, making skirts out of scarves and shawls from blankets. To her and the producers' delight, Harper began to copy Kirk, tying sweaters around her waist, tweezing her eyebrows, and at her insistence, allowing Kirk to twist and tie a scarf around Harper's head. It all added up to Rhoda's signature look, which became such a long-standing national trend that Harper maintained it throughout her run on *TMTMS* show as well as on her *Rhoda* spinoff.

With two feminist style icons in the making, the series became a marketing flashpoint for products aimed at empowered young women. "Charlie perfume, Breck shampoo, and Aquanet hair spray now had the perfect place to advertise their wares. . . . Women's magazines hung on Moore's every word."[46]

Moore, Harper, Leachman, Ed Asner, Ted Knight, and Betty White all won Emmy Awards. In total, *The Mary Tyler Moore Show* won twenty-nine Emmys, second only to *Frasier* for the most won by a scripted series comedy. Episodes such as the death of Chuckles the Clown; Lou's divorce; Sue Ann Nivens's affair with Phyllis's husband, Lars; and the laughter-through-tears evoked by the final episode are the hallmarks of great comedy. At the end of that episode, viewers were treated to a rare final bow in front of the studio audience by the players, surrounding the lady whose smile we will forever be grateful for, as she declared, "To the best cast ever!" Who are we to argue with Mare?

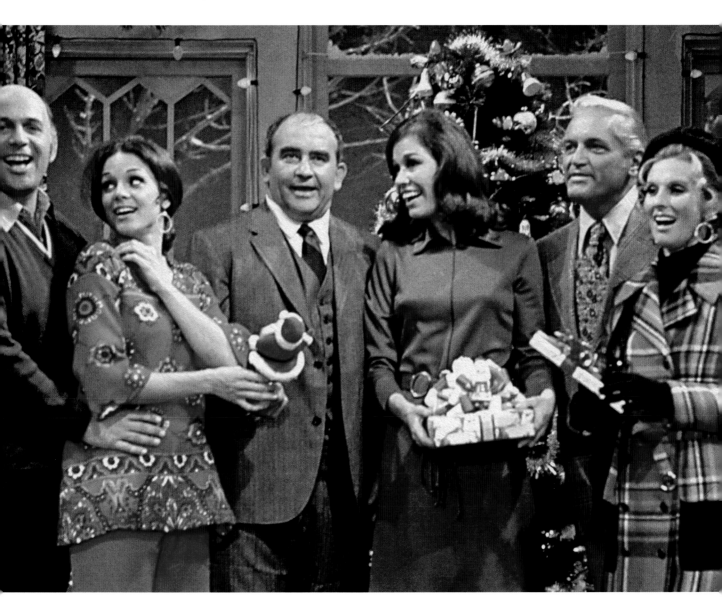

Ally McBeal

TELECAST from **1997–2002** on **FOX**

STARRING: Calista Flockhart, Greg Germann,
Jane Krakowski, Peter MacNicol, Lisa Nicole Carson,
Lucy Liu, Portia de Rossi, Courtney Thorne-Smith

COSTUME DESIGNERS: Yana Syrkin, Rachael Stanley,
Mimi Melgaard

*A young lawyer with an overactive fantasy life, joins a firm
where the clients don't have nearly as many idiosyncrasies
as the attorneys representing them.*

EVIDENTLY, THE BRASHLY HEADSTRONG, relentlessly flirtatious partners at *L.A. Law*'s McKenzie, Brackman, Chaney and Kuzak were not off-kilter enough for David E. Kelley, that show's Emmy-winning executive producer and prolific, gifted head writer. When it came time for Kelley to create his own firm from scratch, he roped in a gaggle of litigators of whom you'd be justified to cry out, "Get the net!" And in the middle of the voluble, sometimes brilliant, often contentious, and always flawed neurotics that make up Cage & Fish stands this willowy, saucer-eyed young woman, looking like a Keane painting with a better wardrobe. Yet, what drove *Ally McBeal*'s story line for five seasons was that this seemingly fragile, hallucinating attorney was the grounded touchstone of the firm. Calista Flockhart didn't look or move like anyone else on TV. Her seductiveness is singular: one's initial response is to shield her because she looks so waiflike and vulnerable. But when we discover how clever and confident she is in the courtroom—bordering on fierce—fears quickly turn to cheers.

Ally even has the savvy to disarm and unbalance both bench and prosecution by her choice of attire. While *L.A. Law*'s defenders dressed appropriately in high-end, conservative garb, Flockhart's tailored suitings not only emphasized her angularity, the skirts stopped way short of her palms, let alone her fingertips. Those skirts were often topped by long, slim-cut jackets hemmed below the hip, making *That Girl*'s Carnaby Street–inspired mini-dresses look positively prim. The fact that little mention was made of Ally's thigh-highness only made her impact more arresting, and more tempting to copy. According to a headline in *Nylon* magazine, "The Micro-Mini Skirt Was a Celebrity Favorite in the Early 2000s."[47]

"It always bothers me that women feel that if they are in a professional capacity, they have to mimic a man," says Rachael Stanley, who designed for the show's second and third seasons. "Of course, your number-one goal is always to set that character visually, and David Kelley is such a brilliant writer that what's on the page helped design her silhouette for me. Ally's dress is completely appropriate in a courtroom, for her. Calista was clear from the beginning that she didn't want stuff designed for her. She wanted name brands. So, I used a lot of Giorgio Armani, Prada, and Calvin Klein. But the problem with those choices is that it limits your colors."[48]

To diversify her wardrobe's color palette, Flockhart's underpinnings popped with brights. To ensure Ally's look remained distinctive, the other women in the cast were deliberately dressed at odds to her. Portia de Rossi as Nelle accessorized her sleek guise with a gaze so chilling, the office didn't need an ice machine. Lucy Liu as Ling Woo was brittle and, in today's woke climate, her dragon lady persona would probably be considered ethnically objectionable. Jane Krakowski's Elaine was pushy and forever on the make. Courtney Thorne-Smith was as close as any of them came to being labeled "nice." "It was a big cast," says Stanley. "We did about sixty costumes a week, mostly sourced. I dressed Portia like an ice queen. Sea-foam green, ice blue, silver and white, with the exception being red. For Lucy, I pushed the Asian theme. She was the oddball. Jane was fun because at the beginning she was shapelier. So we played up those curves, kept it tight and sexy. For Courtney, we played it straight. Suits and blouses."[49] In the final season, Christina Ricci's Liza Bump, a dominating nightmare nicknamed Lolita, wore suits and dresses so severely fitted they looked as if they cut into her skin.

On multiseason shows, characters often evolve and mature, sometimes mellowing in what's called an arc. However, though the eventual Cage, Fish & McBeal undergoes major staff changes, and the heroine navigates her way into and out of a half-dozen romances (not counting ghosts), Ally pretty much stays true to her soft yet unyielding core. How can we be so sure? In the last episode, her suit jacket is cut just as long waisted. Her skirt just as short. But five years later, and five years older, Flockhart's blouse is a crop top. And she's looking just as good.

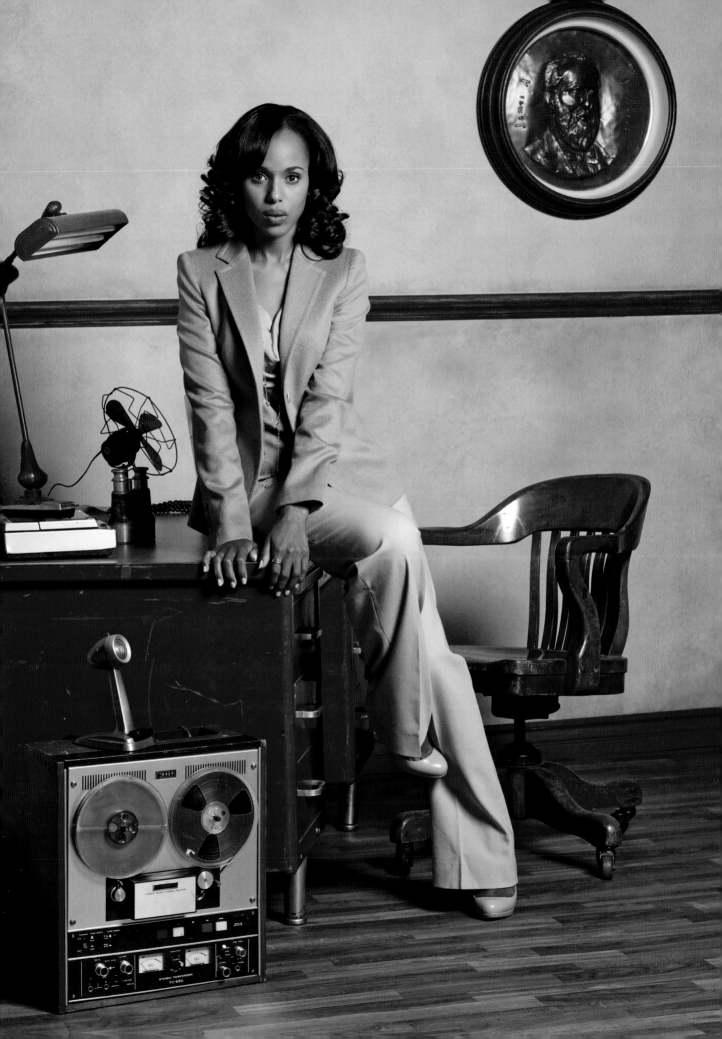

Scandal

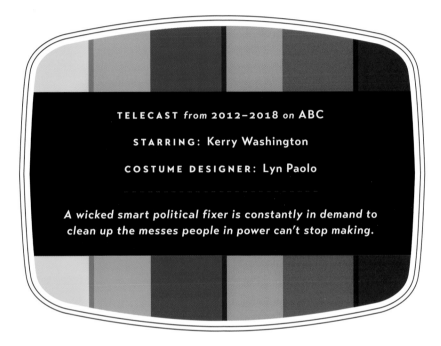

TELECAST *from* 2012–2018 *on* ABC

STARRING: Kerry Washington

COSTUME DESIGNER: Lyn Paolo

A wicked smart political fixer is constantly in demand to clean up the messes people in power can't stop making.

N ONE OF THE MOST RIVETING PILOT episodes ever to launch a series, Shonda Rhimes managed to seamlessly introduce political "fixer" Olivia Pope, seven other lead characters, and five story-lines in a single, breathless hour. And for the entire first season—climaxing with the startling assassination attempt on Olivia's off-again, on-again paramour, President Fitzgerald Grant (Tony Goldwyn)—the show was so quick, smart, and unpredictable, its characters' choices not always ethical but always expedient, that its instant fan base was delightfully winded just trying to keep up.

But by the time *Scandal* ended six seasons later, the drama had blasted off on a trajectory that long since had left reality in the rear-view mirror, careening from one cataclysmic collision into another, its cast indulging in the show's title with such frequency, that no one was left without blood on their hands. No one remained

a good person, not even Olivia, whose elbow-length gloves could only temporarily hide the dirt under her fingernails.

Yet, *Scandal*'s fans grew even more devoted, thanks to Rhimes's deft handling of her characters' ability to justify their moral lapses for the expedient, if not greater good, as well as to the brilliant casting of Olivia, her conspiratorial team of "Gladiators," and their insatiable clients—all of which left us asking ourselves, "How could these people have become so horribly amoral?" and "Shit, I really hope they wind up okay!"

Now, it's smart thinking that if you're only going to fake being good, how much more convincing is it to look that good? And Kerry Washington never looked like less than someone for whom it was worth giving up a presidency, thanks to a synergetic collaboration between her and costume designer Lyn Paolo. "Within two minutes

of meeting Kerry, we just clicked," says Paolo. "I haven't experienced that kind of symbiotic relationship with an actor before. We were together for four hours, instantly agreeing that Olivia is a pants girl, not a skirt girl, and that we were going all in on using white, starting with the opening shot of her in the white trench and suit. We sent Shonda forty costumes, including gowns. Ninety percent of those initial looks wound up in the show, including Olivia's obsession with Prada bags."[50]

Since Olivia's image was as sharply etched as she was quicksilver-tempered, her go-to palette for the first five seasons hovered around white, black, and gray. Paolo telegraphed her sublimated femininity by designing a host of silk cowl necks in soft, elusive hues like sand, champagne, and smoky lavender, accented with long, fluid chains. Naturally, it was a bonus that not only is Washington a knockout, but as Olivia she possessed a get-out-of-my-way, coming-through! gait that demanded attention.

The style world frenzy that *Scandal* evoked was kick-started by a social media tactic that has since become routine. As Paolo recalls, "We were the *first* show to live tweet with the audience. The cast and crew would get together on Thursday night with some wine and laugh about what we were doing, until one night when we broke Twitter. I would even give the cast a source book so fans would know where they could buy the pieces."[51]

In the fall of 2014, Paolo and Washington collaborated with The Limited to launch an appropriately monochromatic, forty-two-item capsule collection with pieces ranging from $49 to $249, followed by a holiday collection. Both sold out. But after season five, Olivia's color palette drastically changed to match her now combative, hell-hath-no-fury stance. Pale colors were jettisoned in favor of cherry red trenches, purple suits, and citrus orange shifts.

Washington wasn't the only cast member worth watching. The other female lead whose clothes had a story to tell was Bellamy Young as First Lady and eventually President Mellie Grant. As the president's wife, she chose silhouettes and hues that are politically expected, dark and dramatic but familiar. But because *Scandal* was at its core a show about the intoxicating nature of power, as Mellie's political profile ascended, her wardrobe began to take on some of the more subtle shadings that defined Olivia before the latter became enraged.

By the show's byzantinely plotted finale, with enough core cast members offed to qualify as an Elizabethan tragedy, Olivia is placated, at long last with Fitz and once again strutting down Pennsylvania Avenue in her white trench. Five years later, Olivia's wardrobe still looks fresh and covetable. "It was so satisfying," says Paolo. "At the end, there was nothing we couldn't have. It was as if we had our own Rent the Runway. We caught lightning in a bottle."[52]

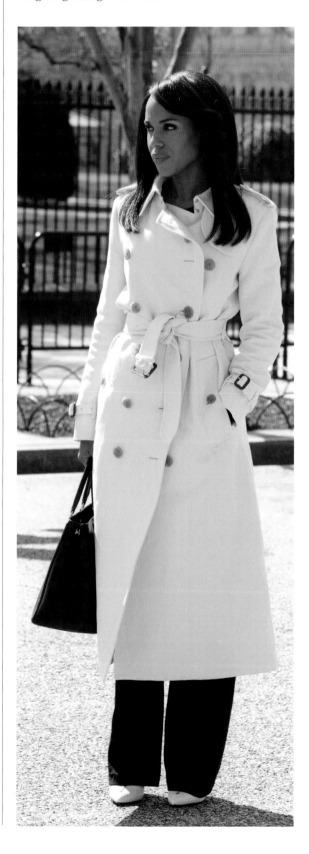

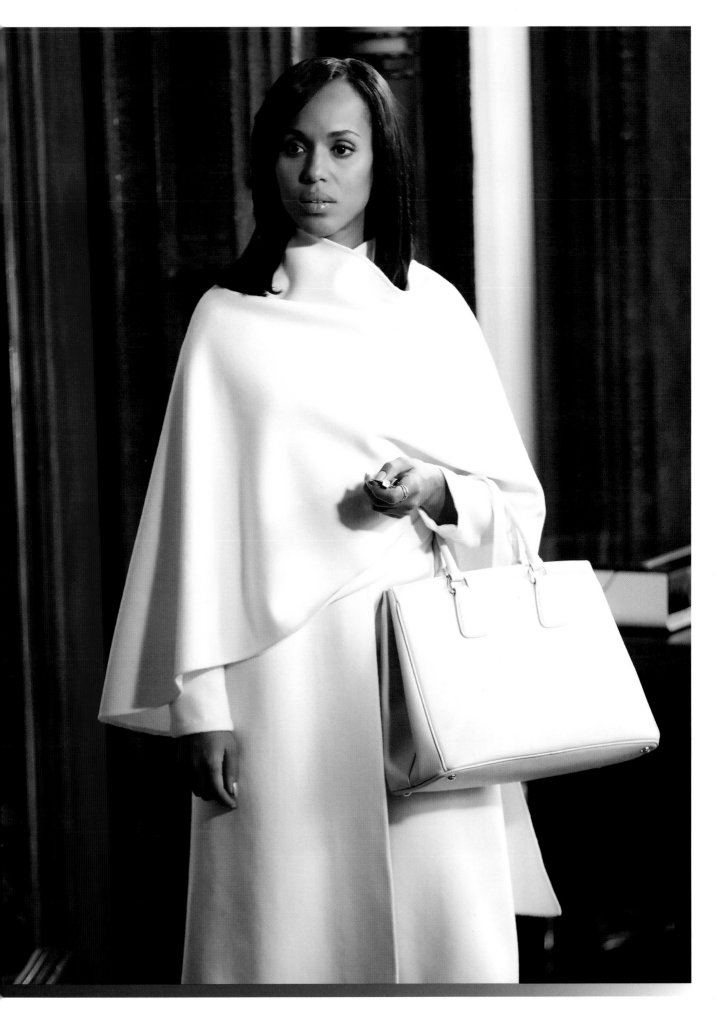

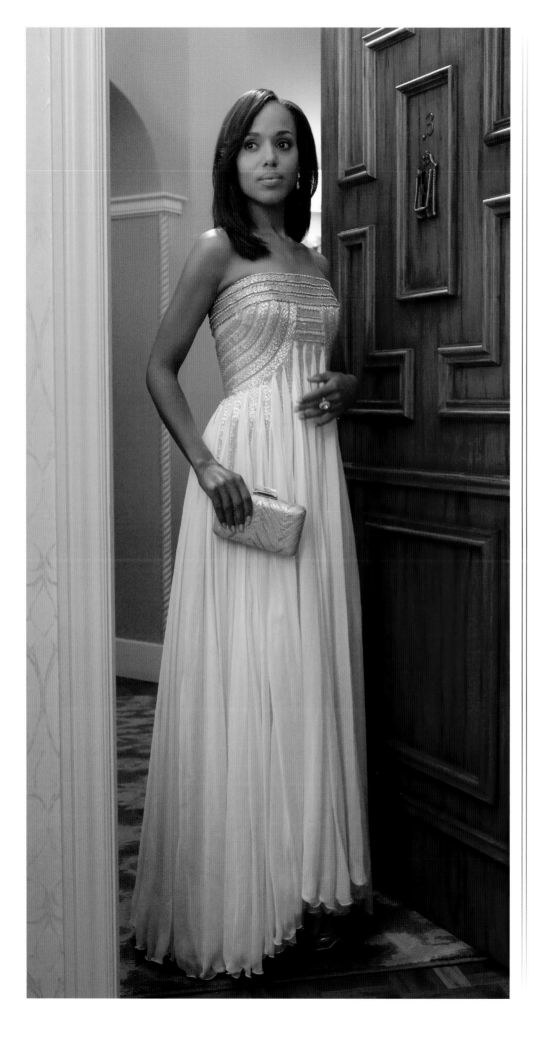

IN CONVERSATION WITH LYN PAOLO

What first attracted you to *Scandal*?

I got a phone call from a lady called Shonda. I didn't have a clue who she was. So, I wrote to John Wells (producer of *The West Wing*), and he said, "Oh, she lives down the street. You should meet with her." And the first thing she said was "I loved your work on *The West Wing*." What attracted me to that show was keeping it so true to the real West Wing. But Olivia Pope isn't working there when the show begins. She's outside the Beltway. So, that gave me more freedom.

Where did you find the iconic white trench that Kerry wears from the first episode to last?

I always give credit to Shonda. When she hired me, I didn't know Kerry was going to be the actor. But Shonda had written that Olivia's team referred to themselves as "Gladiators" and her outerwear as being armor. It's actually a seven-hundred-dollar Tory Burch trench that Burch kept making for multiple seasons because it kept selling out.

What are the biggest misconceptions about the show?

There are two. The first is though Kerry always looks put together, she is rarely in a suit. She is usually wearing separates. But what struck me was how many people thought Olivia's wardrobe was so fashion forward. Most of it was quite classic. We mainly picked the best pieces from established and mainstream lines: a lot of Armani pants, Escada jackets, lots of Max Mara coats. My favorite coat, in pale blush pink wool with a huge portrait collar, is Ferragamo. It was all about the styling.

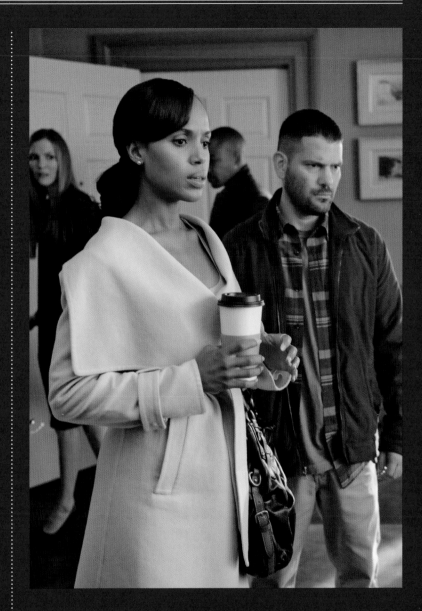

Where did you find my favorite dress—the gown she wears the night President Grant is shot?

The gown is by Jean Fares, a Lebanese luxury designer. It had been a runway piece, but we discovered it in the bottom of a box at a costume house, falling to pieces. It had been there three years. The reconstruction was amazing. Our tailor forged a work of art.

Is there anything you regret not keeping?

When we wrapped up the show, there were, count 'em, fifty-seven Prada bags!

So where are they?

They were all shipped to Disney. Their show. Their bags. Can you believe it?

The Mindy Project

TELECAST *from* 2012–2017 *on* FOX

STARRING: Mindy Kaling, Chris Messina

COSTUME DESIGNER: Salvador Perez Jr.

A driven ob-gyn is determined to have a life as filled with romance and surprise as it is with delivering other people's miracles.

O F ALL THE GIFTED HYPHENATES NOW redefining comedy from a woman's perspective for a new generation, Mindy Kaling is the one who has captured my heart. She is a wickedly clever yet generous writer, nailing her male coworkers' and paramours' foibles and strengths as astutely, and hilariously, as she draws her female friends and adversaries. She is a game, not overly self-deprecating physical comedian, rarely, if ever resorting to cheap shots or woefulness. And, perhaps the sweetest and most singular surprise of all, Mindy Kaling is beautiful.

Sadly, Kaling didn't always think so. She has costume designer Salvador Perez Jr. to thank for first guiding her to that realization.

A suggestion from a fellow scribe, when she was co-writing and costarring in *The Office*, that her character should be advised to lose fifteen pounds, landed like a gut punch. "This is my greatest insecurity and someone just called it out," revealed Kaling in a 2021 *Good Morning America* interview. "It was devastating . . . [people] verbalizing their displeasure with how I look because I don't look a certain way."[53] So, while Perez had reservations about doing a show about an ob-gyn and feared that he would have a problem finding clothes to fit the actress on a tight budget, he was struck that "she didn't have confidence when I met her. I didn't care that she was five-foot-four and a size twelve. I told her she was beautiful. And that when you get dressed, you never hide. You flatter."[54]

Trusting Perez, Kaling went to *The Mindy Project*'s producers and "asked for the world," says the designer. "And she got it! You rarely get the opportunity to do custom fashion when someone with an hourglass figure isn't a sample size."[55] Perez first made Kaling a gown for the Oscars. Then another one in five days. The press

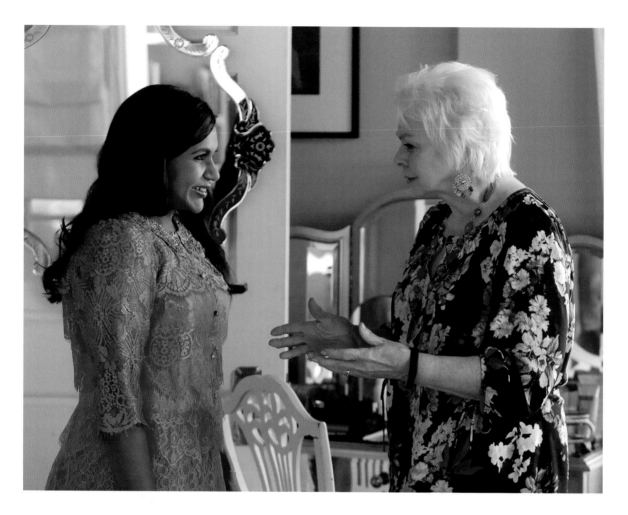

picked up on Kaling scoring two custom dresses made within two weeks. Perez encouraged her to stay away from black, neutrals, and pastels (or "Easter colors" as Kaling called them), and indulged her love of bright golden yellows, oranges, scarlet, mint, and candy pink, and of lace, ombré, and beading, richly hued saris, and authentic Indian jewelry.

Actors are notorious for dreading and/or skipping fittings. But with Kaling's date-happy doctor sometimes having twenty changes in an episode, Perez recalls how the two would meet for "massive four- and five-hour fittings. One July Fourth weekend we met for over six hours, talking fashion the whole time. I ran the sewing workrooms for the film *Titanic*, so I can work fast. But what really drove me was watching Mindy come alive when she put on the clothes."[56]

By mid-second season, Dolce & Gabbana and just about every other designer was calling, offering whatever Kaling wanted, but Perez's pieces still suited her best because he understood the power of high contrast color-blocking on the actress. Kaling tagged him in every post to her six million Instagram and eleven million Twitter followers. The impact was global. Gilt.com

approached Perez to design a coat line that the ready-to-wear Tocca brand agreed to produce. The $425 coats sold out. Perez recalls sitting at Angelina's on the Rue de Rivoli in Paris during a film festival when a group of women sat down at his table—he assumed because they thought he was a Latin film director. No. The ladies wanted to talk to him about what he had done for the woman shaped just like them on *The Mindy Project*.

His muse never took his work for granted either. Dior agreed to let Perez borrow a ten-thousand-dollar purple watch for Kaling. A week later, she presented him with the watch as a gift, along with a card on which she had written, "You've always dressed me like the most beautiful girl in the world. More importantly, you made me feel like it. Thank you."[57]

In the final episode of the series, Dr. Lahiri winds up with Dr. Danny Castellano (Chris Messina), as we always knew and hoped she would. There is no denying that the two actors emitted the kind of sparks every Cinderella yearns for. But in reality, Danny was not the beautiful baby doctor's true prince. That title belongs to the guy who didn't carry around a glass slipper, but his thimble made for a perfect fit.

Home Sweet Home

DRESSING FOR DOMESTIC BLISS

I Love Lucy

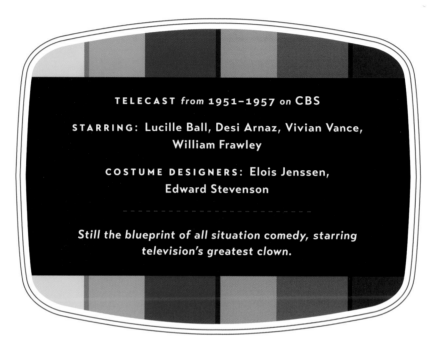

TELECAST *from* 1951–1957 *on* CBS

STARRING: Lucille Ball, Desi Arnaz, Vivian Vance, William Frawley

COSTUME DESIGNERS: Elois Jenssen, Edward Stevenson

Still the blueprint of all situation comedy, starring television's greatest clown.

SHE IS THE MOST IMPORTANT WOMAN IN the history of the medium, having created with her husband, Desi, a template for situation comedy that still resonates with validity and generates breath-heaving, nose-running hilarity no matter how many times we've seen her stomp grapes, stuff chocolates into her cheeks, spoon-feed herself boozy tonic, or remain the only isle of calm as those around her lose it when Little Ricky signals it's delivery time. *I Love Lucy* was the first scripted TV series to be shot in front of a studio audience with three cameras using 35mm film. But that's not why it was the most watched show in America during four of its six-year run (it was third for the other two), or why the readers of *People* magazine voted it The Best TV Show of All Time, or why 44 million viewers tuned in to kvell over Little Ricky's birth on January 19, 1953 (an even more astonishing number when you realize there

were fewer than 17 million TV sets in the United States at the close of 1952).[58]

We were glued to our twelve-inch black-and-white Philco, DuMont, and RCA screens because the lady most often in close-up was a sensational, if unlikely, clown. After all, clowns aren't supposed to be gorgeous, but this peerless jester was a former Hattie Carnegie model, and one of filmdom's original Goldwyn Girls; before switching mediums, she had earned the unofficial title "queen of the Bs" (as in B-movies, a dubious distinction).

Though it's now unimaginable that anyone would question whether Lucille Ball was as lovable as she was lovely, CBS seriously doubted that the public would believe an all-American redhead married to a thickly accented Cuban bandleader (though this had been a fact for eleven years when the show premiered). So, the couple shelled out five thousand dollars from their

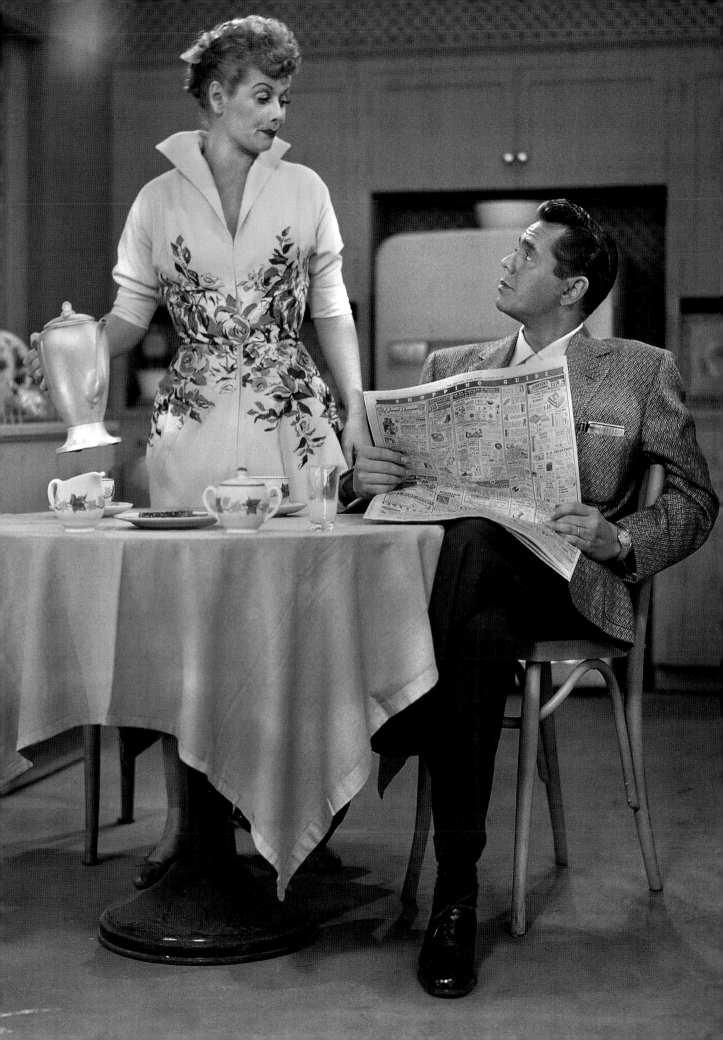

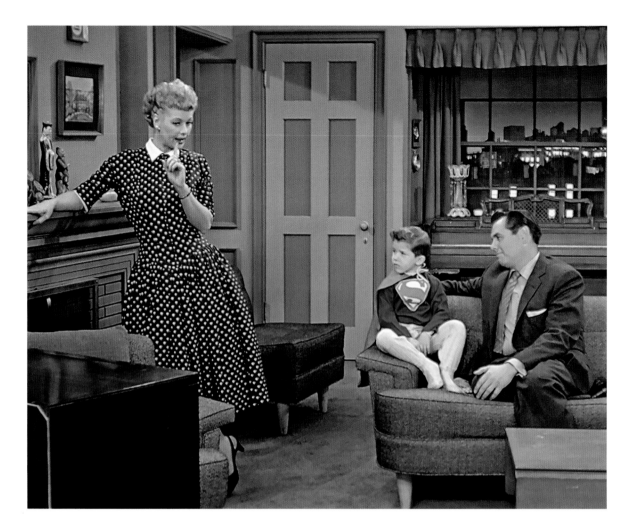

piggy bank[60] to produce the pilot episode and wore their own clothes for the next fifteen. *I Love Lucy* was an instant hit, however, and once the network gave the go-ahead for a second season, Ball had clothes purchased off the rack from the Los Angeles branch of the fashionable but affordable Ohrbach's department store. This went on until 1953, when veteran Hollywood designer Elois Jenssen, with whom Ball had previously worked, became available to dress her on, and eventually off, camera.[61]

When Jenssen arrived, she discovered that the new, rapidly expanding Desilu studio had no wardrobe department. First she had to create one, buying new machines, cutting tables, hiring seamstresses for Lucy and shoppers for the rest of the cast. Then the Oscar-winning designer (for *Samson and Delilah* in 1949) took stock of her model. "What did I have to work with?" Jenssen explained to illustrator and Lucy archivist Rick Carl, when he was creating the book *The Official "I Love Lucy" Paper Dolls.* "Nice broad shoulders; a long-stemmed waist; lean hips; those wonderful legs. A designer's delight. Nothing to camouflage."[62]

Jenssen spent hours going over ideas for the clothes with Ball, who was adamant that Lucy Ricardo always appear relatable as a middle-class housewife to ground her outrageous antics. However, Lucy was also playing a New Yorker married to an increasingly successful entertainer, who got off on her looking as spiffy as he almost always did, so it wasn't as if her wardrobe ever had to address plowing the back forty.

One of the first ensembles Jenssen offered Lucy was a jersey top and contrasting skirt banded at the waist with a cummerbund. Jenssen stated that "Lucy had just had her second child by Caesarian section (so that the birth of Desi Jr., her real-life son, would coincide exactly with airing of the episode introducing Little Ricky), and her stomach muscles were still not as strong as they once were. She loved the cummerbund idea and asked me to incorporate a cinched waistline into many of my designs."[63]

Lucy also favored high collars, often in pale hues that approximated white on camera (early TV cameras would photograph white too harshly) atop some of the most memorable looks from both Jenssen and Edward

wearing potato sacks, claiming the scratchy chemises are the work of top Paris couturier Jacques Marcel—only to have the designer steal the idea and feature it in the windows of his tony atelier, after Lucy and Ethel set fire to their phony couture.

But the defining social statement for both Lucy and *Lucy* occurs in season three, when the comedienne single-bumpedly kicked maternity wear out from house-bound exile. Upon learning that she was five months along with her second child, the ever-timid executives at CBS instantly roadblocked on-air use of the word "pregnant," despite the urging of a diverse trio of clergymen hired specifically to act as cultural advisors. (This immature ban lasted for another decade, through the early seasons of *The Dick Van Dyke Show*.) In fact, the episode when Lucy finally shares the joyous news with Ricky is titled, "Lucy Is Enceinte," a French word for "pregnant," though no one in the cast spoke the language on or off the set.

But the now powerful star dismissed the network's agitated desire to obscure her growing contours behind sofas, plants, and oversized purses. (The Hermès "Kelly" bag got its name when Princess Grace of Monaco used hers to hide her belly when she was carrying Prince Albert.) Instead, Ball and Jenssen devised a parade of colorful, often printed, voluminously pleated artist's smocks. Just as significant were the decisions not to suspend the show's trademark slapstick or diminish any display of Ricky's affection toward Lucy despite her "condition."

As I wrote in my previous book, *The Looks of Love*, both choices were "an affirmation that being with child was more than a fact of life to be dealt with, but something to be proud of, and that it enhanced one's existence rather than impeded it."[65]

The $18 billion global maternity wear industry should religiously light candles, honoring Lucille Ball as their patron saint. Some may find it surprising, that a couple enterprising enough to build television's largest privately held studio during the '50s never cashed in on everything Ball did for expectant moms. But it's not like they needed the money. Remember the claim that *I Love Lucy* was the first TV series to be put on film? Well, because early TV shows were routinely shot on 16mm kinescopes and then taped over (resulting in so few remaining in existence), CBS was happy to let the couple take a salary cut in exchange for retaining the residual rights to all filmed footage after it first aired.[66] CBS may have not seen the potential, but Lucy and Desi were responsible for still one more, incredibly lucrative, television benchmark: they invented reruns. Lucrative reruns. So much for being a zany redhead.

Stevenson, the costume designer for *Citizen Kane* who replaced her in season four. Those designs included a navy blue-and-white polka-dotted dress with an interchangeable placket front (its versatility helped the frock become a wardrobe staple) and an elegant white full-skirted housedress with embroidered roses at the waist, as well as numerous drapey, sometimes embroidered, blouses that formed a flattering silhouette when paired with slim black capris. "When you are on a sound stage, the bright lights are all above you," says Carl. "Lucy knew that by sporting a nearly white collar, the light would reflect back up, framing her face with an added youthful glow."[64]

Lucy never looked more glamorous than in my favorite of her looks. She wore it multiple times, swanning through the Ricardo living room, Hollywood's Brown Derby restaurant, and a Paris *boite*. It first appears to be a black point d'esprit rhinestone-emblazoned hostess gown, until the skirt splits open with a *whoosh* to reveal pale, slim lounging pants worn underneath.

Her giddiest fashion statement was made in season five, when Ricky and Fred Mertz trick their wives into

The Donna Reed Show

TELECAST *from* 1958–1966 *on* ABC

STARRING: Donna Reed, Carl Betz, Shelley Fabares, Paul Petersen

The ideal middle-class American family, in which both Mom and Dad were smarter than the kids, for once.

W HEN REVISITING FAMILY SITUATION comedies of the '50s from today's vantage point, our vision is likely to be jaundiced. Come on, you tell yourself, no way were real kids ever that naive and obedient, dads so filled to the brim with balmy banalities, and wives so numbingly placid. But to properly gauge the original appeal of this programming, it's essential to recognize how much social media has conditioned our rush to snap judgment and resurrect a factor too many now overlook, and almost no talking head on TV bothers with anymore: context.

Television was still a novelty during its first full decade, and since there was likely to be only one screen in the house, each had the galvanizing power of the monolith in *2001: A Space Odyssey* to bring the family together nightly for a shared experience. However, after a devastating world war, followed by the Korean conflict, the last reason anyone had for adjusting their antenna was to get a clearer picture of global conflict and hard times. Postwar prosperity, bolstered by the G.I. Bill, had given rise to a brand-new stratum of American society—the middle class—and the most advantageous reason for tuning into *Father Knows Best, The Adventures of Ozzie and Harriet*, and *Bachelor Father* was to observe and adopt the behavior and tenets of these idealized middle-class households. Viewers had no thought of making fun of how they strove for perfection, how their homes were decorated, how they dressed, or how they resolved all crises in thirty minutes. Quite the contrary, they were taking notes.

Though *The Donna Reed Show* was on the air for eight years, longer than any other show in this genre, it's also the one that gets the most darts aimed at it for not being realistic. But was *Seinfeld* meant to play like a documentary? Is there anyone living in New York City, earning

her TV family to look perfect so we could be surprised to discover that they weren't flawless. Her son got Cs in school; her daughter would sometimes use her good looks to be a tease. Her husband, a pediatrician when family doctors still made house calls, was absent too often and at all hours.

Consequently, it was Donna Stone, a former nurse, who friends and family turned to for ballast and instruction. Reed made sure that Donna was smart, assured, nearly omniscient. Over time, with only stills to gauge the show's impact, Reed's beauty has betrayed her because in promotional shots she seems without blemish, causing her to be tagged a proto-Stepford wife long before Ira Levin's novel was published.

Yet, during the shows initial run, hers was the most serious of the domestic comedies. Mrs. Stone had a sobering attitude toward laziness and the easy way out. She also had a temper, and she would call out her husband for being patronizing, or occasionally smug, asking him, "Do you want a dog biscuit with your coffee? You're barking at everyone."[67] "My TV show certainly aggravated men," Reed said. "Hollywood producers were infuriated that mom was equal and capable."[68]

Reed, like her contemporaries, favored shirtwaists. But you could spot her doing chores in sweatclothes. She wore jeans in the garden (the Stone backyard was a duplicate of Reed's patio in Los Angeles). It was Dr. Stone (Carl Betz) who never loosened his tie, even in the living room. Since Shelley Fabares, who played their daughter was nearly a young doppelganger of Reed, the star let her wear most of the pretty stuff. Reed, whose career stretches back to the Frank Capra classic *It's a Wonderful Life* (1946), had had enough of Hollywood's superficial judgment of women.

"We have proved on our show that the public really does want to see a healthy woman, not a girl, not a neurotic, not a sexpot," she said during a tart interview with the *Saturday Evening Post* in 1964. "We proved you don't have to have an astonishing bosom.... The public doesn't give a damn about such things. Another thing—on my show I wear one kind of bra, and it's not too small, and it's not stuffed with cotton, and I'm not pushed up, pushed out, squeezed in, out, or sideways. I simply wear a bra that fits. Forty movies I was in, and all I remember is 'What kind of a bra will you be wearing, honey?' That was always the area of big decision—from the neck to the navel. Even with all the girl-next-door parts I played, there would usually be someone on the set whose job it was to look me up and down and say, 'Is that dress tight enough, baby?'"[69]

Now, would a Stepford wife ever say such things? Nah.

three times what Monica Geller made as a sometime caterer on *Friends*, who has an apartment as sprawling as hers? Granted, few families on your block are as handsome as the Stones of Hilldale, USA. The former Oscar winner (for playing a prostitute in *From Here to Eternity*, 1954), who produced the show with her husband, Tony Owen, had a strategy in mind. Reed wanted

The Dick Van Dyke Show

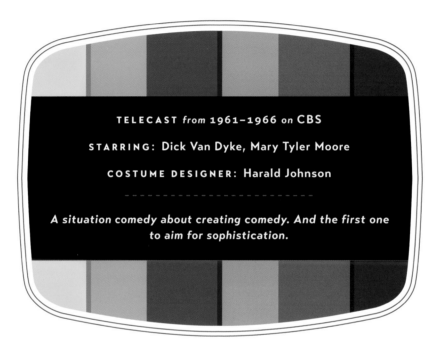

TELECAST *from* **1961–1966** *on* **CBS**

STARRING: Dick Van Dyke, Mary Tyler Moore

COSTUME DESIGNER: Harald Johnson

- -

A situation comedy about creating comedy. And the first one to aim for sophistication.

WHEN I WAS A KID, I ASKED MY PARents if we could move from New York City to New Rochelle, not because I wanted to live in the suburbs, but so that Rob and Laura Petrie could be our neighbors, and Rob could teach me how to write comedy. *The Dick Van Dyke Show* introduced a fresh, sophisticated urbanity to situation comedy. The humor eschewed jokes and one-liners but excelled at both character-driven jesting and Buster Keaton–worthy slapstick. Plus, the series was about how people craft the genre, taking advantage of two seasoned vaudevillians (Morey Amsterdam and Rose Marie) and one comic legend (Carl Reiner), so it subliminally served as a master class.

But the show sparkled most brightly when the attention was on two leads. Though the Petries had a son,

Ritchie, the weekly plots rarely revolved around him. Rather, the focus stayed on Rob and Laura, two delightfully appealing people whose obvious attraction to each other was only partially created by what was written on the page. (Long after the series ended, Van Dyke and Moore admitted to having had "teenage crushes" on each other, though they never acted on it.)[70] Though TV was still prudish enough to relegate married couples to twin beds separated by a nightstand, there was never any doubt that Rob and Laura were intimate, often. In fact, the episode that convinced Reiner and his head writers, Bill Persky and Sam Denoff, that Van Dyke and Moore generated palpable and minable chemistry had them separated on either side of a locked door after Laura, who had been playing hide-your-big-toe-in-the-faucet

while taking a bath, gets it jammed. Like Rob, the viewer can only hear Laura. But also like Rob, we're happy to use our imagination, and as Moore recalled in a 1997 interview with the Television Academy, Reiner told the young actress that she had now become "every man's fantasy."[71]

Moore looked pretty great with her clothes on, too. They both did. Because the *Van Dyke* show was produced for a spare fifty thousand dollars per episode, the two leads were the only actors who didn't have to provide their own clothes. Morey Amsterdam became known for his porkpie hats. Rose Marie's signature was wearing little black bows in her hair at the temples. Carl Reiner's toupee was usually anywhere but on his head. No one took issue with any of these accessories. Botany 500 was contracted to supply Van Dyke's slim gray one-, two-, and three-button suits; turtlenecks; and cardigans—all of which could have hung harmoniously alongside the contents of Don Draper's (*Mad Men*) closet thirty-five years later, except that Van Dyke was so lean his suitings had to be custom tailored.

But when Moore learned that Laura would be hanging out at home during the day in what she considered cocktail attire, she balked. In her own home, "I walked around barefoot, and I wore pants."[72] As Moore told the Television Academy, "The way she was written, Laura actually had opinions of her own. And while she was asserting herself, she also didn't make Dick Van Dyke look like a dummy. I mean, society's expectations at that point still said, 'Hey, wait a minute, lady, you only go so far here.' But I think we broke new ground. And that was helped by my insistence on wearing pants."[73]

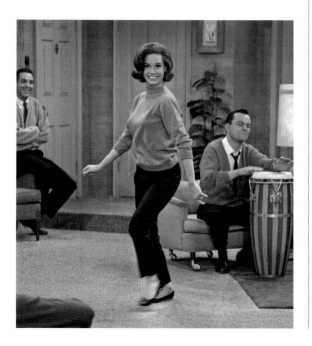

It's not as if other TV actresses had never worn pants. Lucille Ball chose them often. But the pair that Moore brought into rehearsal were body-hugging black capris. Reiner loved them. Van Dyke loved them. But once again—guess who?—those predictably skittish CBS executives tried to impose their sartorial paranoia.

"There was a little too much definition,"[74] says Moore. The term the execs used to describe the fit in their area of concern was "cupping." A tentative agreement was reached. "So, they allowed me to continue to wear them . . . one scene per episode, and only after we checked to make sure that there was as little 'cupping under' as possible."[75] Within a month, there was a nationwide run on capri pants. Within a year, they were Laura Petrie's signature look. Within two years, Dawn Wells was wearing second-skin short shorts as Mary Ann on CBS's *Gilligan's Island*. Evidently, a number of those execs must have taken early retirement.

Bewitched

TELECAST *from* 1964–1972 *on* ABC

STARRING: Elizabeth Montgomery, Dick York,
Dick Sargent, Agnes Moorehead

COSTUME DESIGNERS: Vi Alford (women),
Byron Munson (men)

*A rising ad executive marries his dream girl and moves to
suburbia. Turns out she's a witch. But a good witch.*

SOME THINGS, LIKE COWBOY BOOTS, Armagnac, and hopefully your relationship, get better with age. Others, like a linen loveseat, fried chicken, your abs, and your eyesight, don't. *The Dick Van Dyke Show* belongs in the first category. Sadly, *Bewitched* belongs in the second.

It's not because the premise is stale. Magic is still a universal crowd pleaser. *Wicked* may run on Broadway forever. The mesmerizing card tricks of Shin Lim not only won the thirteenth season of *America's Got Talent*, but the Tournament of Champions the following year as well. And as primitive as trick photography and pre-CGI special effects may have been in the late '60s, watching a purportedly domesticated Samantha Stephens clean the kitchen in less time than it takes you to reach for the Windex, or float her almost forgotten keys down the stairs into her Vuitton bag, is still fun, especially when

Elizabeth Montgomery activates Samantha's powers by giving her nose a twitch, complete with xylophone accompaniment. Such stunts hint at why the tale of a witch capable of summoning Julius Caesar to her home so he can make his famous salad, but who now wants to live in mortal marital bliss, was the best-reviewed new show of 1964, ascending to number two in the ratings quicker than Sam can send Caesar back from whence he came, when he shows up without any oil.

No, *Bewitched*'s setup, while hardly innovative (*I Dream of Jeannie, My Favorite Martian*), was beguiling, but the series never moves ahead with its narrative. Try picking episodes at random on Hulu across all eight seasons, and you'll soon realize there's no need to access an earlier half hour to catch up on the story line, because there isn't any. Samantha is always solving husband Darrin's dilemmas on the sly; an infinite roster of eerily

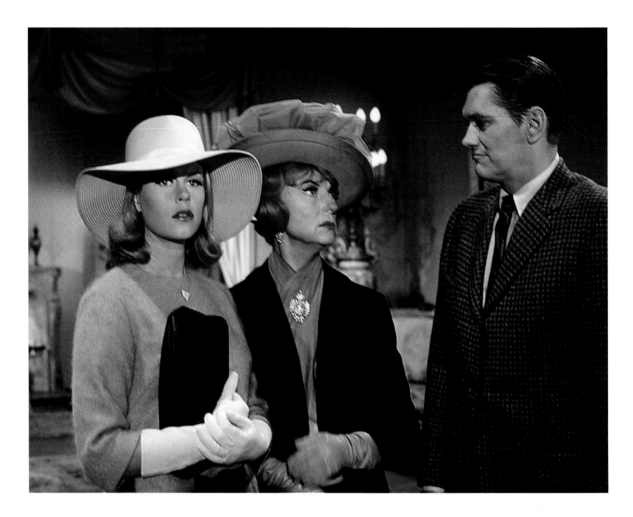

unattractive neighbors and coworkers bray with suspicion; Darrin sputters and nearly bursts his jugular vein each time he finds out; then bewitcher and bewitched hug it out on the orange couch in their mid-century modern living room.

Apart from two pregnancies, nothing in Sam's life ever significantly changes, including an attitude toward clothes that scores points for rotation and repurposing, but exhibits neither a passion to impress nor the desire to be noticed. Maybe such overt stylelessness was meant to reflect the young witch's quest for by-the-fireside normalcy, but the repetition of clothes that displayed more function than distinctive form eventually put a damper on Montgomery's radiance.

If the show turned monotonous, why is it on my list? Because one noteworthy cast member had a seismic effect on a certain demographic that, at the time, was short on touchstones. *Bewitched* was considered by many in the LGBTQ community to be a gay allegory about people with a secret who must remain closeted in public. In an interview Montgomery, an early gay rights supporter, gave to *The Advocate* in 1962, the actress admitted, "We talked about it on the set ... that this was about people not

being able to be who they really are.... It was a neat message to get across to people at the time in a subtle way."[76]

This book cites two series characters (the other is on page 81) who, by our owning up to adoring them, confirmed to certain men of my generation that we knew we were gay.

Now, unlike Samantha, Endora was *not* subtle. There was no way she was keeping her uniqueness under wraps. Not that I ever wanted to appropriate Agnes Moorehead's lash-to-brow turquoise eye shadow, learn to apply eyeliner parallel to the cheekbone in one cantilevered stroke, or own a steamer trunkful of Vi Alford's voluminous caftans, so uproariously printed and patterned that one could never stay lost in the Arabian desert for long. By constantly giggling over Moorehead's getups (she spent two to three hours in makeup prior to filming), guffawing at her unrepentant mangling of Darrin's given name, and, okay, maybe, every now and then imitating her viper-tongued delivery, she cued me into the humor, self-possession, and occasional arrogance I would need to acquire and hone so as to face a still challenging future. So, thank you, Endora. Don't you agree, Derwood?

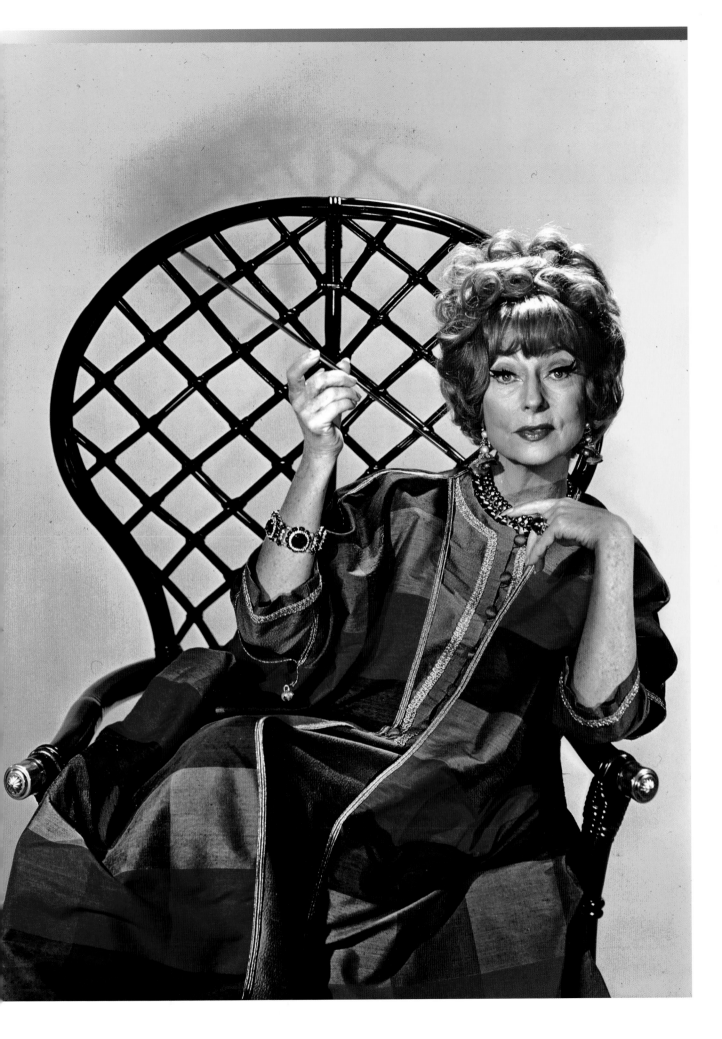

The Sonny and Cher Comedy Hour

TELECAST *from* 1971–1974 *on* CBS

STARRING: Sonny Bono and Cher

COSTUME DESIGNERS: Bob Mackie, Ret Turner

--

Married pop stars sing and taunt each other as casually as if you'd been invited to hang out at their house. She is also a fashion goddess.

"I ALWAYS WANTED TO DO SHOWGIRLS AND strippers," says Bob Mackie, the nine-time Emmy Award–winning costume designer. "Some people may think that sounds tawdry, but Las Vegas showgirls carry themselves like royalty. Showgirls are proof that it's a mistake to separate elegance and sexiness, since the combination makes for a marvelous fantasy."[77] And even greater than that fantasy has been Mackie's spectacular collaboration with a singular performer who combines the glamour of a showgirl with the voice of a crowd-pleasing diva.

Cher and Bob Mackie first found each other backstage at *The Carol Burnett Show*, when she was guesting for the first time. "When I first saw her, I said out loud to no one in particular, 'What am I going to do with her?' recalls Mackie. "She was so small and exotic. I was repairing a

beaded dress, and Cher looked at it and mused, 'One day I would like to have something with beads on it.' And I thought, just one?"[78]

Mackie happily admits that he was drawn to her immediately. "She didn't look like anyone else. Also, her heritage was Armenian, but she could have been from anywhere. It's like she was universally exotic. I immediately thought she could be the greatest vamp in the world."[79]

A few years later, Mackie got the chance to sew some beads for her and prove his hunch. For *The Sonny and Cher Comedy Hour*, Cher reached out to Mackie, who agreed to costume the singer, while the rest of the cast would be dressed by his colleague, Ret Turner. The *Comedy Hour* began as a summer replacement in August of

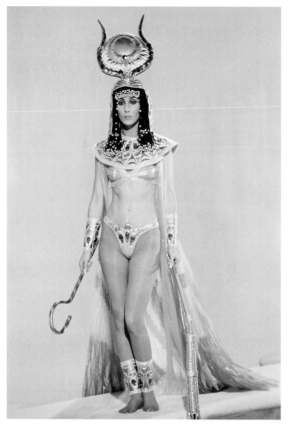

1971, but its ratings kept rising with the temperature. The duo already had a youthful fan base for their music. As rock groups go, Sonny and Cher didn't look angry or threatening to middle-aged and/or older Americans—more like hippies who'd gone to Nordstrom's for a make-over, complete with mani-pedis. Plus, the pair exuded an unexpected but charming Lady and the Tramp kind of sexual chemistry.

By December of the same year, CBS installed their variety show as the centerpiece in the network's enviable Sunday night lineup. Cher dove into more genres of music. And the costume designer as Pygmalion had found his perfect Galatea. Put more simply, Mackie had the best Barbie doll ever. Heaven was now missing an angel. "Nobody has a body like that. Her armpits look like they're sculpted! Of course, it was a challenge to dress her, but a lot of the difficulty had more to do with it being television, not with her."[80]

It was darn lucky for Mackie and his team that *Carol Burnett* and *Sonny and Cher* were shot on adjacent sound stages at CBS's Television City in Los Angeles, because Mackie's duties for the *Burnett* show required about forty costumes a week. Cher alone often racked up twenty, even more when it was discovered that the contralto also had an ear for comedy and started developing characters like Laverne Lashinski, the leopard-print-wearing man-chaser.

But it was during the hour's "Vamp" section where Cher would portray legendary femme fatales like Helen of Troy, Nefertiti, and Marlene Dietrich in brief comedy sketches that the collaboration hit its can-you-top-this stride. "Cher was always late for fittings, but she was immediately up for anything," says Mackie. "It's not [that] she came in with ideas. She didn't have a history of clothing, or an awareness of styles from different periods. Other than Cleopatra, she rarely knew the queens or famous women she was portraying, or that it was a Modigliani painting her character had just stepped out of. But she didn't ask for a bio. She just needed a cue."[81]

Cher liked showing off her body. She didn't like hot colors. She wouldn't go with anything orange, gravitating toward richer, more romantic hues like purple and turquoise. Because she appeared to be permanently tan, Mackie loved dressing her in white. She wasn't a diva, but she changed her mind often, sometimes rejecting a song one day before taping. (If there was no rehearsal time, Cher's go-to replacement was "He Ain't Heavy, He's My Brother." I think I've caught it about four times.)

Mackie admits that she could be equally quixotic about wardrobe. "She might come in one day with her heart suddenly set on Day-Glo. That would be tough.

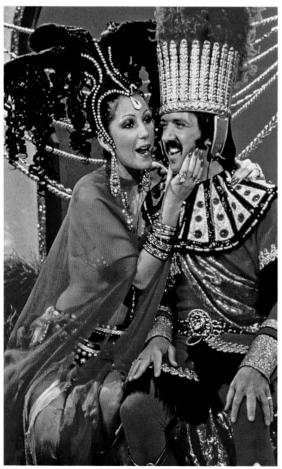

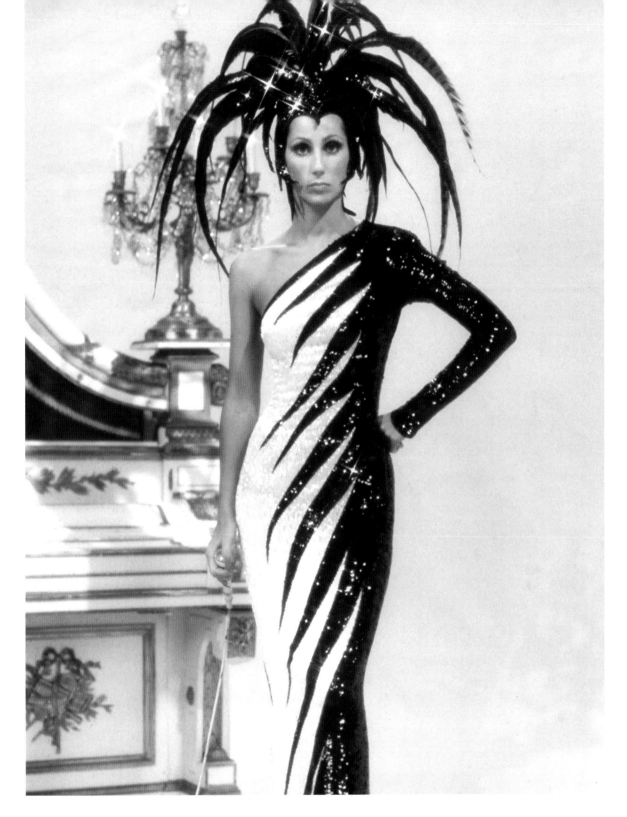

But the truth is, I could grab four yards of jersey, wrap it around her multiple times, and then put a spray of orchids in her hair, and she'd look magnificent."[82]

It was an odd juxtaposition. Playing to an audience that was beginning to embrace the soon-to-be-regrettable silhouettes of the '70s, Cher's resplendent one-woman runway show—direct from Hollywood's Golden Age—was irresistible, gotta-see-what-she's-got-on-this week

television. But as dazzling as it was to watch her blissful transformations, the lady can't be credited with igniting even one major, lasting trend, instigating any unexpected obsessions, or generating a parade of doppelgangers (drag queens excepted). There's only one explanation for such shortcomings: she will always be Cher. And you're not. "Other women just don't have those armpits," concludes Mackie. "They're still sensational."[83]

Married... with Children

TELECAST *from 1987–1997 on* Fox

STARRING: Ed O'Neill, Katey Sagal, Christina Applegate, David Faustino

COSTUME DESIGNER: Marti M. Squyres

- -

The Bundy family is not a class act.
And that suits them just fine.

INVENTORY OF PEG and KELLY BUNDY'S CLOSETS (WHICH ARE IDENTICAL):

- Leopard-print halter dress
- Tiger-striped bandeau
- Zebra-print leggings
- Angora cardigan (to be worn with no underpinnings)
- Strapless gold lamé sheath with wide black buccaneer belts

- Black leather bustier, miniskirt, and motorcycle jacket
- Teal Jazzercise leotard
- Wallpaper-floral off-the-shoulder crop tops
- Polyester lace bodysuit with frayed crotch snaps

- Ball-drop earrings
- Neon pink lingerie
- Peep-toe heels
- Two cartons of cigarettes
- Whatever looks best with cold pizza

ET ALL THOSE WITH GOOD TASTE BE
forewarned. Keep moving. You have no power here.
Your advice is destined to fall on deaf ears. Peg and
Kelly Bundy happen to like the way they look. Of course,
you think it's trashy. They think so too. It was precisely
their intention.

Peg doesn't work, but you'd hardly label her a home-
maker, as she doesn't clean, cook, garden, or sew. She
barely parents, content to plop on the couch, suck on
chocolates, and project enough entitlement to host a
Master Class for Easthampton newbies. Besides, teas-
ing brashly dyed hair this high and getting into a dress
this crassly tight must have been exhausting. Though
designer Marti Squyres chose all the tight squeezes for
this mother-daughter tag team, the boundaries were first
set by Katey Sagal.

The producers of *Married... with Children* originally
envisioned Peg as (surprise!) Roseanne Barr. But once
the offer was made to Sagal, the actress recalled in an
interview with the Television Academy, "I thought we
should doll her up. I was really working as a musician
until I started on *Married... with Children*, and I kept
thinking, they're gonna fire me any second and I'm going
to have to go back to my real job . . . going to go play gigs.
So, I sort of had this idea that I'll disguise myself so that
no one will recognize me when I take this off. Because
[Peg] was really in drag."[84]

Sagal's savvy rationale assumed that because Al and
Peg spoke so horribly to each other in front of their kids
and in public, they must have something hot and animal
going on. That made leopard print Peg's perfect alterna-
tive to the Little Black Dress. It wasn't that wild a notion.

In the 1930s, the rise of Art Deco incorporated leop-
ard print into home design. In postwar 1947, Christian
Dior's revolutionary New Look collection included crepe
leopard-print dresses. Vanity Fair Lingerie added the
pattern to its underwear line in the '50s.

In 1962, a photograph of First Lady Jacqueline
Kennedy in a leopard-skin coat designed by Oleg Cas-
sini ignited a copying frenzy, and led to the death of
nearly 250,000 leopards, burdening Cassini with a guilt
he never shook off.[85] First Lady Michelle Obama took
a lighter approach, donning Jenna Lyons's rendering
in knitted sequins for J. Crew. Drama has repeatedly
used leopard print to signal the approach of a bad
mom—for example, Anne Bancroft as Mrs. Robinson
in *The Graduate* (1967), Ann-Margret in *Tommy* (1975),
Katherine Helmond's leopard-shoe hat in *Brazil* (1985),
and most recently, Taraji P. Henson in *Empire* (2015).
(See page 100.)

"You would be surprised how many people called
our costume designer, wanting Peg's clothes," Sagal
admits. "People wanted to look like her."[86] And per-
haps be a little like her. Compared with the toxic Roy
family on *Succession*, were the Bundys really such bad
role models? Their kids weren't dropouts, always came
home eventually, swiped liquor but not drugs, got along
better than most TV siblings, and were very popular,
if only because both were perpetually horny. In fact,
Kelly (the irresistible Christina Applegate) was beam-
ing when she showed Bud (David Faustino) what she
was going to wear for her yearbook pic: a black leather
bustier encrusted with a dozen crosses. Mom must have
been so proud.

Now, Where's My Black Card?

GLAMOUR WITHOUT APOLOGY

Dynasty

TELECAST *from* 1981–1989 *on* ABC

STARRING: John Forsythe, Linda Evans, Joan Collins, Heather Locklear, Pamela Sue Martin, Diahann Carroll

COSTUME DESIGNER: Nolan Miller

--

The Carrington family becomes the template for how to live large during the Reagan era. Big houses, big cars, big shoulders.

AT ITS HEIGHT—AND *DYNASTY* WAS ON a pedestal as mile-high as its hometown—'80s fashion was as subtle as a disco ball and just as hypnotic to watch, which is probably why each week 60 million Americans lapped it up like a chocoholic who's told that tonight's special entrée is Blackout Cake.

When I was the restaurant critic at *Details* magazine, the staff staged weekly *Dynasty* dinners. The host had to cook something grand like duck a l'orange, or grossly decadent like foie gras on Ritz crackers, and guests were required to wear an au courant ensemble from one of Soho's newest boutiques or a garish and glittery getup from Patricia Field's store in Greenwich Village.

It was impossible to take *Dynasty* seriously, but we really wanted to, because life would be so much more entertaining if melodrama was the norm; if everyone had a PhD in sarcasm and was as adept at flinging open doors for grand entrances as they were at flinging over-the-shoulder exit lines; if the evening news covered only clandestine liaisons, secret business alliances, surprise inheritances, contested prenups, and the discovery of a new emerald mine in Colombia. And one more thing: your walk-in clothes closet with a divan had its own catalog.

Designer Nolan Miller told the interviewer at the Television Academy that his longtime boss, producer Aaron Spelling (*Charlie's Angels, Fantasy Island, Beverly Hills 90210*) came into his office one day and told him, "I have a script that is going to make even you happy. I never want to see anyone wearing the same thing twice. This is a fantasy of a lifestyle. If you were rich, rich, rich, how would you live?"[87]

But even starting with a clothing budget of $15,000, (equal to $50,000 today), the first season of *Dynasty* did

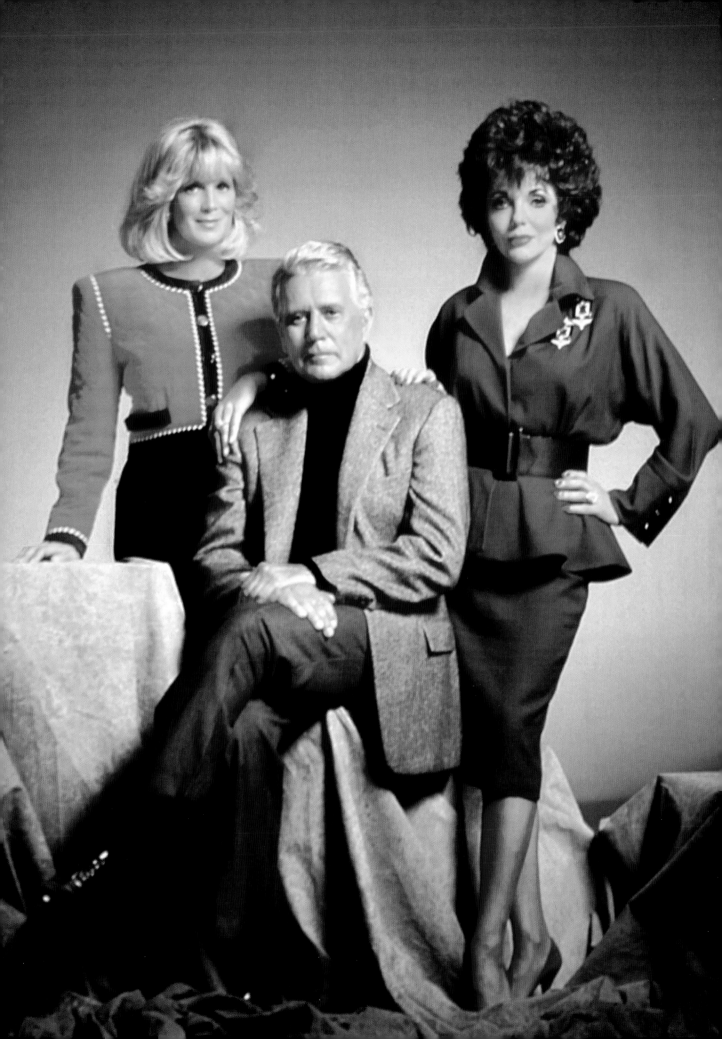

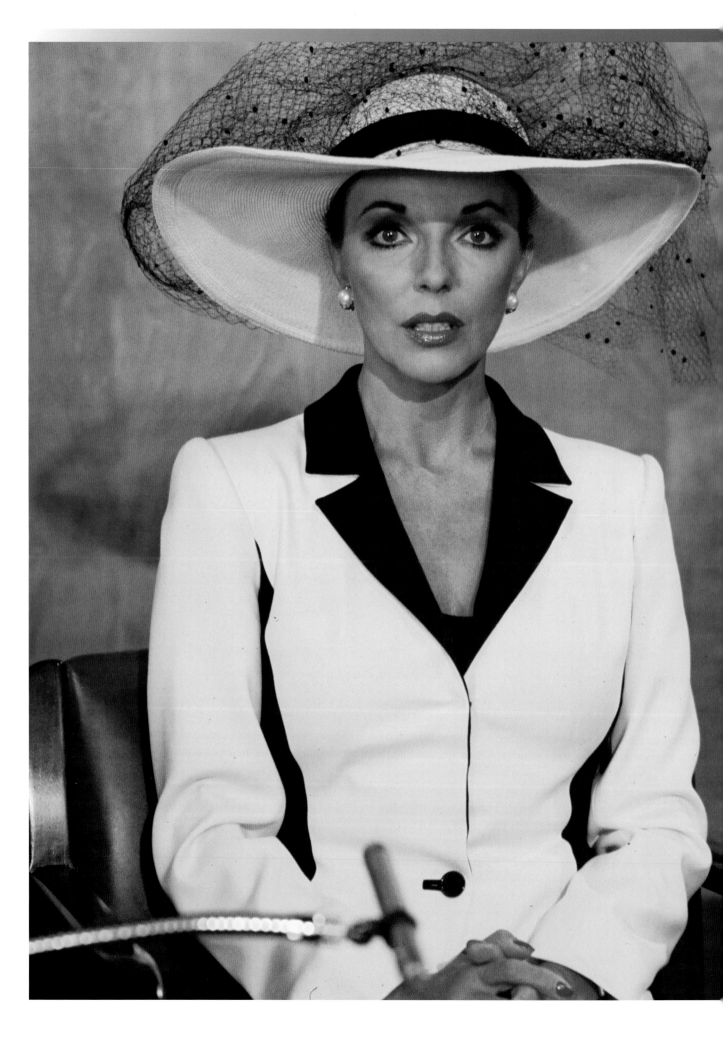

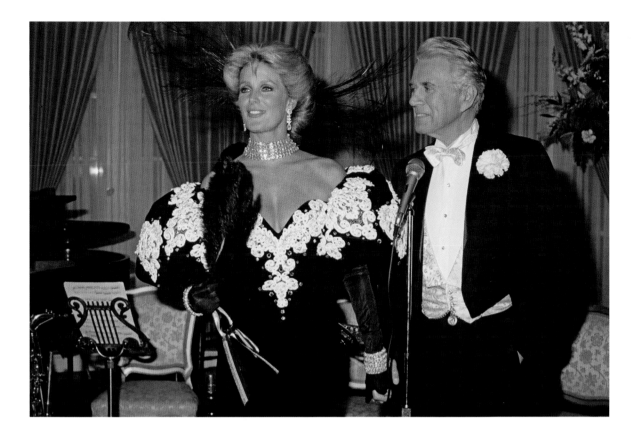

not give *Dallas*, its archrival in greed and ostentation, much to worry about. Ratings were middling. At the season finale, at Blake's trial for "accidentally" murdering the lover of his gay son, Steven (how's that for simultaneously being radically inclusive and actively homophobic?), we see a partial view of a female figure in a wide-brimmed hat cross the courtroom, as she lifts her veil, Blake's daughter Fallon exclaims, "Oh my God, it's Mother!" Fade out.

So, who was the mystery mommy? "They didn't have anyone yet," Miller continues in the interview. "They had been negotiating with Sophia Loren. . . . They offered her $600,000 for six episodes, which was a lot of money even back then . . . but the deal fell through." Aaron Spelling, however, recalled an episode of *Fantasy Island* where he was taken with how striking Joan Collins looked. *Dynasty*'s creators, Esther and Richard Shapiro, dismissed Collins as a B actress. They wanted Jessica Walter. Spelling held firm, predicting, "Joan will be a bitch made in heaven."[88]

When the veil was lifted that fall, the face belonged to Collins. "She set the show on fire," claims Miller.[89] By the end of the second season, *Dynasty* was number five in the overall Nielsen ratings. At end of season three, it was third. By the fourth season, it was number one.

With Collins on board, the clothing budget was increased to $25,000 a week, though Miller was always

going over. With the addition of Diahann Carroll as Dominique Devereaux, the budget increased to $35,000. Dominique's sudden appearance as Blake's secret half sister remained an unconvincing and awkward fit into the melodrama, however, one more begowned meanie than necessary, but that's not how the star saw her mission. "[Carroll] came in like a diva who had stormed the place," says Miller as he rolls his eyes in the video interview. "She thought she would outdo. . . . To quote her, 'It was about time TV had a black bitch, and I want to be it.' Say no more."[90] But Miller believes nobody could upstage Collins. "You could load her up with an envelope bag, a fur thrown over her shoulder, a cigarette, and a martini, and she'd stir the olive. She could handle accessories better than anyone I have ever known."[91]

Linda Evans didn't compete with Collins or enjoy dressing up as much. "One of the nicest human beings I have ever met," according to Miller. "I became known for the silk blouses I made for her. We sold lots of those."[92] Oddly enough, Evans rarely wore shoulder pads. "She was a size twelve on top and a size six on the bottom. She had shoulders like Joan Crawford."[93]

Miller was soon responsible for seven retail collections, not counting an eponymous fragrance. When Bloomingdale's launched an exclusive *Dynasty* collection in 1984, they flew the entire cast out to Manhattan for the launch (there were also clothes for Sammy Jo, Fallon, and

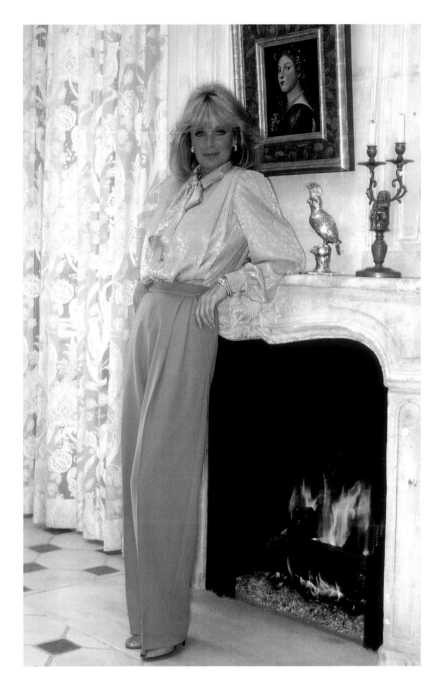

Dominque fans), but the thousands of people camped out in the street overnight stormed the doors when the store opened, forcing management to shut down the escalators and sneak the cast out through the freight entrance. Marshall Field featured a Carrington Christmas. Neiman Marcus and Saks expanded their hat departments. In the late '80s, the show's producers attempted to shift the plot and alter the show's aesthetics to counteract dwindling audience numbers after the Moldavian massacre mess—which, in fact, killed only Lady Ashley Mitchell (Ali MacGraw's contract had run out). They issued a statement claiming they were moving in a new fashion direction and would be eliminating shoulder pads. The next day, the edict was a feature story in the *Wall Street Journal*. Bergdorf Goodman called and asked Miller, "Are you mad?" because most of their women's collections still featured bolstered rotator cuffs. *Dynasty* issued a retraction.

In a rare and surprising example of understatement, Spelling and Co. never made a big deal of the fact that the most copied women in America were a blonde in her mid-forties and a brunette in her fifties. They set the standard for the women of *Falcon Crest*, *Knots Landing*, and *Hotel* while, as Spelling promised, never wearing the same dress more than once. It just goes to show that you're never too old for a good catfight and an even better push-up bra.

Absolutely Fabulous

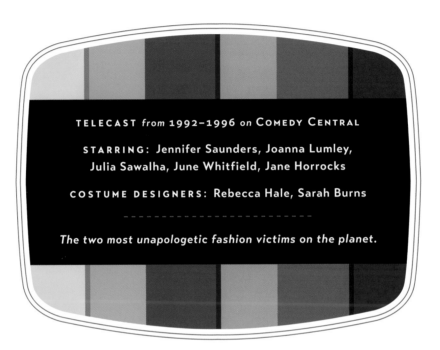

TELECAST *from* 1992–1996 *on* COMEDY CENTRAL

STARRING: Jennifer Saunders, Joanna Lumley,
Julia Sawalha, June Whitfield, Jane Horrocks

COSTUME DESIGNERS: Rebecca Hale, Sarah Burns

- -

The two most unapologetic fashion victims on the planet.

THE BEST WAY TO DESCRIBE THE SHOW IS TO LET THE CHARACTERS THEMSELVES DO THE TALKING:

EDINA: Inside me is a thin person just screaming to get out.
MOTHER: Just the one, dear?

PATSY: One snap of my fingers and I can raise hemlines so high,
 the world is your gynecologist.

EDINA: (to daughter Saffron): Oh darling, mummy loves you.
 On the day you were born I knew I wanted you.
PATSY: However, the day after . . .

EDINA: When have you given up drinking?
PATSY: Worst eight hours of my life.

EDINA: I don't want a great big fat bum like J.Lo,
 do I, darling? I mean how high have those heels got
 to be to keep that nancy off the pavement now?

PATSY: (on Julia Roberts): Could her lips get any bigger?
 It looks like she's giving birth to her own head.

DRESSING THE PART

T HEY ARE BEST FRIENDS WHO BRING OUT the worst in each other. But it's not like there are better qualities left untapped. As long as Patsy can inhale, it had better fill her lungs with nicotine. As long as she can exhale, she's sure to fail a breathalyzer test. Her fashion MO is a clash of Russian hooker in Cavalli snakeskin with *Sons of Anarchy* biker chick.

Edina gets out of a cab feet first as often as Anna Wintour takes off her sunglasses at fashion shows. She is a terrible mother, a tone-deaf daughter, and a clueless shopper. Regardless of the fad she's latched onto this week, Edina always looks like two Cub Scouts fighting under a pup tent. It's not random name dropping that

causes her to cry out "Lacroix, sweetie!" "Lacroix, darling!" "Lacroix, baby!" with the fervor of a holy roller speaking in tongues because she blindly worships the designer who duped the fashion world in 1985 with le pouf, the dumbest, least modern, most unflattering silhouette of the decade. Patsy and Edina are fashion victims who have no desire to be resuscitated. They only have one redeeming quality: they are hysterically funny.

Of course, *Absolutely Fabulous* didn't generate any fashion trends. Would anyone want to look like that? But the joyous rush of hearing the rip-roaring Joanna Lumley and the frantically clumsy Jennifer Saunders take rapid-fire potshots at fashion, motherhood, public relations, sex, youth, Botox, and Americans with marksman accuracy produced supercharged comedy with a caustic, merciless energy that had never before been attempted on either side of the Atlantic.

The BBC hedged at first, putting Saunders's first project without her longtime partner, Dawn French, on its junior network BBC2, but moved it to its main feed because the acclaim and attention were immediate. In America, no major network had the guts to run it, so *AbFab* launched on Comedy Central. The American public's embrace was just as swift, however, even if the audience didn't understand words like "bollocks" or know that Harvey Nichols was as posh as Bergdorf Goodman.

More importantly, *AbFab*'s success opened doors for brazen humor delivered by women. The *Sex and the City* quartet were better dressed and nicer to each other (on camera anyway), but their unladylike table talk over Cosmopolitans is in debt to *AbFab*. Mindy Kaling, Amy Schumer, Tina Fey, and Lena Dunham have all openly bowed in gratitude. In *Variety* several years ago, Saunders once imagined a perfect *AbFab* prequel: "I think Lena Dunham would play me, and Amy Schumer would be Patsy."[94]

Unfortunately, Saunders now fears that the current need to apologize for every slight or "silly joke" has put a damper on her dream. Speaking with the London tabloid *The Mirror* in 2021, she felt that "small-mindedness" would prevent her from doing *AbFab* today. "I think people do talk themselves out of stuff now because everything is sensitive. . . . This is a modern thing, isn't it? If someone says something, it always has to be, 'Oh, but sorry, you can't say that.' I say, 'Oh fuck off.'"[95]

Maybe Patsy isn't so clueless after all, when she claims, "If you want to talk bollocks on the meaning of life, you're better off downing a bottle of whiskey. At least that way you're unconscious when you start to take yourself seriously." Can somebody please put that on a pillow? Better yet, a cocktail napkin.

Ugly Betty

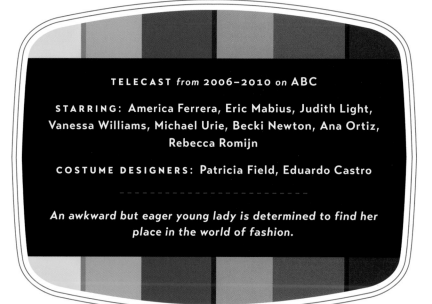

TELECAST *from* **2006–2010** *on* **ABC**

STARRING: America Ferrera, Eric Mabius, Judith Light, Vanessa Williams, Michael Urie, Becki Newton, Ana Ortiz, Rebecca Romijn

COSTUME DESIGNERS: Patricia Field, Eduardo Castro

An awkward but eager young lady is determined to find her place in the world of fashion.

UGLY *BETTY* LOOKS AS CUTE AS IT appears insubstantial. Showrunner Silvio Horta constructed a cartoonish take on life at *Mode*, a *Vogue*-like fashion mag, where the sets were bright and shiny, and a not-very-threatening Vanessa Williams as editor-in-chief led a handsome lineup of caffeinated, likable personalities featuring Judith Light, Rebecca Romijn, Michael Urie, Ana Ortiz, and Becki Newton— cast as sweet friends, devoted family, and intermittently snarky coworkers in glam getups from Patricia Field. At the show's center gleamed America Ferrera's mouthful of braces, but since they couldn't outshine her megawatt smile, we knew that Betty's eventual winning hand was never in doubt.

Kudos to actress America Ferrera's buoyant spirit for making Betty's victory appear to be a foregone conclusion. In a spirited but unnerving TED talk, Ferrera relayed that "I never saw anyone who looked like me in television or in films. And sure, my family and friends and teachers all constantly warned me that people like me didn't make it in Hollywood. . . . I didn't need my dream to be easy. I just needed it to be possible."[96]

But the odds against that dream being fulfilled for people of color were daunting. The daughter of Honduran immigrants went on to give an example of what she faced when going up for the only parts open to Latinas, which she cites as "the gangbanger's girlfriend, the sassy shoplifter, pregnant chola number two"[97]—only to have a casting agent request after her first reading at an audition, "Could you do that again but this time sound more Latina?"

Ferrera asked if that meant the agent wanted her to speak in Spanish? No, "in English" was the reply, "just 'sound Latina,'" and when Ferrera pointed out, "Well,

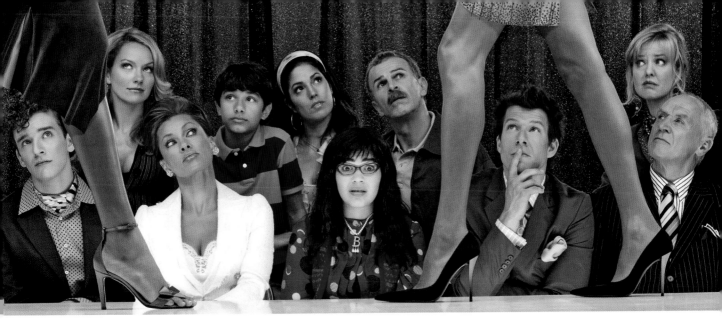

I am a Latina, so isn't this what a Latina sounds like?" there was a long, awkward silence, and then, "Okay, sweetie, never mind. Thank you for coming in. Bye." It took me most of the car ride home to realize that by sounding more Latina, she was asking me to speak in broken English."[98]

Ferrera was not referring to the 1950s, when Rita Moreno has often spoken about facing the same issues. Ferrera wasn't born until 1984. She was talking about 2003. Fifty years later, and Ferrera still felt the industry was telling her that she was "too brown, too poor, too fat, too unsophisticated."[99] "Someone has to tell that girl she has unrealistic expectations," Ferrera overheard her manager say. "And he wasn't wrong. I mean, I fired him, but he wasn't wrong."[100]

Yet, there are more than half a billion people of Hispanic heritage in the world, which helps explain why *Yo soy, Betty, la fea* ("I am Betty, the ugly one"), which began in Colombia in 1999, is now the most famous Latin telenovela in history, having been viewed in more than seventy countries, and adapted into twenty-five languages, including independent productions in India, Brazil, and the Philippines—all with the same positive message for minorities.

With justifiable pride, Ferrera brings her lecture to a climax with a slide featuring an affirmation from Nobel Prize winner, Malala Yousafzai, the Pakistani activist, who wrote, "I became interested in journalism after seeing how my own words can make a difference and from watching the *Ugly Betty* DVDs about life at an American magazine."[101]

What sustained the show's popularity is that, as in the original telenovela, Betty never stands on a soapbox. The show is not preaching a message. It merely ingratiates by example. Betty is simply a warm, caring,

resourceful, potentially indispensable young woman who needs some help in the wardrobe department.

"Oddly enough, America is wearing more designer clothes than you might imagine," said costume designer Eduardo Castro, who took over design duties after Field had dressed the principals for the pilot. "She's not wearing Gap."[102]

In dressing Betty's family and coworkers, Castro was consistent in giving each character clothes that were price-tag appropriate. For Ana Ortiz, who played Betty's sister Hilda, Castro says that he "shopped for Cavalli knockoffs at either Bebe, or Le Chateau." For Michael Urie and Becki Newton, as Betty's less than trustworthy coworkers Marc and Amanda, "it was a knowing mix of Burlington Coat, Burberry, and H&M (which is how a fashionista would shop). Though Vanessa is so beautiful she can make cheap clothes look amazing, we usually went to Saks for her.

"Betty's clothes are a more complicated mix. America would often have on a Chanel skirt, an Etro jacket, and an Escada coat. We just mixed it up horribly. We didn't want to make her look ugly. We wanted to make her look 'off' and then slowly combine the pieces more harmoniously in the later seasons, which gave her more dignity. And, of course, we got rid of those heavy bangs."[103]

America Ferrera became the first Latina to win an Outstanding Lead Actress Emmy, for *Ugly Betty* in 2007. No Latino has won an Emmy Award since. Ferrera is far more frustrated than flattered. She concluded her TED talk with a simple statement: "I am what the world looks like.... Collectively, *we* are what the world actually looks like. And in order for our systems to reflect that, they don't have to create a new reality. They just have to stop resisting the one we already live in."[104]

Who's wearing the braces now?

Empire

TELECAST *from* **2015–2020** *on* **FOX**

STARRING: Taraji P. Henson, Terrence Howard, Jussie Smollett, Bryshere Y. Gray, Trai Byers

COSTUME DESIGNERS: Paolo Nieddu, Rita McGhee

An African American music mogul ruthlessly battles to maintain his supremacy over old rivals, new upstarts, and threats from within his own contentious family, especially his ex-wife.

F YOU'VE LIVED LONG ENOUGH, YOU PROB- ably have one: a passionate memory so vivid you can recall every element as precisely as if you just posted it on TikTok and even though it sounds like an overheated Harlequin romance to everyone else, it was an emotional epic to you. What's more, your desire was so inflamed, you knew it couldn't last forever. And it didn't. But while you were caught up in the throes of this big love, it was everything.

That's how I feel about *Empire*. The show came from out of nowhere, in January of 2015; it swooped in and hijacked our viewing attention with a mesmerizing visual style that alternated between the blow-it-out, span- gled showmanship of the BET Awards, and the moody, almost too-close-for-comfort intimacy of Wong Kar-Wai's *I'm in the Mood for Love*—one of the great romances of the twenty-first century and a film that *Empire* creator Lee

Daniels adores. It took a mere twelve weeks for Daniels to make *Empire* the show everyone was gushing about. By the time the season finale aired in March, with 17 million staring slack-jawed, it had become the first show in the history of the Nielsen ratings to gather a bigger audience with each episode.

How did Daniels pull it off? First, he borrowed Kar-Wai's moody, atmospheric lighting to seductively frame *Empire*'s world. Next, he created for hip-hop titan Lucious Lyon (Terrence Howard) a tempestuously tem- pered family that made King Lear's look benign. Lyon has three sons: Hakeem, a potential hip-hop star with a chip on his shoulder the size of a Cadillac Escalade, who wants to take over the company; Andre, the company CFO, who also wants to take over the company, but whose bipolarity is so severe that, next to him, Dr. Jekyll and Mr. Hyde just appears moody; and Jamal, who sings like

an angel, looks like a dream, has a closet of more covetable menswear than Justin Timberlake's, and is openly gay, which sends Lucious into a homophobic tailspin. Naturally, Jamal wants to take over the company.

But the boys are child's play compared to the Lyoness who roars her way back into Lucious's life. Cookie Lyon, the mother of his children, and the woman he built the empire with, who underwrote the company with drug money, and most audaciously took the fall for Lucious with a seventeen-year prison sentence, is out now, and hungrier than a carnivore at a vegan buffet to claim everything and everyone due to her, by whatever means necessary. Only Lucious knows how ferocious Cookie can be. As she reminds him on her first day out of prison garb, "You messin' with the wrong bitch, Lucious. I know things."

She sure does. Cookie has a sixth sense about making artists hot and records a hit plus she has a built-in divining rod for locating where every dirty secret is buried. And just to make sure attention will be paid, Cookie has spent her prison time not only figuring out how to transpose *Dynasty* into present-day Chicago, but learning what it takes to outdo Krystle, Alexis, Dominque Devereaux, Lil' Kim, Foxy Brown, Cardi B, and even Beyoncé.

All hail, Taraji P. Henson, who, with a whopping assist from costume designer Paolo Nieddu, rolled through racks of vintage Dolce & Gabbana tiger prints, Roberto Cavalli snakeskin, rainbow-dyed fox and mink from Fendi and Michael Kors, Versace liquid gold suits, jewel-toned sparkle from Moschino, vintage Todd Oldham, current Tom Ford, and a treasure trove of rhinestone-encrusted Judith Leiber novelty bags, and declared, "Look out world, get offa my runway!" Henson turned *Empire* into the choicest, cheekiest one-woman fashion spectacle since Grace Jones rose twenty-five feet in the air in a Keith Haring gown that wouldn't stop growing on New Year's Eve at Roseland in 1987.

With Henson as grand marshal, *Empire* was a fashion parade, and every member of the Lyon family got their own float in what *Vogue* journalist Jonathan Van Meter called America's new favorite "do-rag to riches story."[105] Terrence Howard sang in silk pajamas from Brooks Brothers and Gucci floral blazers. Hakeem, dressed outrageously in Jeremy Scott, rapped love poems to Naomi Campbell. Jamal came out nationally wearing Hedi Slimane and Haider Ackermann. Cookie's archrival, Anika, donned Roland Mouret lace and Ralph Lauren cashmere.

With veteran producer Timbaland (Justin Timberlake, Rihanna, OneRepublic) overseeing music production, *Empire* attracted a busload of Black artists to sing at Lucious's club, Leviticus: Rita Ora, Alicia Keys, Jason Derulo, Mariah Carey, Kelly Rowland, Gladys Knight, Jennifer Hudson, Snoop Dogg, Patti LaBelle, and Mary J. Blige. *Empire* turned our flatscreens into a membership pass to a club cooler than any branch of Soho House.

In its first season, *Empire* was the number-one scripted show in retail's prime eighteen-to-forty-nine demographic, bested only by *Sunday Night Football* in the overall category.[106] In reviewing the show, *The Guardian* wrote, "And yet here Cookie is, putting a final nail in the coffin of casual wear and steering us all toward maximalist bling, mega-high heels and makeup. In one short record-breaking season, she became the embodiment (and one of the drivers) of a moment."[107]

Shortly after its debut season, *Empire*'s influence was ubiquitous. Saks Fifth Avenue devoted all its windows in New York and Los Angeles to the show. Hood By Air clothing featured pictures of the cast in its sportswear. Nicolas Ghesquière sold oversized fur coats at Louis Vuitton. MCM had to increase production every time Hakeem appeared onstage rapping in its leather goods. Deborah Lippmann introduced nail polish colors called Hustle Hard (fuchsia) and Power of the Empire (gold). But maybe the highest accolade came from Marc Jacobs. Cookie's most memorable outfit appeared in episode six, when she showed up at a Lyon family dinner in a purple sable coat over Victoria's Secret lingerie. That summer, Jacobs sent out a party invite advising guests of his recommended dress code: "fur coats over lingerie, lip gloss . . . sequins, sky-high stilettos . . . no flat shoes, no matte surfaces, no natural looks."[108]

How fun. But how many purple sables does the RealReal have for rent?

Schitt's Creek

TELECAST *from* 2015–2020 *on* POP TV *and* NETFLIX

STARRING: Dan Levy, Eugene Levy, Catherine O'Hara, Annie Murphy, Emily Hampshire, Noah Reid, Chris Elliott

COSTUME DESIGNER: Debra Hanson

- -

Embezzled out of their fortune, a family goes to live in the only asset they have left—a rural town with a run-down motel.

MY ETERNAL GRATITUDE TO CANADA FOR allowing me the joy of seeing Catherine O'Hara and Eugene Levy. It was reason enough to start watching *Schitt's Creek*. However, my initial response to the show was: I know this is supposed to be a satire on the vapidity of pop culture and success, but why am I watching this annoying family? The Roses are cranky, argumentative, and completely disconnected from one another emotionally.

The town they move to, because it's the only asset they have left after becoming big-time victims of embezzlement, is dull as the decor of the motel they own by default and now live in. Worse yet, its mayor is portrayed by Chris Elliott, a man who's made a lengthy career of playing painfully unattractive characters.

And what's with O'Hara and Dan Levy's weird procession of black-and-white fashion? Why are they getting dressed up to go nowhere, and how can they afford it when they're broke?

I stopped watching *Schitt's Creek* after a season and a half, dismissing both friends' claims that it had found its rhythm and social media's inundation with *Schitty* one-liners and fashion postings. But while its final season was running during the pandemic in 2020, *Creek* accomplished something no other comedy had ever done. It swept every major comedy category at the Emmys: best show, directing, writing, and all four acting categories. Okay, I must be missing something. So, I went back, caught an episode from season four, and was delighted to rejoin a program that had found its purpose.

It wasn't just because the tone of Dan and Eugene Levy's writing had lightened and softened. Far more intriguing was the shift in the source of their humor. The show had evolved from a comedy full of fast, easy

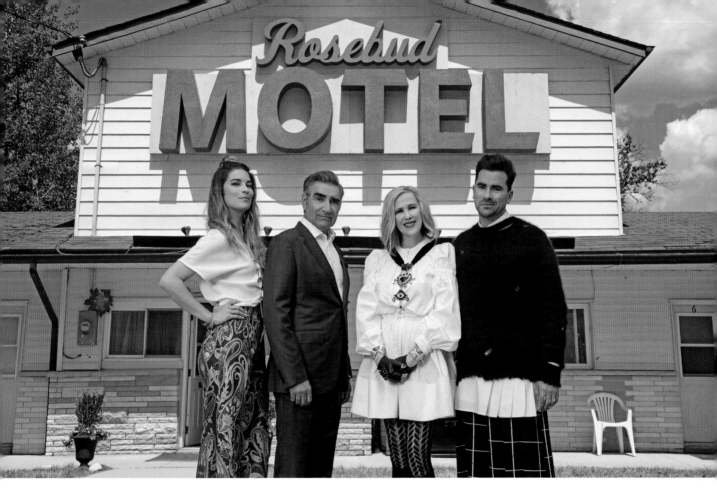

jabs at the foibles of the formerly pampered and pouting but now in desperate need of a manicure, to one about a family who, because they can no longer keep up their guard, realize in their halting attempts at conversation and engagement that being vulnerable makes you feel more alive, that there is nothing ordinary about ordinary people, and that life's more fun when you don't try to go it alone. Catherine O'Hara put it more bluntly in a *New York Times* interview: "It's like we're aliens, learning how to be humans."[109]

But due to my initial disappointment, I misread one major element *Schitt's Creek* had gotten right, right from the beginning. Shouldn't you *always* dress as if you have somewhere to go? And if you do, won't people think you *do* have somewhere to be? If anyone was going to prove that edict, it was O'Hara's Moira, whose fashion imperative was so consistently bananas that if *Absolutely Fabulous*'s Patsy and Edina had ever found their way to Moira's table at Café Tropical, they would have popped and chugged yet another bottle of champagne.

Maybe the best thing that could have happened to *Creek*'s wholehearted embrace of fashion excess is that every major network rejected the Levys' project, so when they signed with the sparsely funded Canadian Broadcasting Corporation, they barely had petty cash for a weekly fashion budget. Without Chanel and Louis Vuitton racing to dress an unknown, initially barely seen comedy, Levy the younger and costume designer Debra Hanson began a six-year obsession with trolling eBay and other resale or online consignment sites.

"We had taste but no money," says Hanson. "Our initial budget for the early seasons was twenty thousand dollars. So, we were maniacal. Online at all hours. Just me, Dan, and my assistant. Bargaining and borrowing for our lives. We would shop from the RealReal because they took returns, which meant you couldn't eat a thing from the moment anyone put on a piece from them. What's amazing is that Eugene's was the only closet that employed repeats, though his suits were Zegna, Canali, and Boss. For everyone else, somehow, we found fresh pieces each week."[110]

O'Hara admits to taking on a "black is my favorite color" mantle inspired by the socialite, fashion-forward icon, and brewery heiress, Daphne Guinness. Every morning Moira dressed as if she didn't want to be late for whatever the evening promised. Incredibly, Hanson managed to dress O'Hara in McQueen, Comme des Garçons, Balmain, Lanvin, and Prada on her skimpy budget. "All her designer pieces were classics," said Hanson. "They were just from six or seven years ago, which is perfect because that's when the Roses would have had money."[111]

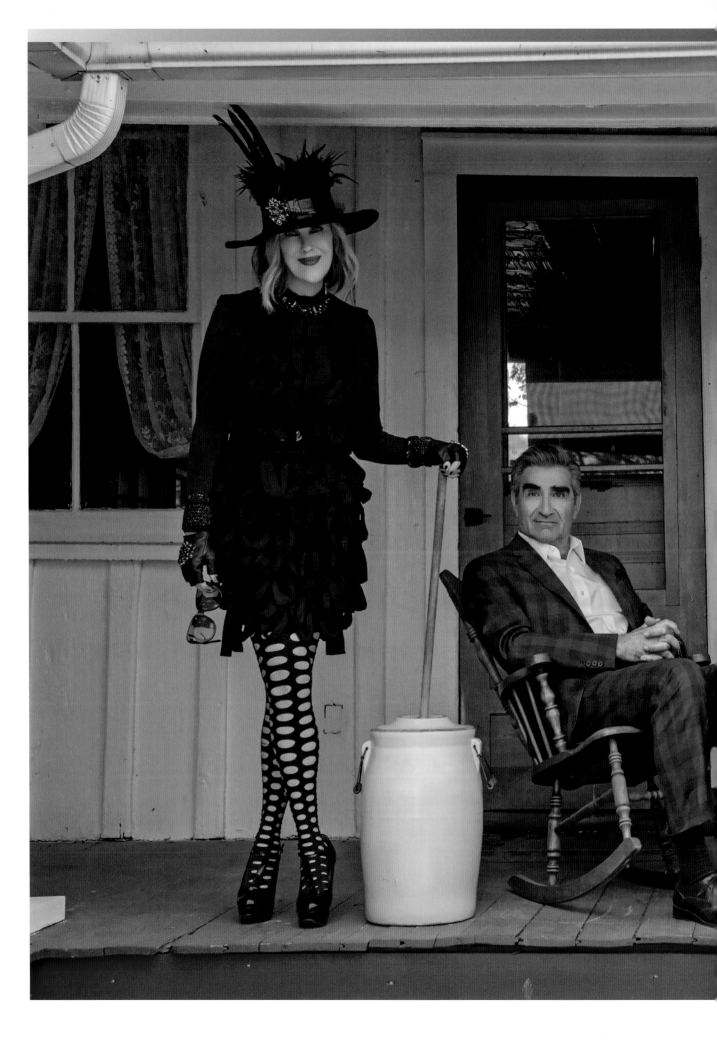

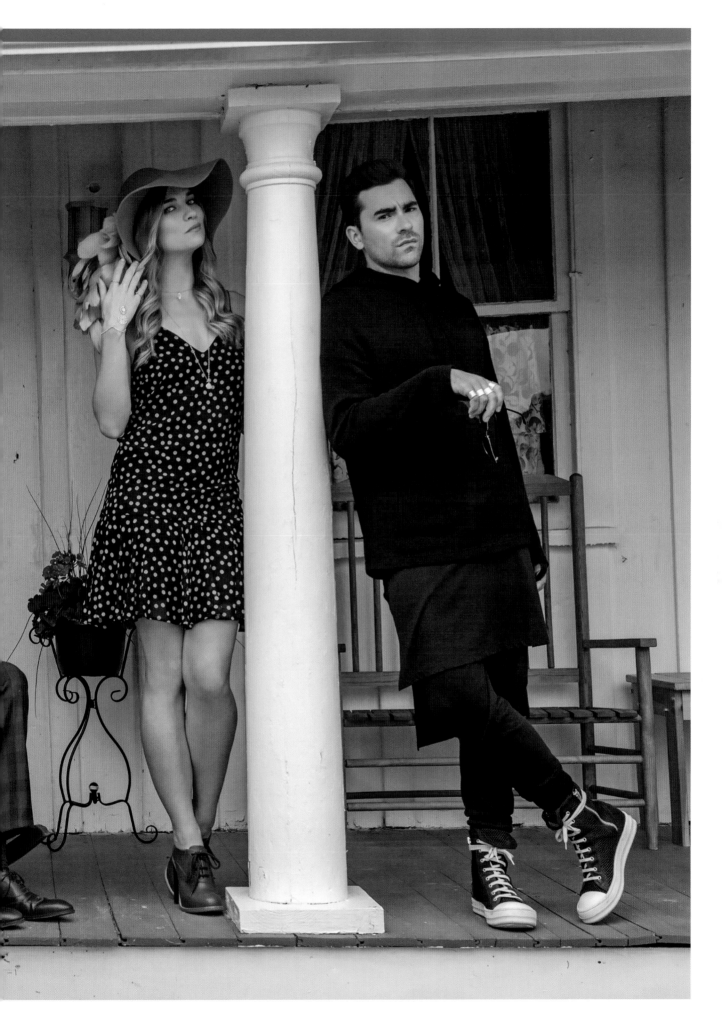

Alexis's (Annie Murphy) fashion sense wasn't as developed or confident. She often wore fast fashion from places like Zara. Dan, on the other hand, "loves, loves, loves fashion," says Hanson. "It wasn't just because he was playing David. He was on a personal quest. We put him in Neil Barrett, St. Laurent, Rick Owens, Dries Van Noten. And skirts."[112]

Speaking of skirts, David earlier on used his pansexuality as a way of separating himself from others. But then he meets Patrick (Noah Reid). Full disclosure: the specific episode that brought me back to *Schitt's Creek* was season four, episode six, in which David's new boyfriend gets up at an open mike to sing Tina Turner's "Simply the Best." David naturally grimaces, expecting the worst. He always does. Moira offers to pull the fire alarm. But then Patrick,

accompanying himself on guitar, sings the most lilting, contemplative, lump-in-throat revamp of the rock classic. Watching Dan Levy melt moment by moment from trepidation to bliss had me diving for tissues and setting the "record series" button in minutes, to keep watching the most engaging and believable same-sex couple ever portrayed on the small screen. Noah Reid is not someone you'd normally call a knockout. Yet, for the remainder of the series, what I saw was a younger, gentler combination of Cary Grant, Gene Kelly, Brad Pitt, and Ryan Gosling. And he did it without ever affecting one major costume change.

Turns out that *Schitt's Creek* was not a satire after all. It was always a love story. About learning how to leave yourself open to let somebody in. And it was better than all the rest.

Emily in Paris

TELECAST *from* 2020– *on* NETFLIX

STARRING: Lily Collins, Philippine Leroy-Beaulieu, Ashley Park, Lucas Bravo

COSTUME DESIGNERS: Patricia Field, Marylin Fitoussi

- -

A bright-eyed Chicagoan with a keen awareness of the power of social media scores a dream job at a Paris marketing firm.

OUTFITTED BY THE LEGENDARY PATRIcia Field in one pretty, giddy explosion of color after the next, Emily is a Gen Y Alice in a Parisian wonderland, with a dream job for any girl who loves fashion as much as her phone. In a matter of months, the girl who no doubt was voted most likely to succeed already has—at a PR firm in the City of Light whose new Gallic colleagues resent her social media expertise almost as much as they envy it. You gotta love her.

Or, you can hate her guts. *Emily in Paris* is Netflix's most popular comedy globally, but the press, both French *and* American, has come crashing down on this kid as if she had posted a picture of herself slathering peanut butter on a croissant with a torn packet of Equal next to her glass of Veuve Clicquot. In his review of the show for *Premiere*, Charles Martin wrote that the show depicts the French as "lazy . . . flirtatious and not really attached to the concept of loyalty . . . and of course, that they have a questionable relationship with showering."[113]

The popular French website AlloCiné snapped about the French being characterized as "arrogant, dirty, lazy, mean, bitter . . . but luckily this young American arrives to explain to us how life works."[114] Perhaps, most condescending of all, a writer in *The New Yorker* poses that "Netflix is pioneering a genre that I've come to think of as ambient television."[115]

Wow. Methinks someone's TV diet is a little too full of *Scenes from a Marriage*, *The Bear*, *Frontline*, *Better Call Saul*, and *Black Mirror*. Hate to break it to you, but television has always been dense with wildly successful shows that are more visual treat than verbal stimulation. What else would you call *Baywatch*, *Falcon Crest*, *Fantasy Island*, *The Bachelor*, *Project Runway*, and *Hawaii Five-O?* To assume that we must apologize for not

wanting to confine our binge-watching to series with scripts as superlative as *The Wire* or budgets as epic as *Lord of the Rings* is darn smug.

Speaking of smug, here's a reminder to all those who have traded in their sense of humor for "fairness." Comedy has always been steeped in stereotypes—or is every smart New Yorker a Jew who sounds like Jerry Seinfeld and Midge Maisel?

Pay attention. How can you criticize a show for not being realistic when a luminous Lily Collins, as the perennially effervescent heroine in question, is walking the cobblestone streets of Paris in a pair of pink tulle knee-high boots? Or for presenting a Paris where every single eligible male is not only successful, but wildly attractive? If only. (Didn't hear anyone complaining about that stereotype, though, did you?) Or when

Emily's brusque and sardonic boss, Sylvie, replies to Emily's sincere questioning about whether she is happy by asking, "Do you really believe people are happy all the time? Of course, you do."

"Emily is a smart girl from Chicago, with a great little body. I didn't want to take away American style from her and make her French chic," says Field. "Her character is all optimistic innocence, and I wanted to portray that in her clothing. But she's also not naive about Paris. She's not trying to fit in. She's having more fun dressing up."[116]

Accordingly, Field and Marylin Fitoussi cast an international net to afford Emily a wide array of options, featuring many names less familiar to Americans—Mary Katrantzou, Vassilis Zoulias, Giambattista Valli, Kenzo, Essentiel Antwerp—alongside a few that we do

know, like Christian Siriano, Elie Saab, and, naturally, because she's in Paris, Chanel.

To dress Sylvie, Field relied a lot on Marylin Fitoussi to "respect Philippine's fierceness" both as an actress and as the uptight, withholding but glamorous character she is playing. "I was trying to approach a modern French chicness. So we stayed close to her home for the most part: Rick Owens, an Alaïa jumpsuit, St. Laurent, Helmut Lang."[117]

As for criticism about stereotyping the French, Field ain't kowtowing to any of it. "You really want to know what the French are wearing in the street in Paris?" she asks, barely waiting to spit out the answer. "Jeans and sneakers. The international uniform. Chic is dead here."[118] Well, that certainly won't make for very ambient television. Pity.

Just Us Girls

THE COMPANY OF WOMEN

The Carol Burnett Show

TELECAST *from* 1967–1978 *on* CBS

STARRING: Carol Burnett, Harvey Korman, Vicki Lawrence, Tim Conway, Lyle Waggoner

COSTUME DESIGNER: Bob Mackie

A perfect hour of entertainment with an irresistible talent at its center.

THE FASHION INDUSTRY IS A STUDY IN extremes, vacillating between tantalizing the masses and standoffish elitism. When it favors the former, crowd-pleasing creativity and beauty thrive. But should the industry lose faith in whatever was previously reliable, it too often assumes that people are impatiently eager for something radically different and exclusive (they almost never are), routinely overlooks "pretty" as too easy a way forward, and irrationally leaves its sense of humor in the back of an Uber.

Fashion's arbiters should pay close attention to Bob Mackie's six-decade trajectory: an unwavering ascendancy proving that, though where you finish certainly counts, where you start sometimes improves the ride.

Mackie began as a sketch artist for two designers who helped cast the template for Hollywood glamour: eight-time Oscar winner Edith Head (*Roman Holiday*, *Sabrina*, *To Catch a Thief*) and Oscar winner Jean Louis, who created Rita Hayworth's signature "Put the Blame on Mame" strapless sheath in *Gilda* (1946). Louis then topped himself by creating the ultimate stealth dress, Marilyn Monroe's strategically unnerving, strategically beaded, and strategically sheer "Happy Birthday, Mr. President" gown (1962)—the one Kim Kardashian hijacked sixty years later for the 2022 Met Gala. Having used his income from sketching to pay for sewing and design classes, Mackie then teamed up with his mentor (and life partner at the time), costume designer

Ray Aghayan. Together, they won the first Emmy ever given to costume design on television in 1967 (for the TV movie *Alice Through the Looking Glass*).

After their win, each designer elected to work on his own. Mackie's timing was fortuitous, as it coincided with Carol Burnett developing her team for her variety show. Burnett took note of how Mackie's consistent alchemy of glamour had attracted an impressive roster of devoted young acolytes—Bernadette Peters, Ann-Margret, Diana Ross & The Supremes, Barbra Streisand, Bette Midler, even Elton John—and because his charm and good looks were as impressive as his potential, she hired him. He immediately proved to be an integral collaborator, turning out wickedly clever, sight-gag-worthy costumes for Burnett's best-ever mini-repertory company of resident comic actors, to strut in and ravenously chew scenery during the *Burnett Show*'s trademark—elaborately costumed movie-classic spoofs. These raucous parodies included:

- *SUNSET BOULEVARD*, with Burnett as the demented silent-film relic, Nora Desmond, garishly garbed in a spangled purple chemise, thick beaded choker, and thicker beaded headband, barely aware that she is merely being considered for a bug spray commercial.

- *LOVELY STORY*, with Burnett and Harvey Korman, outfitted more preppily than a Chaps ad, romping around campus, gloating over their nonstop good fortune, and then, just as they finally come in for an embrace . . . Carol utters the teensy-weensiest of coughs.

- *WENT WITH THE WIND*, this twenty-minute send-up of the grand cinematic melodrama of Margaret Mitchell's bestseller is Carol and company's twisted masterpiece. Starlet O'Hara (Burnett), faced with an empty closet and the imminent arrival of Captain Butler (Korman), takes a tip from her hysterical, Black mammy (played by the very white Vicki Lawrence), and descends Tara's curved staircase wearing the green velvet curtains, literally, complete with threaded metal curtain rod running across her shoulders. The overwhelmed Captain compliments her on the formerly sashed finery. "Thank you," she drawls with a slight drool, "I saw it in the window, and I just couldn't resist it."

The Carol Burnett Show was television's last great variety hour. But with so much energy devoted to raucous parodies, and spirited duets with guests like Dinah Shore, Julie Andrews, and Peters, plus frequent visits from Burnett's alternative personae, like the charwoman, Burnett's producers wanted to begin the program at a slower, softer pace, so they suggested that Burnett open the show with a Q&A session in front of the studio audience.

When you view the first season's sessions, the dynamics of the interactions are clear. The audience asks sweetly inane questions or wonders if "Carol" would mind hauling out her trademark Tarzan yell one more time. What's apparent is that they don't regard Burnett as an unapproachable star. Rather, she's more like the really nice lady who lives down the block, whose house smells like cake, and who always throws the best birthday parties for her kids.

The dynamics of Burnett's wardrobe are equally clear from those viewings. She looks as if she'd forgotten she was coming out to the audience and had scurried out of her dressing room at the last minute. For one session, her hair was cropped boy-at-sleep-away-camp short, her body lost in an ungainly, neon chartreuse, eyelet mini–smock dress with thick white rickrack around the neck and baggy short sleeves. If only the outfit had been part of an upcoming skit. But it had been a choice.

"If Cher is pumpernickel, Carol is white bread," says Mackie. "And you have to be careful what you put on white bread or it gets overwhelmed. Carol grew up in Hollywood and was made aware at a young age how much attention you get when you aren't the prettiest, or whether you're even considered. Even someone as particularly gifted as Judy Garland grew up feeling her talent didn't make up for not being as pretty as the other girls at MGM."[119]

Factoring in Burnett's long limbs, demure stature, dress size (actually the same as Cher's), and most importantly, that she would start the show not in character, Mackie proposed dressing the host as he might offstage—as a well-to-do grown woman who loved entertaining friends in her beautiful home. Dresses were tailored close to her handsome frame; skirts often had pockets for comfort; and beading was plentiful but applied only to the simplest of shapes, like shells or hostess gowns.

Regardless of how outrageously she might be costumed later in the hour; Mackie convinced Burnett to begin her show polished and sophisticated. In some ways, the refinement the designer brought to Burnett's look is a more impressive achievement than the parade of scene

stealers he concocted for Cher, because the comedienne didn't start with either extraordinary features or a strong awareness of personal style.

Equally uplifting is the message Mackie sent out to American women via Burnett: you don't have to be a classic beauty to feel and look like a star. Instead, elevate the silhouettes, colors, and fabrics that flatter you best, and allow your current reflection to guide you with the confidence your adolescence lacked.

For the Q&A of her final show, Carol walked onstage with her hair in a soft, full, light auburn bouffant, wearing a sleeveless white sheath gown with a bateau neckline that gave height to her bodice; a slight drape nipped her waist, and a roomy skirt flowed gently as she moved. She wore a minimum of accessories. Carol Burnett looked maximally wonderful. The only way she could have looked better was if she'd been wearing that dress while waving to me from her house down the block.

The Golden Girls

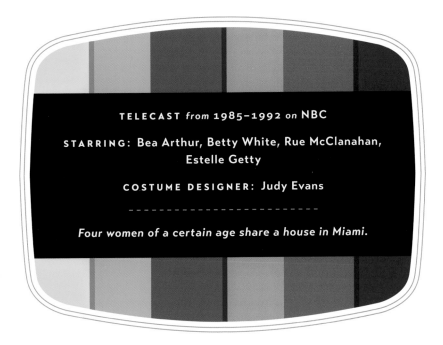

TELECAST *from* 1985–1992 *on* NBC

STARRING: Bea Arthur, Betty White, Rue McClanahan, Estelle Getty

COSTUME DESIGNER: Judy Evans

Four women of a certain age share a house in Miami.

URING THE DAY, GOLDEN GIRLS PLAYS almost nonstop on the Hallmark Channel. The beloved situation comedy about four retired women living under one roof in Miami began with almost everything in its favor, starting with solid, play-like scripts from executive producer and head writer Susan Harris; they delivered a Solomonically equal distribution of one-liners, comebacks, and sarcasm to four seasoned pros, who served, volleyed, and smashed their individual shots while staying in sync as neatly as the Williams sisters playing doubles.

Dorothy (Bea Arthur) is the den mother and decider: wise, acerbic, and often cynical because she is probably the most vulnerable. Once a Southern belle with a perpetually full dance card, Blanche (Rue McClanahan) still manages to have more dates in a month than are shipped daily from the loading docks in Tunisia. Rose

(Betty White) is more innocent than dim-witted. Her constant befuddlement is due to her seeing the world through the same-colored lenses as her name. And Sophia (Estelle Getty) . . . well, the moment she commands you to "picture it! Sicily, 1912. A beautiful young peasant girl with clear olive skin meets an exciting, but penniless artist . . ." it doesn't matter if Picasso ever did get arrested for showing her how he can hold his palette without using his hands, she has your attention.

Golden Girls owes its longevity to humor so succinct and specific to each character, that half the fun is anticipating Dorothy gently urging Rose, "Go to sleep, sweetheart. Pray for brains." Or hearing Sophia philosophize, "No matter how bad things get, remember these sage words: you're old, you sag, get over it."

But with no disrespect to Harris and her team of rapier-sharp scribes, it was probably easier to write jokes

for women in their sixties than to dress women in their golden years. As Dorothy tells Blanche, "Now, when you lean over [a mirror], it's like someone's let the air out of your face." Nevertheless, costume designer Judy Evans was on board with the show's mission to contradict the assumption, expressed by *Golden Girls Forever* author Jim Colucci, that "after a certain age you become invisible. You wear matronly clothes and just try to be comfortable."[120] To counter that, Evans "wanted a sexy, soft and flowing look for Rue; a tailored, pulled-together look for Bea; a down-home look for Betty; and comfort for Estelle."[121]

But during the '80s, there was very little in the mall designed to make an older woman feel attractive, let alone sexy. She was ignored as a customer. Dressing Sophia was off-the-rack easy, because, though the diminutive Getty was actually a year *younger* than her TV daughter, she was turned into a grandma by buttoned-up-to-here dresses with decorative doily collars, contrasting bibs, or a large jabot, and a bulbous, curly white wig. Sophia's one wardrobe constant was the wicker purse that appeared glued to the crook of her left arm; Getty had found it in a thrift shop. Not only are such bags common in Sicily and Sardinia, but it also served as ballast for Getty's intense stage fright. It was a logical and pragmatic accessory because Getty believed that "older women are forced to shed so many possessions in their later years that everything winds up in their purse."[122]

The *Girls'* home made an emphatic case for the shotgun marriage of wicker and pastels, and the ladies did their best not to clash. Rose favored coral and blush pink shirtwaists or A-lines. Once Blanche outgrew her Olivia Newton-John–inspired neon leg warmers and unitards (after all, it was the '80s), she opted for bolder, bright jewel tones; open or cowl necklines; wide, minaret-high beaded shoulders (I repeat, it was the '80s) to broaden her bodice; and lots of jangly, chunky jewelry.

According to Jim Colucci's exhaustive exploration of the series, Arthur was the hardest to dress. At five-foot-ten she towered over her costars. She insisted on wearing flats on show day and signed an injury waiver so she could attend rehearsals in her bare feet. Evans designed her dresses as camouflage, with dropped waists so low they gathered at the knees, deep cowl necks to offset a slight paunch Arthur was self-conscious about, and tunics as wide as her wingspan. Evans added long necklaces and big earrings for added glamour. "Dorothy didn't want to disappear, but Bea did," Colucci says, "And what made things worse were the writers increasingly making fun of her looks."[123]

It didn't anger Betty White if someone called Rose stupid, because Betty wasn't. Blanche was obviously always in hot pursuit, but the label didn't apply to McClanahan, and no matter how many times Sophia's age was used as a zinger, Getty could brush it off, because minus the white wig, she was much younger. But Dorothy's size, shape, and booming deep rasp were Bea Arthur's inherent qualities, and as they were increasingly mocked and ridiculed, it hurt.

Finally, at one table read, a character referred to Dorothy as "ugly," and as Colucci reports, Dorothy was supposed to tell Rose, "You know how uncomfortable I am in front of the camera. Besides, I always come out looking like Fess Parker [the ruggedly macho six-five actor who played Daniel Boone on TV in the '60s]." Arthur had a meltdown, burst into tears, and left the table. From then on, the writers had to find other ways to tease Dorothy besides body shaming.

Looking at *Golden Girls* now, the fashions of the time haven't aged well. The shoulder pads, the sequins and beading in all the wrong places, the hair too full, makeup too thick, colors either garish or oh-so-cute. And yet so many women wrote to Evans asking where they could buy Dorothy's tunics or Blanche's boatneck sheaths. The answer was nowhere because they were custom made, but Evans felt so guilty, that she would sometimes send sketches and fabric swatches to fans, with instructions they could give to a tailor.

The one glaring incongruity that everyone seems to have overlooked for decades is that these women lived in Miami. I vaguely recall once seeing Rose in shorts to play tennis. But Miami is hot, and I don't mean from a social perspective. I mean there are days you could bake bread on the sidewalk. Why were these women always swathed in layers? How come no one ever talked about going to the beach? Why wasn't anyone ever in a bathing suit? Were we being denied, or spared? Perhaps, it's as Rose's mom used to say: "The older you get, the better you get. Unless you're a banana."

Sex and the City

TELECAST *from* 1998–2004 *on* HBO

STARRING: Sarah Jessica Parker, Cynthia Nixon, Kim Cattrall, Kristin Davis

COSTUME DESIGNER: Patricia Field

- -

Four single, successful women in love with their lives, their friendship, and the most exciting town in the world.

THE FIRST HALF OF THE '90S HADN'T BEEN kind to New York City. Out-of-town friends and relatives would repeatedly harp on the futility of living somewhere more known for its noise, rats, crime, graffiti, gangs, garbage, traffic, and social and sexual tensions than for opportunity. By the end of the decade, life in the world's capital had markedly changed for the better, except that stigma comes with an extended shelf life. Who knew that New York would soon have a lithe, effervescent, witty, *Vogue*-reading fairy godmother with an insatiable shoe fetish? And yet, the moment Carrie Bradshaw appeared and started bestowing big, juicy Chanel Rouge Coco Bloom lacquered kisses across the cityscape, a wondrous spell was cast.

Banishing all darkness so the sun could stream through yards of organza, tulle, and silk crepe, *Sex and the City* presented Manhattan as an enchanted island for everyone, but particularly for women in their thirties and forties. No doubt aware that, at the millennium, almost half of the U.S. population over thirty-five was now single, *SATC* creator Darren Star reimagined a New York City, custom made for Carrie and her cohorts—as a singular oasis for grownups, where maturity added to one's allure, flirting was to be played at all-star level, sex without promises was just fine, and talking about sex too seriously guaranteed that everyone else laughed twice as hard. It had friends to whom you could reveal anything, and best of all, you always dressed as if everyone would be watching.

And watch we did, but the show's instantly devoted fan base didn't stop there. Blessed with four bottomless closets whose contents instigated both aspiration and envy, and with Instagram still a decade away, Carrie, Samantha, Miranda, and Charlotte became Gen X's first major influencers. Without fail, every favorite slingback

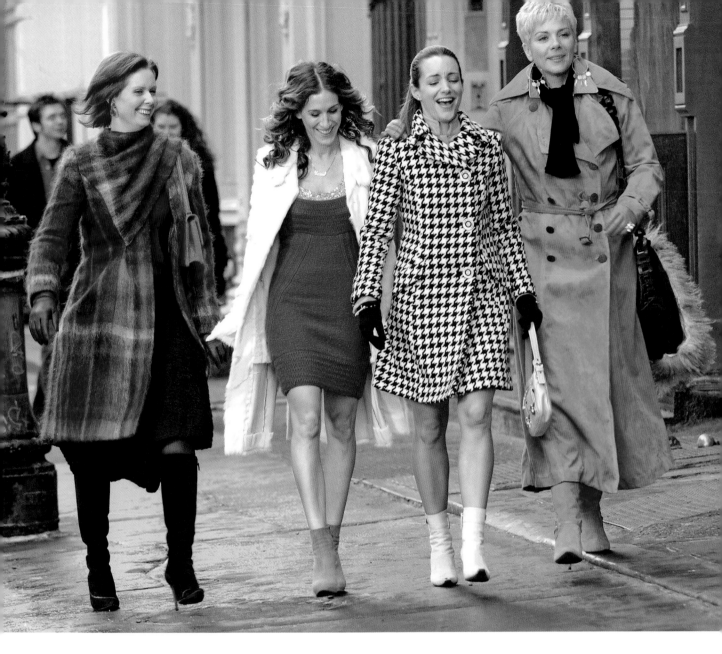

(Manolo Blahnik), cocktail (Cosmopolitan), handbag (Fendi baguette), pink sandal (Christian Louboutin), meal (brunch!), hangout (the original Pastis), can't-miss sheath (a pale blue, one-shoulder Norma Kamali), and cupcake (vanilla base with pale pink buttercream icing from Magnolia Bakery) that Carrie brought to her own never-ending Easter parade turned into a nationwide gotta-have-it obsession.

The public's devotion to Sarah Jessica Parker is only partly due to her being one of fashion's most enthusiastic cheerleaders. More likely, her irresistibility stems from her attitude, daring, carriage, and inextinguishable hope that this dress might be The One, as much as from her looks. Parker can look beautiful. She could also look foolish. But you were always aware that she was vulnerable, and this elevated her to an enduring style totem for millions.

Credit for her cravings, however—even her trademark gold-plated Carrie necklace—deserves to go to that retail entrepreneur, eternal punk goddess, and den mother to half a dozen acolyte designers cited in this book: costumer Patricia Field.

Now in her eighties and, still vermilion-tressed, Keane-girl thin, and more likely to be holding a cigarette than a pencil (she doesn't know how to sketch or sew), the woman responsible for *SATC*'s overachievement in glamour has always dressed like the drummer in an acid-rock band that would play on Wednesdays at CBGB. For almost sixty years—first in Greenwich Village then shifting to the Bowery—the House of Field wasn't merely an innovative and affordable clothing store. It was a design lab, wig boutique, makeup salon, drag emporium, Halloween one-stop for gays, secret weapon for smart stylists and savvy celebs, community center and

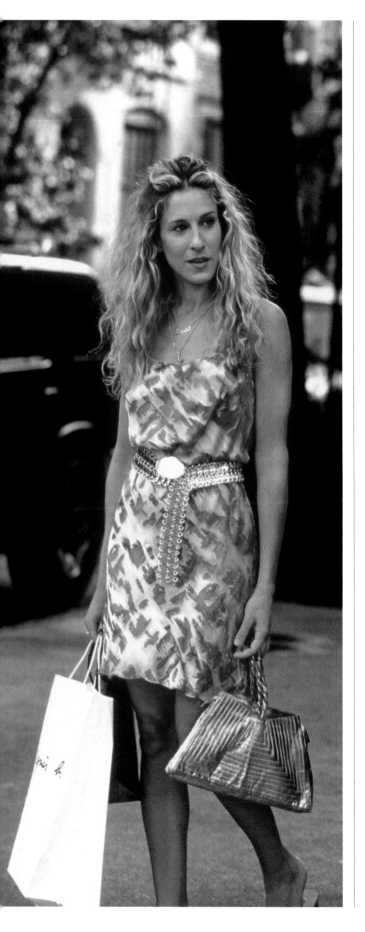

source of employment for LGBTQ youth, pickup spot, and tonic for when your wardrobe or your spirit needed some oomph. If you think no one could be more beloved by former club kids of the '80s and '90s than Madonna, then you never asked them about Patricia Field.

Field styled for years, but never made a big deal about it. In fact, what some may find even more surprising than her work at *SATC*, is that during the entire second half of the twentieth century, she was wardrobe consultant for *The Guiding Light*, the longest-running soap opera in television history. Field met Parker during the making of the film *Miami Rhapsody*. The movie flopped, but the friendship flourished. "Sarah instantly got style, which is even more important than loving fashion," says Field, "She's the one who introduced me to Darren Star, and we liked each other right away, but it was Sarah's enjoyment of fashion, and her openness not to get stuck in a particular style, that persuaded me to take the job. It doesn't always happen, but we became two peas in a pod."[124]

The two went shopping together, finding Carrie's big fur coat at Ina in Soho, one of the city's best resale shops. Field was good friends with George Malkemus, who was the president of Manolo Blahnik for years, "and he would let me pick up all the leftovers from their big end-of-season sale to put in my store. That's how Sarah got hooked on Manolos."[125] The signature Chanel flower pins were Parker's idea, but Field discovered the emblematic white tulle skirt Carrie wears when she gets splashed by a bus in the show's opening credits at the bottom of a showroom markdown bin. "Darren didn't get it. He wanted to see options. But Sarah fought for it. And I added that if the show is going to be a big success, that skirt will never look tired. It still doesn't."[126] The skirt had no label. It cost five bucks.

It didn't take long for *SATC* to reverberate not just with the public, but with the industry. Consequently, it became the first television series for which ready-to-wear and haute couture designers from all three fashion capitals offered to lend clothes and accessories. That made it a lot easier to dress Carrie's pals. Field remembers visiting "Kim [Cattrall]'s dressing room, and she would be watching old movies of the great vampy comediennes like Jean Harlow and Mae West. Her body was made for Dolce & Gabbana, Versace, and any hot color. I kept reminding her in bedroom scenes to leave her high heels on. Kim knew how to do sexy with a wink."[127]

Of the four, Kristin Davis was the most curvaceous. "Oh, I wanted to put Charlotte in Thierry Mugler, but she was the uptown girl," says Field with a wistful sigh. "Still, I couldn't bring myself to make her too J. Crew preppy, so we worked in Prada, Ralph Lauren, Dior, Diane von

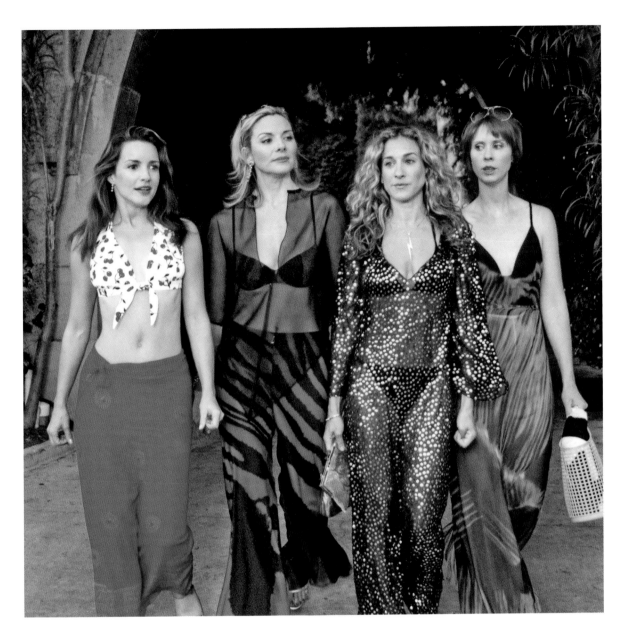

Furstenberg wrap dresses, a Burberry trench. She still had to hold her own."[128]

Dressing Miranda was the biggest challenge. As a lawyer, she was the only one with what someone uninterested in fashion might call a "serious job," and had to look the most professional. "Cynthia is a strong, smart woman, and because she's an actress who does her homework, she already had a wardrobe in mind when we met," Field recalls, "and it was all very cool and tailored. I got it, but I can't help it: I like glamour. I had to give her a little flair or I wouldn't be inspired. Luckily, she had a relative with a jewelry collection that we agreed on for starters. And then we started to dance."[129]

Sex and the City keeps on dancing, dating, drinking, and screwing, but it's not the same. It couldn't be. The women are older in the reboot; based on the overtly aging garb they wear in the first season of *And Just Like That...*, the next season could have them entering assisted living. Covid, economic imbalance, social media, and their impact on dating habits have altered the rhythms of the city. And Field is no longer involved. As she declares, "I did it. I loved it. I'm done."[130]

I'm not. Watching the original series again is like slipping under a yummy cashmere blanket and finding an equally yummy companion there. The show celebrated a time when living it up, laughing it up, dressing it up, and giving it up in the Land of Enchantment seemed to have no downside. Carrie's big love was never Mr. Big. It was always New York—though she admits in the finale voice-over what we all know, even if we're too quick to brush it aside: the person you need to love most, is yourself. All the more reason to always look fabulous for the one you love.

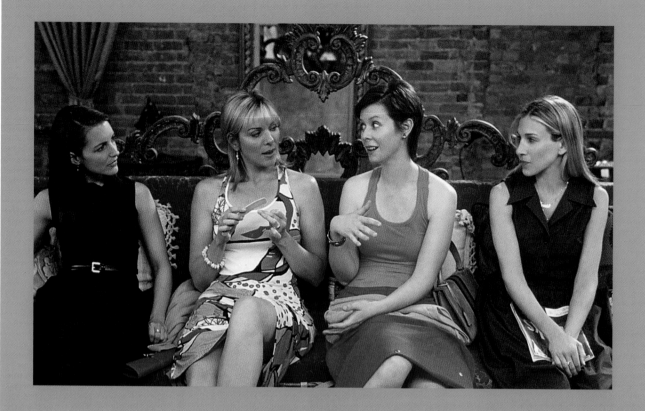

IN CONVERSATION WITH PATRICIA FIELD

You may not dress the part, in your leopard leggings and old motorcycle jacket, but the consensus of younger costume designers like Eric Daman (*Gossip Girl*, page 162), Molly Rogers (*And Just Like That...*), and Paolo Nieddu (*Empire*, page 101) is that you are the grande dame of contemporary costuming. Do you embrace the title?

It's very flattering, but it makes me a little uncomfortable. Maybe because it's all a surprise. When I was in the store, it was the kids working for me who were in the spotlight. I liked that. I'd rather people recognize my work than recognize me.

To have worked so long, so often, and so successfully, you must have a system for designing that works seamlessly.

I do design some things, but TV is paced so quickly that designing clothes is usually not a practical idea. Besides, there is so much merchandise out there, so, for me, it's more about how you put it together. My experience in my shop, styling my customers, is what helped me the most. I learned by doing. But I consider myself a stylist.

You stated that your relationship with Sarah Jessica Parker is rare because you were so in sync. How much input do you give other actors who may not be as at one with your ideas?

Let's call it a friendly game of tennis, where you keep hitting the ball back and forth until you understand the other person's game. Even then, it's not your goal to win but to have a good time. The actor's job is to come in with

a strong idea of who she or he is: how they're going to walk, speak, wear their hair, look; and in the end, they're the ones in front of the camera, not me. So, you have to respect the actor. If you do, you'll have a better time on the set.

What do you think was your biggest source of inspiration?

I'm a native New Yorker. I love this city because it's the place where the best always rises to the surface. I've never been focused on fame. But I've always been focused on doing my job well. Do well in New York, and people notice it. They don't make a big deal, and I'm very glad about that. But they know.

Desperate Housewives

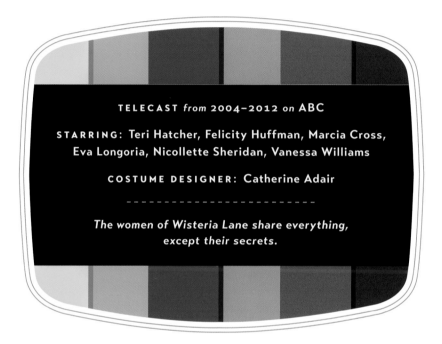

TELECAST *from 2004–2012 on* ABC

STARRING: Teri Hatcher, Felicity Huffman, Marcia Cross, Eva Longoria, Nicollette Sheridan, Vanessa Williams

COSTUME DESIGNER: Catherine Adair

- -

The women of Wisteria Lane share everything, except their secrets.

MOVIES ON THE BIG SCREEN CAN BLOW you away with visual impact. Radio, and now podcasts, are easily accessible and earwormy. No other form of spoken entertainment can match the in-the-moment engagement of live theater. But as proof of television's pervasive primacy over all aspects of our culture, executive producer and head writer Marc Cherry recalls going to London for a vacation after he'd wrapped up the first season of his smash hit series. Opening to the "Arts" pages of the newspaper to see if anything worth seeing was playing in the West End, Cherry zeroed in on a review of a new production of the Ibsen classic, *Hedda Gabler*. The critic's opening line had the unhappy woman pegged. Hedda was "the original Desperate Housewife."[131]

Female malcontents were hardly strangers to TV. Joan Collins's Alexis Carrington Colby on *Dynasty*, Julie Newmar as Batman's nemesis Catwoman, Jane Badler's lizard-tongued Diana on *V*, and Jane Lynch's Sue Sylvester on *Glee* were no one's ideal dinner guests, though these ladies owned up to being villains and were proud of it. But the five women we meet on Wisteria Lane initially seem a mutually supportive, relatable, often openly vulnerable quintet. It's why our hearts readily go out to Susan's single-mom anxieties, Lynette's failed attempts to be Mother of the Year, Bree's uncontrollable desire to control, Gabrielle's need to be a winning trophy wife, and Edie's hormonally driven fear of being alone.

We side with the women—who gamely try to reconcile feminism and femininity, while dealing with men driven more by testosterone than compassion—before Bree's made-from-scratch muffins can cool. Except, it's not long before Cherry lets us discover that, to maintain their foothold in the suburban American Dream, these

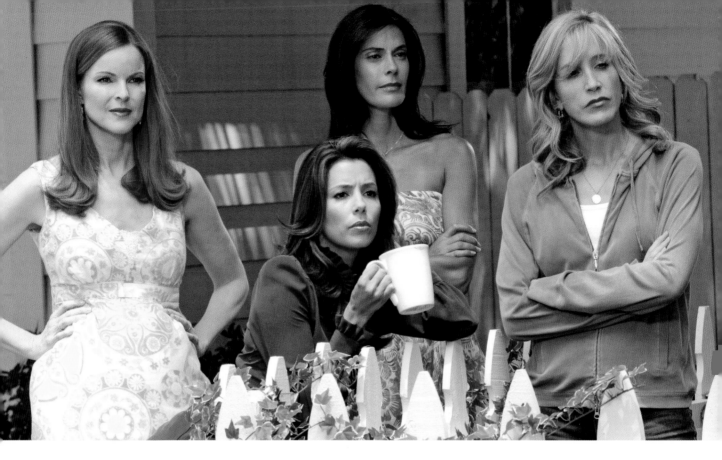

poker-playing neighbors are willing to lie, spy, bribe, steal, seduce, entrap, prostitute, kidnap, commit adultery, sabotage marriages, get very drunk, overmedicate, even commit murder. But it's too late to run. The sweet, musky fragrance of Wisteria has cast its spell. We are hooked.

The rush of imitations that tried to duplicate *Desperate Housewives'* refreshingly brash, insinuating, sometimes treacherous, instant Top Ten formula has dulled memories of the series' initial shocking novelty, but the show deserves bragging rights as the first TV series to spotlight women behaving badly. So very badly. Over *Desperate's* eight-year arc, more than fifty people died within the lane's four-block radius, almost none from natural causes or something in the water. Even more perverse is that none of the croakings caused viewers to reach for a suitable black veil or even a tissue, because one of the two secret ingredients in *Housewives'* formula was its consistent overlay of incongruously blithe humor. The greater the offense, the more flippant the wisecrack. In fact, though it was one of the first shows to be labeled a dramedy, all its Emmy nominations and wins were in the comedy category.

The second secret component was more front and center: a strikingly attractive, strikingly dissimilar quintet, who, thanks to costume designer Catherine Adair's specificity, managed to find and maintain their own sartorial lanes down a very narrow street. "There were so many people to dress, in so many current and flashback scenes,"

says Adair. "Each actress had between nine and fifteen changes per show. And they always had to look distinctive separately, yet complementary when together."[132]

Adair began by giving each principal strict color and style coordinates based on the character's psychology and situation. "Gabrielle [Eva Longoria] had married for money, so to maintain the illusion of a trophy wife, she always had to look fantastic in case her husband suddenly showed up," says Adair. "Considering Eva's physique, height, and energy, I always put her in heels, body-conscious clothes that shine, silks and satins in pinks and other brights that pop. I didn't use as much jewelry because Eva was so animated it would clank and clatter. Besides, I thought it would be gilding the lily."[133]

Susan (Teri Hatcher) was a newly separated, single mother, her income derived from illustrating children's books. Adair felt it was important that we see her as an artist, "eclectic without being a bohemian and alienating the audience. Her colors are smoky, less expected, and her outfits are slightly, but deliberately mismatched, because Susan didn't plan and wanted to go against the norm."[134]

Poor Lynette (Felicity Huffman). To dress the former business exec, now a reluctant mother of four children under the age of five, whose face winds up moisturized more by strained peaches than collagen, Adair focused less on what she wore and more on how it was worn. "Lynette was always five minutes behind," observes Adair. "So, nothing ever fit properly. Everything was covered in

food. She never had time to go shopping, so she wears whatever is almost clean that's already in the laundry bin. It's what overscheduled people do, reach in for some worn garment they like, and if it doesn't smell that bad, it's good to go."[135]

Edie (Nicollette Sheridan) revels in her status as the neighborhood seductress. What redeems her is that she's just fine with her role. Adair believes you could put "Nicollette in a sack and she could make it sexy. She exudes a joy of life that you can capitalize on."[136]

Adair got the biggest kick out of turning Marcia Cross into Bree because "she is the antithesis of her. Cross dresses quite bohemian and loose, came shod in

Birkenstocks, so for her to put on soft wools and cashmere in ice cream colors and low-heeled pumps that make up the armor of a woman so guarded and regimented was fascinating to watch."[137]

During its run, there was constant speculation that the drama was more desperate off camera than on. No one has ever gone on record with a specifically pointed finger, but the infamous May 2005 *Vanity Fair* cover shoot and behind-the-scenes story reference specific instructions from the network that Teri Hatcher not be given first dibs on the bathing suits worn on the cover and that she not be in the center of the photo. Hatcher showed up first and immediately picked the red suit.

IN CONVERSATION WITH CATHERINE ADAIR

When you are faced with such a large cast, how do you first go about dividing up wardrobes?

The clothes don't come first. Costume designers are really storytelling anthropologists. First, we follow two different types of behavior—the actress and the character. Then you work with the actress and her research to create a person that the viewer is allowed to believe is real.

Are there specific traits you look to latch on to as clues?

What is the physicality of an actor? How do they move, gesture? What resonates with her? Is her jewelry making a statement, or the fact that they always want to look taller, so they live in high heels? What sort of armor do they gravitate toward? For some, it's quite subtle. A hat, or a certain pair of shoes can suddenly define a character. I tend to build things organically, so if what someone is wearing still looks more like a costume, then I go back to the drawing board.

Is it tougher to design for film, theater, or for television?

TV is theater in hyperspeed. "'Hello, it's nice to meet you, would you please take your clothes off, no, you are not a thirty waist, you're really a thirty-six, now zip up your trousers and go." But television also offers you intimacy. James Garner, the actor (star of TV's *Maverick*), once said there were not as many actors you wanted in your sitting room as you wanted in the theater. My job is to do what I can to make it easy to welcome that person into your home."[139]

Collectively, they do look dynamic, even harmonious, on the cover, with Hatcher on the left, but everyone was upstaged by the line below that read, "You wouldn't believe what it took just to get this photo!!"[138] (For the record, every actress except Eva Longoria was forty or older at the time. They may be desperate, but they do look swell.)

Could any show be more worthy of having inspired the ever-growing *Real Housewives* franchise, *Keeping Up with the Kardashians*, *Big Little Lies*, *Little Fires Everywhere*, *Good Girls*, even *Scandal*? As Mae West once claimed, "When I'm good, I'm very good. But when I'm bad, I'm better."

Girls

TELECAST *from* 2012–2017 *on* HBO

STARRING: Lena Dunham, Allison Williams, Jemima Kirke,
Zosia Mamet, Andrew Rannells

COSTUME DESIGNER: Jenn Rogien

- -

Four millennials on their own in Williamsburg, Brooklyn.

WATCHING MULTIPLE EPISODES OF *Girls*, I keep reminding myself that this isn't a book about favorite shows, but about those series that effectively chronicled a particular group's behavior and its vision of style—because there is almost nothing I like about *Girls*. It is relentlessly whiny and woeful, overpopulated by too many who are too young to have stockpiled so many regrets and too needy to trust their own instincts. Plus, it's set in Williamsburg, which in 2012 *was* the epicenter of hipsteria, but now holds the land speed record for community transformation, from neglected warehouses to artists' haven, to hipster mecca, then tech oasis, and finally to bougie neighborhood with artisanal pizza and double-wide strollers—all in less than a decade.

Making sure that angst remains as pervasive as Axe Body Spray in a boy's high school locker room is Hannah Horvath (Lena Dunham), quintessentially selfish,

chronically inconsiderate, and as much fun as a cyst. You know how some see the glass as half empty, while others see it as half full? Hannah, a textbook millennial, wants to know if anyone got more water than she did. Hannah has a bifurcated personality. Even in face-to-face conversation, her attitude can shift without warning. Whether it's platonic or sexual, Hannah doesn't work on a relationship. She picks at it. Good to know.

There are aspects of *Girls* I do admire. Creator/writer/director/star Lena Dunham has an enviable gift for capturing the vernacular of her peers. Her dialogue has authenticity. And regardless of the topic—abortion, sex etiquette, periods, dysmorphia—she never equivocates, or wastes breath on positive thinking.

If you don't drown under Dunham's cascade of wry, droning pessimism, watching Hannah and her friends develop their distinctive way of dressing is *Girls'* most

welcome diversion. There are times when it's hard to believe these people would ever be friends, but their wardrobes are spot on. "You're not really grown up until you are out of your twenties," says *Girls* costume designer Jenn Rogien. "The girls are still getting to know themselves. They make good decisions and a lot of bad ones along the way."[140]

First, there is Jessa (Jemima Kirke), the most passionate of the four, but only about her own well-being. Does knowing you can lure any guy you want justify being unapologetically withholding and thoughtless toward everyone? It's easy to imagine her nicking a favorite piece of jewelry from her much nicer cousin, Shoshanna (Zosia Mamet), and feigning forgetfulness when Shoshanna comes to retrieve it. "Jemima has an amazing grasp of fashion's language," Rogien recalls, "and puts things together easily. So, her labels were

wide-ranging, dresses from Century 21, silk nightgowns from flea markets, that amazing Ann Demeulemeester feather dress from Saks Off 5th, and repeated visits to vintage clothing stores like Amarcord in Brooklyn [still in operation] and Geminola [now permanently closed], which Jemima's mom owned and was the source for most of her character's chunky jewelry."[141]

During all six seasons of the show, Shoshanna seems to be standing just outside the circle. Far more ambitious, independent, and adventurous than the others, she's the one least likely to stay home, even moving to Tokyo for work at the beginning of season six. Though she is small, Shoshanna stands out as the Girl most likely to smile. To telegraph her energy, Rogien "started with a palette that branched out from magenta to bright pinks and blues, and highly saturated shades. Her off-to-work clothes were often from Topshop and Club Monaco.

At night, Shoshanna has no aversion to sequins or ruffles. She even carries a real purse. She wouldn't turn up her nose at Bloomingdale's."[142]

While her friends are too eager to provoke or be noticed, Marnie (Allison Williams) is content to blend in with her peers, which is why she is the least likely to have a discussion about her appearance when she goes home for the holidays. She likes to dress up, but hasn't found her lane, so her taste leans toward the conventional. Marnie's most memorable moment, and one of best episodes Dunham wrote for *Girls*, occurs in "The Panic in Central Park" (season five). Marnie runs into her ex, Charlie, and starts roaming the city with him in sweats, but by the time they're dancing in the moonlight, Marnie has become a Bob Mackie Barbie Doll in a cherry red, plunging, halter-necked gown. Rogien found the original at Amarcord and then made multiple copies, tailoring one with skirt slits for dancing, another for the aftermath of falling into the lake. ("We painted the gown to look wet. You can't have an actor standing in a really wet gown for hours. It's cruel.")[143] And one more painted version for the muddy, morning walk home after the busted fantasy.

The image of Elijah, adorable in his short gray suit from H&M, will follow Andrew Rannells for the rest of his career. Due to his standing as Hannah's gay BFF, Elijah is her style sounding board. Lucky him. Though fashion has finally evolved to celebrate the beauty to be found in women of all body types, skin tones, and ages, Hannah's style MO borders on the perverse: a deliberate proclivity for I-dare-you-to-wince shapes and silhouettes that she knows do not flatter her, including rompers, overalls, short shorts, and the infamous and horrifying yellow mesh tank. When asked his opinion of one of Hannah's going-on-a-date getups, Elijah nods and says, "If you want him to think you killed your kids and have been living in the Florida Panhandle, knock yourself out."

But Rogien insists that Dunham's vestiary mission with Hannah is to evoke a visceral response. "Working with Lena was eye opening," says Rogien. "We thrifted our way through Brooklyn and stores like Urban Jungle, going no pricier than Zara, searching for pieces either from or inspired by the fifties and seventies, within a color palette that was slightly off—teal, mustard, olive green, and wallpaper florals. With Lena by my side, I was

no longer looking just for clothes that fit her, but also fit the character she was playing."[144]

And that character, as the show's title insists, was not yet a woman. But for a show that never built a huge audience, *Girls* claimed a disproportionate share of the conversation about contemporary youth while it aired, because it had the audacity to show women-to-be off balance at work, at having sex, or at putting together an outfit at least as often as it showed them succeeding—a situation that routinely generates sympathy for young men, who are all too often endearingly depicted as a festival of wrong moves. Dunham dared you not to feel for her and her friends, to eliminate the double standard. Hannah isn't the only millennial out there making bad choices.

And when someone is struggling to establish an identity, they're an unlikely candidate to be regarded as a fashion visionary. Rogien insists that Dunham was going for the opposite effect, especially during *Girls*' early seasons, when they were "reflecting how scattered Hannah was very much through the fit of her clothes . . . to make them hit in not quite the right places, [something] that literally just looks rumpled and off."[145]

In the first episode of *Girls*, Hannah tells her parents, "I think I might be the voice of my generation. Or at least, *a* voice of *a* generation."

That voice was often irritating. But it wasn't overlooked.

Grace and Frankie

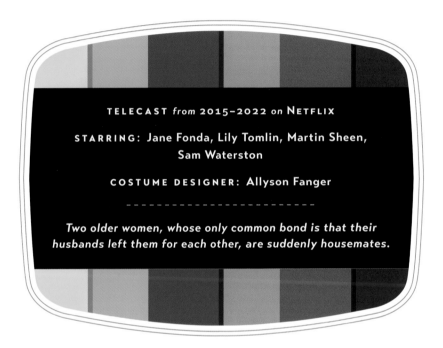

TELECAST *from* 2015–2022 *on* NETFLIX

STARRING: Jane Fonda, Lily Tomlin, Martin Sheen, Sam Waterston

COSTUME DESIGNER: Allyson Fanger

Two older women, whose only common bond is that their husbands left them for each other, are suddenly housemates.

J ANE FONDA AND LILY TOMLIN ARE THE most delightfully odd couple since *The Odd Couple*. They have been good friends since they met while starring in *9 to 5*, forty-two years ago. They have different body types and completely different speech patterns. One is a study in the economy of movement. The other suggests someone who will race down to the shoreline to catch the last ray of a setting sun on the water. On talk shows, Jane makes no secret of her desire for order, planning, and knowing what she is doing next. Lily, as she conveys in her brilliant one-woman show, *The Search for Signs of Intelligent Life in the Universe* (written by her longtime partner, Jane Wagner), finds wonder in life's inexactitude and in why we work so hard to contradict our better judgment. Her open-endedness is captured in this memorable observation, "I always wanted to be somebody. Now I realize I should have been more specific."[146]

They do align on some things. Tomlin admits, "I've been a fan of hers before I even met her. I got a Klute hairdo when she did *Klute*," Fonda's first Oscar-winning film (1971).[147] Both are staunch feminists and get-up-out-of-the-armchair activists, arrested together for civil disobedience in 2019. Tomlin is now eighty-four. Fonda is eighty-five. Their combined age is six years greater than that of the entire cast of *Friends* when that show began. With Betty White gone, they are the two eldest women headlining a series. Separately or together, they are spectacular.

Like all sustainable comedies, *Grace and Frankie* is built on opposition, not compatibility, and the show is at its best when it taps into their natural conflicting personas and foibles. The premise is forced but fun, as conceived by Marta Kauffman (who co-created *Friends*) and Howard J. Morris (whose big hit was *Home Improvement*).

Grace is a retired power suit, having run her own successful cosmetics empire. Frankie is a when-the-mood-strikes-her artist, more likely to speak to crystals than to neighbors. They only know and deal with each other because Frankie's husband, Sol (Sam Waterston), and Grace's husband, Robert (Martin Sheen), both divorce attorneys in San Diego, have—over the years—become "really close" friends. Or so Grace and Frankie think, until their husbands announce that they are simultaneously coming out as gay, moving out of their respective homes, and moving in together as lovers. Cya!

Suddenly Grace and Frankie are uneasy housemates. Granted, the house they are stuck in is an oceanfront utopia: sunlit, breezy, so ready for its *Architectural Digest* cover, it's surprising that virtuoso home-porn director Nancy Meyers (*Something's Gotta Give*, *The Holiday*), doesn't show up in the third episode to buy it for cash.

And to the writers' credit, the humor isn't generated Felix/Oscar style, with one woman a slob and the other OCD about how napkins are folded. Rather, it arises because nothing meshes in how they approach the surprise situation, their now disrupted families, the way forward, or the prospect of future sexual desires.

Grace is wound so tight you couldn't get a mascara wand up her butt. She swallows and suppresses so many emotions at once that it's a miracle, even for Fonda, that her waistline is so taut. Frankie is an open book, with most of the pages having come loose from their binding. She readily lets it all hang out to a TMI-resistant Grace, as well as to strangers in the supermarket and delivery men.

But Grace's cool reserve in dealing with Sol and Robert—who despite their finally out-in-the-open romance, are not exactly a matched set—yields a resolution in the women's favor. And Grace has to hand it to

Frankie: a blast of anger can be a good thing. Cautiously at first, the two women set out to reconstruct their lives with one another's help. Sometimes it's by collaborating on a vibrator for mature women called Ménage à Moi, or a hydraulic-lift toilet called Rise Up. Sometimes, it's about what to wear on a date, after forty years of not going on one.

And as the two women get closer, you see the effect each has on the other's temperament, confidence, and how they dress to face an unexpected future. "When the show began, I wanted people to know who these people were before they opened their mouths," says costume designer Allyson Fanger. "When you get past forty, you know what works, but as you get older you can fall into rigid patterns, and you don't even know it's happening, until someone else points out you're in uniform."[148]

Fanger is emphatic that "Frankie is not a hippie! She sees herself as more of an artist, so I researched female artists who used rust to dye their dresses. I wanted Frankie doing that or tie-dyeing a dress in a bucket. I felt her clothes had to be unique, as if she had picked them up on expeditions or exotic travels."[149] The designer admits that Tomlin didn't understand what she was doing at first. She found it too complicated, possibly too specific, and had a hard time imagining how the one-of-a-kind pieces would affect her movement. "But I think the most important task as a designer is to help an actor create a full portrait," says Fanger, "So, I made an old-fashioned presentation with storyboards, and showed Lily these flowing, hand-painted tunics from Harari [now closed], multipatterned coats from an Israeli online brand called Alembika, asymmetrical shirred dresses by Magnolia Pearl, and these incredible pieces of crystal jewelry by a woman named Adina Mills from Joshua Tree [California]. Lily quickly realized I wasn't trying to make her look silly or wild, but like someone who didn't plan her outfits, but rather created them daily. It was 'whatever you say' from that moment on."[150]

Fanger found Fonda intimidating at first. "C'mon. She's Jane Fonda!"[151] But the actress immediately got that Grace had always followed a subliminal style manual, dictating that all apparel, whether for work or play, would be elevated but deliberate, unfailingly flattering but rendered in narrow palettes of pewter to cream, blacks to gray, taupe to camel. Carolina Herrera is the chicest woman alive, and her signature silhouette almost always starts with a crisp, high-collared white shirt. Herrera made four of them for Fonda, with Fanger adding pieces by Ralph Lauren, Escada, and Giorgio Armani.

Sol's and Robert's wardrobes complemented their former spouses' garb during the marriages, though their versions were less flattering when viewed on their own.

Maybe they came out so late in life that their gay genes had already receded too deeply to make a difference. Sol wore short-sleeved camping shirts, too brightly printed or too beachy; pants and shorts that were always loose or shapeless; and thick-strapped sandals, so that he looked like a sedentary retiree in Wilton Manors (possibly the densest gay enclave in Florida). And where Grace was deliberate, Robert was merely predictable: Brooks Brothers, Loro Piana, Bruno Magli. If he ever put on a hoodie, it was cashmere.

But one lover's taste never infiltrated the other's, which could be why their relationship, while affectionate, always seemed at odds. Meanwhile, as the ladies' friendship evolved, Frankie began to temper her flamboyance with more harmony. Her sweaters and coats acquired hems instead of trailing the floor. She even combed her hair. Conversely, by season four, Grace showed up in a navy button-down with a print boasting an aviary of pastel birds. By the last season, she had acquired a pink blazer and, a claret-red suit, and got plastered (not out of character for her) in a taco palace while wearing a big black sombrero.

TV still hasn't quenched its thirst for teenage and postadolescent superheroes, vampires, Jedi knights, gunslingers, club denizens, and private-school brats. So, where does this leave a show that endorses the belief that

if you want more—more life, more work, more adventure, more love, more sex—your age is immaterial, because it still can be yours for the taking? *Grace and Frankie* is the longest-running original series on Netflix to date. And one reason for that may lie in a memorable scene late in its run.

The two women are trying to get the attention of a young clerk who's deliberately oblivious to Frankie's request for a pack of cigarettes. Finally, he appears to walk toward them, only to turn his back again to wait on a nubile blonde in a strapless top who wants to buy lottery tickets. As he flirts, Grace asks if he's in a coma. Frankie tries to be polite. He still pays both no mind. Suddenly, Grace, goes insane, shaking the cash-register tray and screaming wildly, "What kind of animal treats people like this? You don't see me? Do I not exist because I don't look like her?" As the kid stands frozen, Frankie escorts Grace out to the parking lot and into the car, where to Grace's surprise, she promptly lights up a cigarette. "You stole those?" Grace asks. "I learned something," replies Frankie. "We've got a superpower. . . . You can't see me? You can't stop me. You wanna hit Citibank?"

Youth may not be wasted on the young after all. If enough septuagenarians get a second wind, you kids better watch out.

That's What Friends Are For

JUST US KIDS

Happy Days

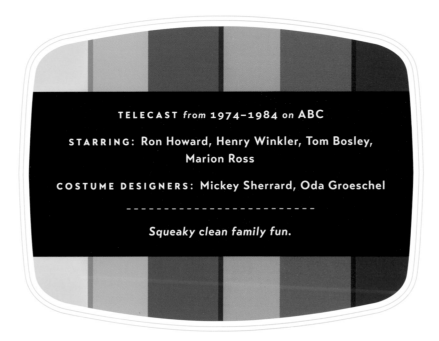

TELECAST *from* 1974–1984 *on* ABC

STARRING: Ron Howard, Henry Winkler, Tom Bosley, Marion Ross

COSTUME DESIGNERS: Mickey Sherrard, Oda Groeschel

- -

Squeaky clean family fun.

I'M GLAD RON HOWARD GREW UP TO BECOME a fine film director (*Apollo 13, A Beautiful Mind, Parenthood, Splash*), because it meant that during the twenty years he spent on two numbing shows (*The Andy Griffith Show* was the first), he found more talented people to pay attention to than the writers who penned the wit-free scripts for *Happy Days*.

With a cast as benign as a bake sale, *Happy Days* became the number one show in America in 1976–77 thanks to just one originally featured player—Henry Winkler as Arthur "The Fonz" Fonzarelli. And the only justification for including *Happy Days* in a celebration of style is because Winkler instigated a radical reinterpretation of the most storied article of clothing in a man's wardrobe.

Leather jackets first started becoming popular after World War II, when a surplus of brown bomber jackets worn by military aviators like the Tuskegee Airmen saturated army navy stores and resale shops. Because of their origin, the jackets were immediately associated with hypermasculinity. Two companies, one started by the Schott Brothers, the other by Harley-Davidson, began making zippered, black leather versions with higher collars for the growing motorcycle ridership in Southern California.

Two events solidified the jacket's rebel image. In 1947, a rally of four thousand leather-clad bikers converged on a small California town called Hollister, and the ensuing bar and street fights were publicized by *Life* magazine. Two years later, Marlon Brando became the face of bad boys in leather when the Schott Brothers outfitted the charismatic actor and his troop of biker buds in Brando's film debut as an angry army vet in *The Men.*

Then, in 1955, Nicholas Ray's *Rebel Without a Cause* introduced us to modern cinema's first brooding teen idol, James Dean. Despite film buffs swearing otherwise, Dean never wears a leather jacket in any of his three films he made before his tragically premature death, but he was often photographed on his bike wearing the same Schott Perfecto jacket that Brando wore, complete with rolled-up jeans and dangling cigarette. The Perfecto was soon banned by high schools around the country for symbolizing a new teen demographic: the hoodlum. Now add Steve McQueen in a brown bomber, breaking out of a prisoner-of-war camp in *The Great Escape* (1963), and the leather jacket's fate as the bad boy's uniform was pretty much sealed.

And then the Fonz rewrote the book. Yeah, he had a bike parked in his living room. And he wore his hair slicked back. And he talked like a tough guy. But the Fonz is who Richie (Ron Howard) came to with all his problems, who Richie's mom liked so much that she danced the tango with him during the dance contest, whose poster was on the walls of high school girls across the country, and whose jacket now hangs in the Smithsonian, as a symbol of the good guy.

Everybody has at least one leather jacket now. Lil Nas X's is bright pink. Makes you wonder what kind of advice Nas would give Richie. Betcha that could make for some *really* Happy Days.

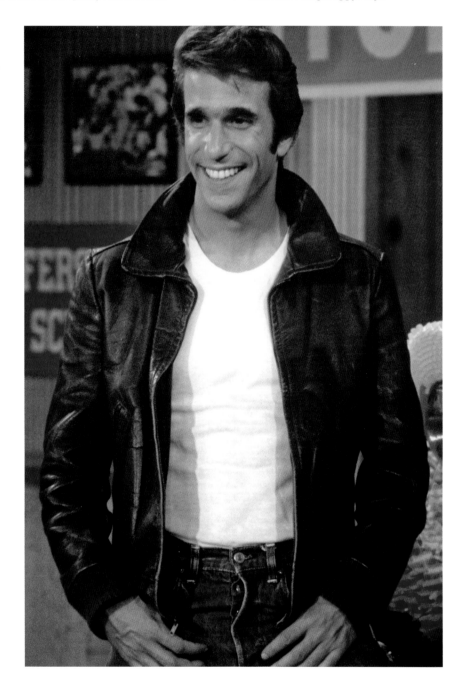

A Different World

TELECAST *from* 1987–1993 *on* NBC

STARRING: Lisa Bonet, Jasmine Guy, Kadeem Hardison, Dawnn Lewis

COSTUME DESIGNER: Ceci

- -

Campus life at a historically Black college in Virginia, an ingratiating mash-up of styles, and a cast that had energy, diversity, and an awful lot to say. Often all at once.

T WASN'T JUST A "DIFFERENT" WORLD. It was one helluva busy one. Just watching the show's opening credits was exhausting. It felt as if the entire student body of Hillman College was living in the same dorm. *A Different World* had originally been set as a logical spinoff of *The Cosby Show*. We were going to follow Denise (Lisa Bonet), the eldest child, as she entered a Black college that was integral to the Huxtable world and to the comedian's wearing of his mortarboard signifying Dr. William Cosby, PhD.

But right before Denise matriculated, Bonet participated in some complicating extracurricular activities. She starred in the Alan Parker film *Angel Heart* as a very horny voodoo priestess. Enough of Bonet's nude scenes were edited to reduce the film's X rating to an R, but that didn't stop her from posing in only nose rings for both *Interview* and *Rolling Stone*. Around the same time,

the good doctor's TV daughter married rocker Lenny Kravitz, became pregnant, and proposed going through her pregnancy on air while a single freshman. It was all much too distracting. Bonet lasted one season on *A Different World* before being called back to the Huxtable brownstone in Brooklyn Heights.

There was also a subplot contrasting a white girl's experience at the school with that of her fellow students. But Marisa Tomei's character was also phased out after one season. Two people are responsible for getting *A Different World* into focus. Actor, producer, director, and choreographer Debbie Allen, who happens to be the real-life sister of Phylicia Rashad (aka Clair Huxtable), was brought in to organize the student body, as she had done on the television version of *Fame*. Allen described how she had taken notes on every episode of the series. "[I] then came up with my own ideas, since I'm a graduate of Howard University.

I felt the show needed to be upgraded to a more mature level of talking and thinking. We couldn't have a show about young people that didn't deal with the things going on in this country. Teenage pregnancy, student uprising, voting, and other issues, like date rape, and the return of ROTC programs on Black campuses."[152] Allen gave the students a voice. Well, a lot of voices, talking nonstop and over each other about stuff young people cared about, beyond who was going to the annual school dance.

And Allen took a chance on a young, Black costume designer named Ceci. "I remember watching the first season of *A Different World* and saying to myself, 'I'm going to do that show.' I guess Debbie saw something in me," Ceci recalls. "I talked to her about how there wasn't much on TV to emulate. And besides *Jet* and *Ebony* magazines, fashion was myopic when it came to celebrating the diversity of Black people. The only white-owned brand interested in dressing us was Nike. I had to find more representation. And this may sound unfair to other designers, but I felt who would know more about dressing us than a young Black woman?"[153]

Ceci took the massive cast and gave each character their own wardrobe lane. Her budget was meager, so each week she would choose one character to award a high-ticket item she might find marked down ten times at Neiman Marcus: a houndstooth Chanel skirt for Jasmine Guy as Whitley, the bougie Southern belle, who was fast becoming the show's breakout star; over-the-top jewelry for Cree Summer as Freddie, the aspiring lawyer. Ceci sourced and made deals with young Black designers hungry for exposure. By focusing on labels either Black-owned or targeted to African Americans, like FUBU, Marc Ecko, Phat Farm, and Walker Wear, the designer feels that "I gave them a platform, and they helped keep the show authentic."[154]

Ceci is especially proud of the way she made two of her favorite cast members stand out. "Dawnn Lewis was older and more mature than her younger classmates, but I didn't want her to look middle-aged, so we used color-blocking to express her energy and have her appear young but sophisticated. It's common technique now, but it wasn't thirty years ago. Kadeem Hardison's Dwayne Wayne had the widest story arc, because he started as an annoying nerd and wound up Whitley's charming husband. It was wonderful to transition a young Black man from oversized sweatshirts to suiting him up as a teacher. Only problem I had were those flip sunglasses. They became Dwayne's trademark, but Kadeem hated them. Debbie finally let me toss them."[155]

When sons and daughters graduate, their parents always warn them, "It's a different world out there."

Ceci is proud that the *World* she was part of "was something not previously seen or celebrated. And what we showed viewers was important in the scope of television, to see multifaceted people who behaved and talked like us. *A Different World* cemented our place, and that let us go forward."[156]

The Fresh Prince of Bel-Air

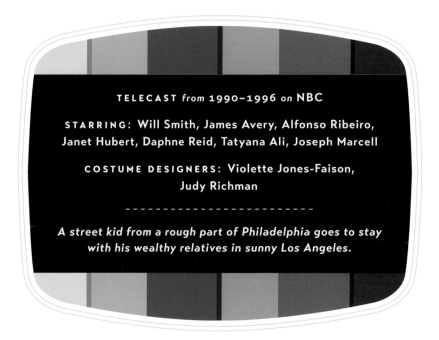

TELECAST *from* 1990–1996 *on* NBC

STARRING: Will Smith, James Avery, Alfonso Ribeiro, Janet Hubert, Daphne Reid, Tatyana Ali, Joseph Marcell

COSTUME DESIGNERS: Violette Jones-Faison, Judy Richman

A street kid from a rough part of Philadelphia goes to stay with his wealthy relatives in sunny Los Angeles.

WHEN CONSTRUCTING A FISH-OUT-OF-water comedy, it helps to know ahead of time that whoever you've chosen to throw into the deep end doesn't just know how to keep their head above water, but can swim, well, like a fish. Because when the setup works—as it did with Julia Roberts in *Pretty Woman*, Jason Sudeikis as *Ted Lasso*, Fran Drescher as *The Nanny*, and Eddie Murphy in *48 Hrs.*—the results are not just enjoyable, they can be star-making career launches.

Will Smith had never even stuck his big toe in acting waters before he was cast, but it takes the twenty-one-year-old rapper exactly three minutes inside the Banks' Bel-Air residence for him to start having the best time splashing around. Smith isn't even acting, not yet. But he's reacting with incredible reflexes, acing one-liners off every member of the family with such speed and accuracy, it's like the rush tennis fans had watching Federer during his unbeatable prime. It helps that showrunners Andy and Susan Borowitz have stocked Will's arsenal with witty comebacks that reference pop music, nouveau riche pretension, ghetto slang, and TV.

It's a terrific pilot that takes full advantage of a game supporting cast, but the best part about it is that you can't get enough of Smith. Evidently, the legendary record producer Quincy Jones's talent for zeroing in on potential star power wasn't limited to music. In fact, he developed the Fresh Prince TV concept not just because he thought it would be a smart next step for the young rapper, but to help Smith financially after the IRS nearly bankrupted him for underpaying taxes.

Despite its well-worn conceit, *Fresh Prince* raced to top-scoring status at NBC because it was spiked with several novel twists. Smith's wardrobe didn't veer from his onstage, ain't-this-a-kick rap getups, but on a TV set the garish, neon-highlighter-bright outfits were goofy and strident, topped by a forever dorky, baseball cap turned ninety degrees, and anchored by unlaced Michael Jordans at least a size too large.

However, *the OG* (Original Gangster if you will) *Fresh Prince* was the first show to present streetwear without apology, and Smith's effortless ability to pull off the hoodies, long shorts, and Afrocentric jewelry with ingratiating sex appeal helped drive sales at Black-owned streetwear companies like Daymond John's FUBU and Russell Simmons's Phat Farm.

On the other end of the sartorial spectrum, the Bankses weren't merely well-off like the successful but still striving *Jeffersons*. They were rich and dressed the part. Though she never mentions the First Lady by name, Vivian Banks does not want Nancy Reagan in her house.

Still, the Bankses were always dressed as if ready to attend a country club lunch or field a last-minute state dinner invite. Their clothes were more classic upper class than fashion forward; notable for being the first African American TV family to wear pastel sweaters tied round the neck, school uniforms, double-breasted blazers, and Lurex-threaded ladies-who-lunch suits by St. John as if these are the clothes they routinely send out to the dry cleaners.

At the end of the series, the Bankses move to New York's Plaza Hotel while Will, the character, stays in Los Angeles to finish school (while Will Smith, the actor, eventually achieves a level of international superstardom that now commands a location trailer as big as the Bankses mansion). Whether Smith's place in the pantheon has been damaged by one cataclysmic case of overreach remains to be seen. People have forgiven worse transgressions. But as for the horrific, ongoing style nightmare Smith incited the moment he turned his ball cap visor to the side, that was a real slap in the face.

My So-Called Life

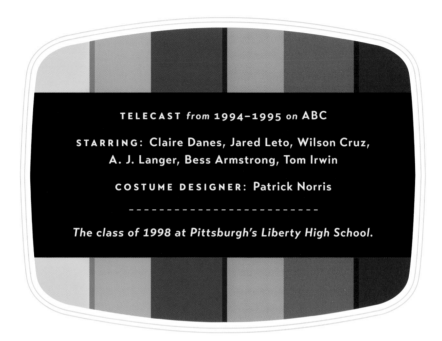

TELECAST *from* 1994–1995 *on* ABC

STARRING: Claire Danes, Jared Leto, Wilson Cruz, A. J. Langer, Bess Armstrong, Tom Irwin

COSTUME DESIGNER: Patrick Norris

- -

The class of 1998 at Pittsburgh's Liberty High School.

"People always say you should be yourself, like yourself is a definite thing, like a toaster or something. Like you can know what it is, even."

—ANGELA CHASE

HAVE NEVER BEEN A FIFTEEN-YEAR-OLD girl. Nor have I ever fantasized about being one. Yet when I watched Angela Chase walk through her high school corridor, her eyes darting left, right, and down, trying to gather clues as to what was going on around her, while avoiding eye contact with anyone who might dare break her concentration, I remembered the intensity of high school. The desperate desire to fit in, slamming up against a nonstop desire to be noticed. Then, finally being noticed, only to fear that now you're being judged.

If the kids on *Beverly Hills 90210* ever felt this way, they never admitted it. Not that they didn't have problems. Donna passed out at the prom. Ariel gave David an STD. Brenda and Kelly wore the same dress to the spring dance. Somehow none of that resonated with the same impact as Angela admitting in a voiceover that "school is a battlefield for your heart."

My So-Called Life lasted only nineteen episodes. Evidently, hallway angst isn't as big a crowd pleaser as Valerie bedding both Dylan and Ray, but for those of us in awe of creator Winnie Holzman's perceptiveness,

My So-Called Life tapped into a teenage girl's inner monologues, especially about sex, with such subtlety and stealth that almost twenty years later, each episode plays as revelatory. Holzman gives a lot of credit to good fortune in casting.

"Claire [Danes] was the second person we met with. She was just fourteen," recalls Holzman. "But when we looked at the dailies, Angela was staring at Jordan [Jared Leto] with this look of such soul-baring lust, we knew that's what we had to tap into. We also instantly had to make Jared a regular, but I didn't want to have Claire and A. J. (Langer, who plays Rayanne, Angela's troubled and troubling best friend) talking about sex. For them, sex should be too overwhelming to articulate, but I wanted to show how deeply they felt sexual urgency."[157]

The most effective shortcut to sharing Angela and Co.'s hormonal rushes with viewers would have been to dress the students at Liberty High in the same duds as their hills-of-Beverly contemporaries: high-waisted, acid-wash jeans; halter tops; tight, striped Ts; and open-weave knits and florals.

Instead, costume designer Patrick Norris did something novel. He created a fresh, alternative wardrobe for his entire *MSCL* cast, one that previously didn't exist for the class of '98. Inspired by his love of vintage, album covers of the '60s, grunge bands of the late '80s, all the vintage shops on Melrose in LA, and his sincere belief that he is an "eternal sixteen-year-old," Norris created a closet of fresh options for each of his principals. For Angela and Jordan, it was layered, languidly bloused soft plaids, short shearling coats, and loose, oversized knits. For A. J., dresses that Janis Joplin might covet, lace tops from vintage bundles, and great pieces from his mother's closets filled with select pieces from the '20s and '30s. (Norris' mother was Patricia Norris, costume designer for *Scarface*, *The Elephant Man*, and *Victor/Victoria*.) And for Rickie, Angela's beleaguered and pansexual best friend and kohl-eyed confidante, cropped ornamental and band jackets. Norris explained his process as follows:

I had a different thought and theory, wanting to break out from how one normally would dress a modern teenager. I'm also influenced by my own teenage years, which would put me right around the time of Woodstock. I couldn't imagine diminishing the range of emotions we were revealing by [using] fashion that was simply current and correct. I wanted to give these kids a more romantic alternative. I wanted them to look vulnerable because teenagers are just that. So, I put together closets for each of them, and let them find their character.

It wasn't 'til they dyed Angela's hair red, that I knew what her trip would be. I think she felt the same way. I think that's when the plaids and softer fabrics started to make sense for her too. She treated the closet as her own. Never rejecting anything. Happy to be playing the part of the grunge girlfriend.

Wilson Cruz [Rickie] was so instinctive and fearless. Like a modern-day Sal Mineo. I gave him lots of embroidered and Beatles-like band jackets.

I love Jared Leto. He may be the coolest guy on the planet. Showed up wearing this leather necklace. [I said], don't you dare take that off. I was so blown away by his energy and personality that I completely supported his choices. I learned from my mom that if an actor is comfortable in their costume, they will be comfortable in their character. Jared starts out comfortable in his own skin.[158]

Holzman knew that Norris's approach was working "when I got a call from an ABC exec: 'We notice in the dailies that Claire is wearing the same dress as last week. She should have another dress.' I told them she was simply picking from her closet what to wear. Isn't that what a teenager does?"[159]

Though the series was a critical success, the ratings didn't match the raves and it was canceled after one season. But *My So-Called Life*'s wardrobe became a campus-altering hit—not completely eliminating the decade's mall-driven trends, but providing options that are actually more conservative in terms of fabric coverage, yet much sexier in overall effect, and still valid. "I remember telling Refinery 29 that my intention wasn't to start a trend, but to offer young people a new way to look at romance," says Norris. "I think we did that, and it worked."[160]

"Every so often, I'll have, like, a moment, where being myself and my life right where I am is, like, enough."

—ANGELA CHASE

Friends

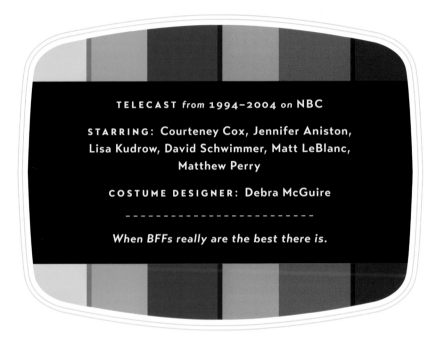

TELECAST *from* **1994–2004** *on* **NBC**

STARRING: Courteney Cox, Jennifer Aniston, Lisa Kudrow, David Schwimmer, Matt LeBlanc, Matthew Perry

COSTUME DESIGNER: Debra McGuire

- -

When BFFs really are the best there is.

WOULD YOU STILL LOVE THEM FOR this long if they were just in T-shirts and jeans? Probably, since they're an irresistible sextet, whose deliberately atopical humor remains forever funny. They're smart, incredibly loyal, always in sync, and never hesitate to let you in on the joke.

Just know you're not the only ones still crushing on them. *Friends* stopped making new episodes almost twenty years ago, yet the show ran in syndication for a decade, almost on a loop; then Netflix paid over $100 million to steal it away. Recently HBO Max hijacked *Friends'* devotion for another $500 million. So, if you are ever short on cash and can score Chandler or Phoebe's cell number. . . .

But the key to *Friends'* unparalleled popularity lies with three people who were also by Monica, Rachel, Phoebe, Ross, Chandler, and Joey's side for all 236 episodes. Writer/creators David Crane and Marta Kauffman never stopped putting worthy words in their mouths. And Debra McGuire always dressed them.

McGuire would agree that on *Friends* it was primarily about the scripts. "The writers were our gurus. We served them. The clothes could never dominate the conversation or be distracting in any way. But what made [the characters] more appealing was how good they looked. After all, New Yorkers thrive on being aspirational, looking good. The trick was making them look good together."[161]

McGuire followed the personae the actors created, rewarding each with colors, silhouettes, and a standing in New York of their own. "I'm a painter. So, I gave each friend a palette. Monica was the New Yorker, sharp, judgmental. She was reds and burgundys, black and grays. We used a lot of Chaiken and Capone, and Vince. When she was home, the Juicy Couture girls helped out a lot."[162]

Of the six, Rachel is the only friend who openly expresses an interest in fashion, possibly because her parents' finances made it within reach. In a few of the rare scenes not set in one of the friends' apartments, we catch Rachel working at Bloomingdale's, then later for Ralph Lauren. McGuire put her in warm blues and greens and in denim, to reflect a more suburban outlook. For McGuire, Phoebe's sartorial lane was an obvious one. "Phoebe was the bohemian, which fit in perfectly with the popularity of the boho look, using lots of earth tones, patterns, hair ornaments, craft jewelry, and fringed handbags."[163]

Considering that womenswear offers more trends, silhouettes, and variety than menswear, McGuire's diversification of the three male friends is surprisingly pronounced. "Ross is the one with the most substantial

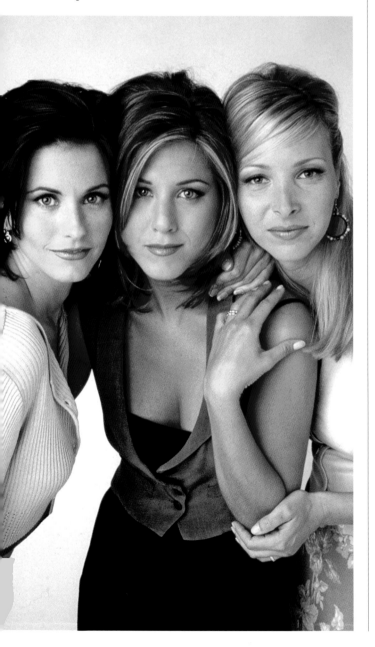

job," she says. "I couldn't make him look corporate, but corduroys, elbow patches, and tweeds seemed right. As he became older and more successful, he evolved from J. Crew to Zegna. Joey, of course, is the New York actor, forever broke and a little haphazard. For a while we thought we could make him look bridge-and-tunnel, except the perfect leather jacket we found for him was an Armani, so we spent hours beating it up and distressing the leather."[164]

You're supposed to love all your children equally, but McGuire admits she had a favorite friend when it came to dress-up: Chandler. "Because Chandler was my father," she confesses. "That's exactly his style. Of course, we never really knew what Chandler did, but his loose attitude made him seem right for gabardine jackets with shoulder pads, double-pleated pants, and vintage ties."[165]

McGuire was responsible for over seventy costumes a week, and at the beginning of the series she tried to make everyone's clothes in house. To her, "it seemed easier than constantly shopping. But when you make things, you have to have fittings, and these were not actors who came from the theater, so they hated them. So, we wound up shopping for about ninety percent of the clothes. The challenge, however, was not dressing everyone. It was getting everyone to look great together. They were almost always in groups from four to all, so I wanted them to look harmonious together, complementing each other. After all, they're friends!"[166]

The only part of the *Friends* group effort that McGuire had nothing to do with was "the Rachel." Aniston's friend and haircutter Chris McMillan was trying out different ways to hide growing out her bangs, which he called a "nightmare," so he gave her choppy layers framing her face. She loved it at first, but the cut became Aniston's anchor when millions started copying it, and it wasn't just half the female viewers who wanted to get the Rachel. The list of celebrities who copied Aniston is almost endless and very diverse: Meg Ryan, Debra Messing, Jessica Alba, Ashlee Simpson, Tyra Banks, Kelly Clarkson, Kerry Washington, Christina Aguilera.

Now, a new generation is discovering the show. "I'm getting texts from girls of every age group," McGuire reports. "Even preteens. They have no context, so, all the new clothes out now that are oversized look fresh to them, even if they are really bringing back the nineties. I find it terrifying, but they love it. Jennifer and I talked about it. [McGuire is dressing Aniston on her new series, *The Morning Show*.] She said, they're even getting the Rachel."[167]

Makes sense. Anything to be more like your *Friends*.

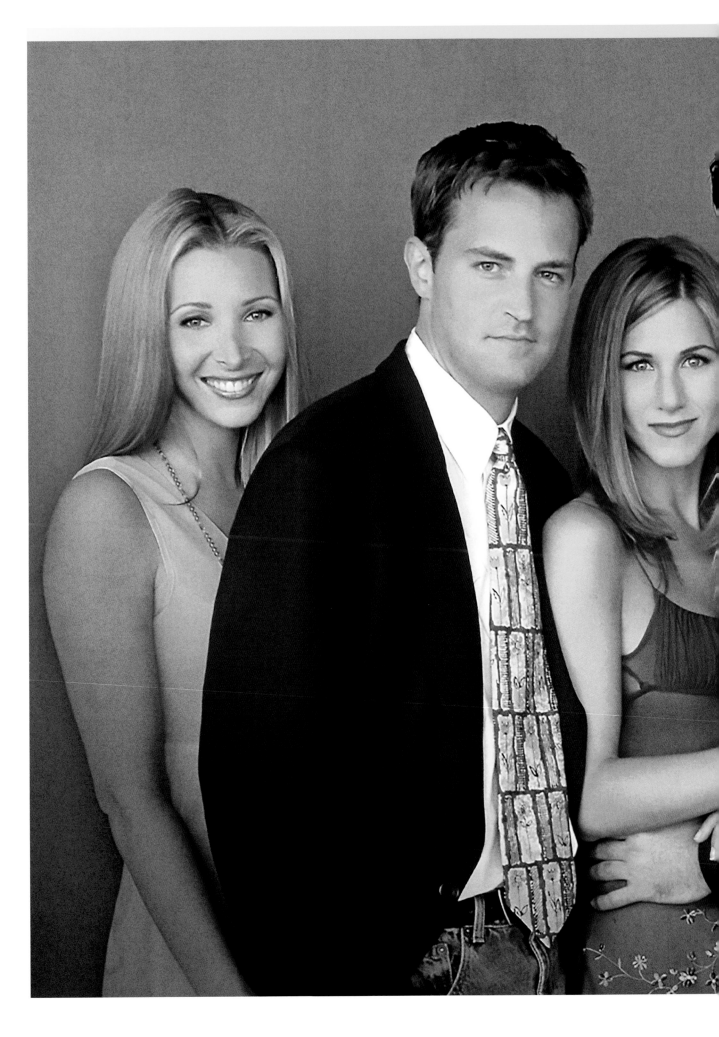

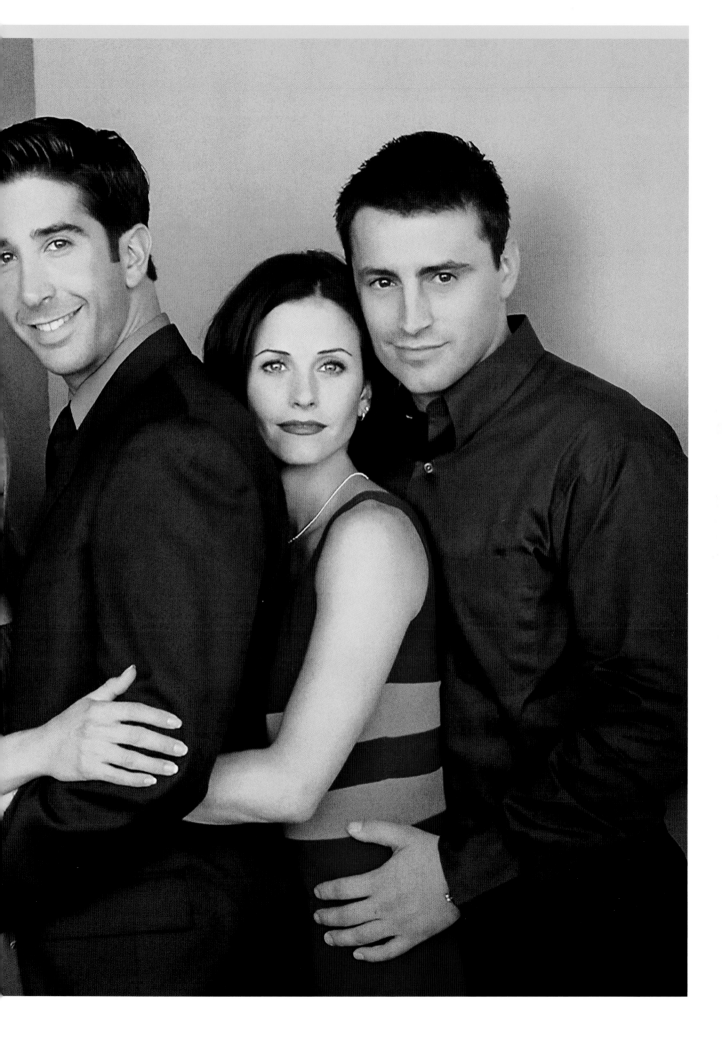

The O.C.

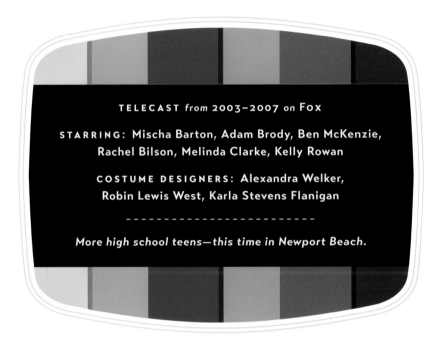

TELECAST *from* 2003–2007 *on* FOX

STARRING: Mischa Barton, Adam Brody, Ben McKenzie,
Rachel Bilson, Melinda Clarke, Kelly Rowan

COSTUME DESIGNERS: Alexandra Welker,
Robin Lewis West, Karla Stevens Flanigan

More high school teens—this time in Newport Beach.

F FOR NO OTHER REASON, I HAVE TO TOAST the show that invented Chrismukkah. And if that inspired, all-bases-covered holiday isn't enough to raise your glass with me, how about we add other fascinating dualities: comely teenage heroines who deserve to be loved even though they drink too much and shoplift; an envied Southern California county that poses as a bastion of stability, except its favorite game is musical beds; and for once, a male lead who is *not* the handsome, muscular, misunderstood bad boy, but the sexier-the-more-he-talks nerd who is both a good guy, an observant one, and funnier than anyone in town. Adam Brody's Seth Cohen offers a running commentary on life's absurdities that, if revived now, would qualify as a must-listen-daily podcast. (Former costars Rachel Bilson and Melinda Clarke do host a podcast called *Welcome to the OC, Bitches!* but my concept is so much better.)

Josh Schwartz's *The O.C.* is sharper, more nuanced, and far more entertaining than what you'd expect from another sunstroked drama about the anything-but-idle rich. The show also promoted the illusion that anyone who isn't adorable, buff, or waxed is forbidden to live in Orange County. No wonder Andy Cohen found his first coven of *Housewives* here.

Though he had nothing to do with their creation, one is tempted to blame Schwartz for such scrapings of the reality barrel as *The Hills, Laguna Beach,* and *Newport Harbor,* simply because everyone looked so good on *The O.C.* that they must have spent the whole day shopping at South Coast Plaza. Because at twenty-five, Schwartz was the youngest and greenest showrunner ever hired to produce a network drama, costume designer Alexandra Welker initially didn't have an easy time securing high-end designers for her cast, so she bought most of the

pleated denim skirts, low-rise jeans, halter and lingerie tops, fake Chanel bags, real Chanel and Marc Jacobs dresses, tight preppy sweaters, chunky knits, flounced midis, and Juicy Couture tracksuits at sample sales. About the only item she had the budget to pay full price for was Ben McKenzie's limitless supply of tight, ribbed white tank tops. "It's understandable that they didn't want to go with a complete unknown," says Welker. "And it also makes sense that they soon wanted to be attached to something setting fashion trends. What a difference ten months made."[168]

Unfortunately, what an even bigger difference two years make. *The O.C.* shot a whopping twenty-seven episodes in its first season. Schwartz sped his large cast through complicated story lines as quickly as Adam Brody's hyperspeak. The lovely Mischa Barton suffered a career meltdown just as the show started to run on fumes, and it didn't recover from her absence. Burn-too-brightly shows like *The O.C.* and *Empire* make you appreciate how difficult it is for others, like *Friends* and *Mad Men*, to sustain excellence for so long.

Luckily, Josh Schwartz learned from his mistakes. He headed east, trading the Santa Ana Mountains for Carnegie Hill, and came back with a new project that proved he knew how to profit from experience. He stuck with the kids and found someone almost as compelling as the guy who created Chrismukkah. Her name? *Gossip Girl*.

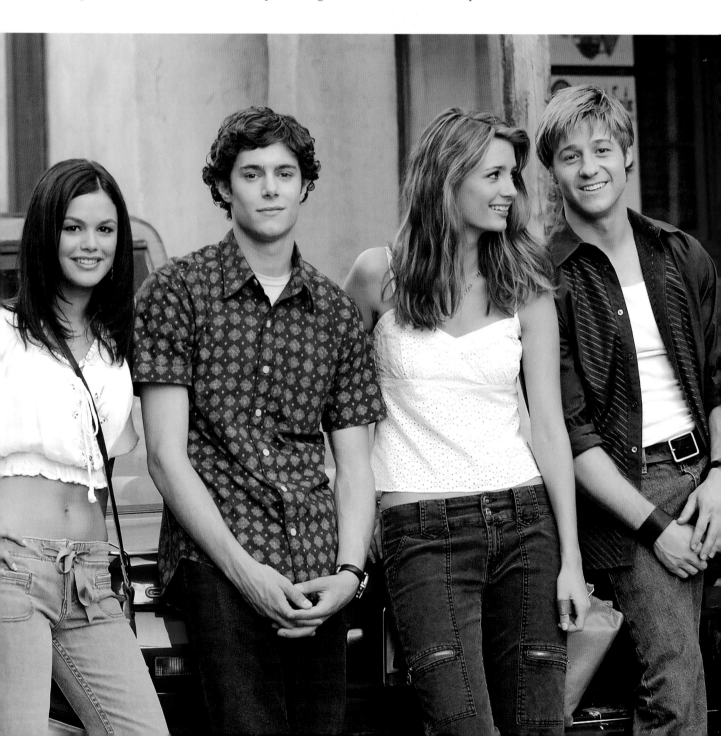

Gossip Girl

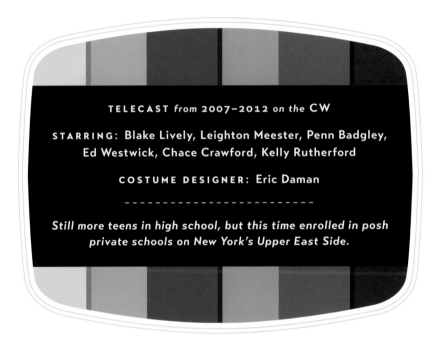

TELECAST *from 2007–2012 on the* CW

STARRING: Blake Lively, Leighton Meester, Penn Badgley, Ed Westwick, Chace Crawford, Kelly Rutherford

COSTUME DESIGNER: Eric Daman

- -

Still more teens in high school, but this time enrolled in posh private schools on New York's Upper East Side.

THE ONLY THING THAT KEEPS ME FROM watching Josh Schwartz's next show with the glee of someone who accidentally got locked inside Bergdorf Goodman for the evening is that I can't get past being insanely jealous of costume designer Eric Daman. It's the dream gig: perusing rack upon rack of the most covetable clothes from three fashion capitals and then choosing the gorgeous person who gets to wear them. This is work? No, being Mariah Carey's dance coach is work, but getting to dress Blake Lively every day would make me higher than Zendaya in *Euphoria*.

Daman used to work with Patricia Field on *Sex and the City*, which transformed New York into an Arcadia of style for grown women, even if the click of their Louboutin stilettos couldn't completely drown out the ticking of their biological clocks. But *Gossip Girl*'s male and female student bodies are as hard as their skin is moist, and the show has but one mission in dressing them: showing them off.

"I was like a creepy stalker outside Chapin [an all-girl's private school on East End Avenue where the tuition is $60,000 a year] with a small Canon, taking pictures of these sweet girls in Marc Jacobs dresses and knapsacks with Tory Burch flats, standing opposite a group of Balenciaga goth girls," Damon recalls. "You know everyone had paid full price for everything."[169]

Then Daman got to play with his own living dolls. "I read the *Gossip Girl* books and learned that Blair Waldorf led a lost childhood, so I decided to give her baby-doll shapes. Her trademark headband came out of that. It was like her Linus blanket. Serena is more like Kate Moss, shiny and confident. Someone who would spend a fortune and many hours to look like she had done nothing at all. She just woke up this beautiful. Serena and Kate have that 'it' factor."[170]

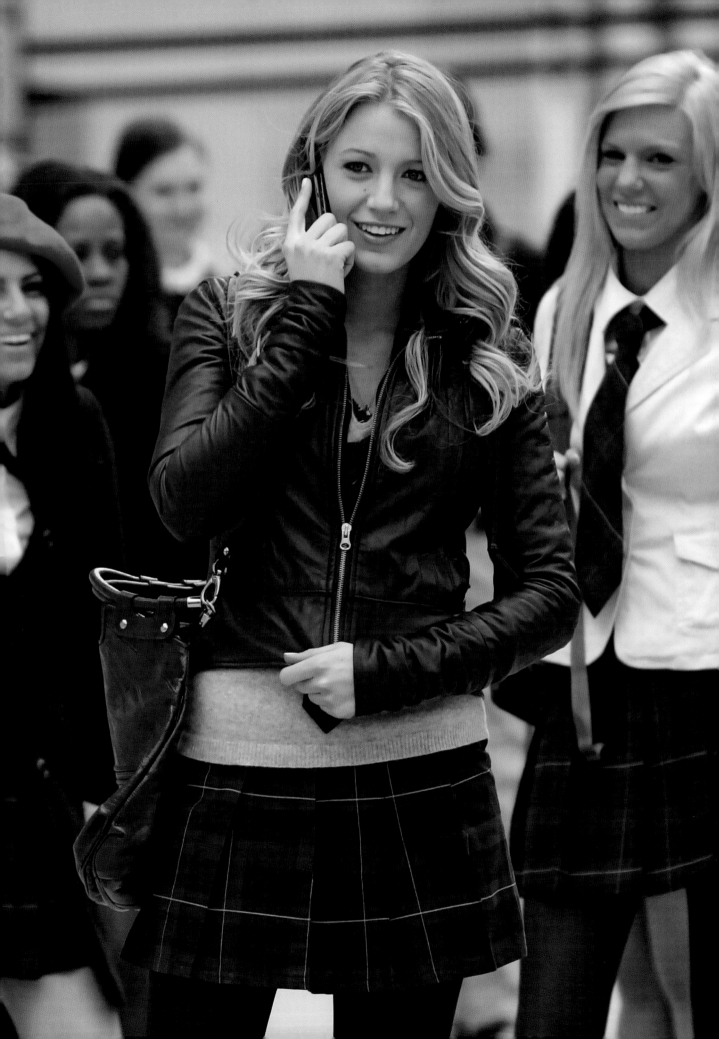

Daman also had the rare opportunity to dress men in more than just well-tailored suits. "Chace [Crawford] is a beautiful all-American Texan," says Daman. "Throw him in some Nantucket sailor sweaters and distressed khakis from Brooks Brothers, and Nate [Archibald] is good to go with a Waspy Martha's Vineyard kind of rumpled look, like he's been out yachting all day. For Penn [Badgley] it was a different, warmer palette. Dan is an intellectual, arty and poetic in corduroy and tweed, with herringbone vests. He would have lived in Williamsburg when it had a really rough vibe. A world apart from his spoiled classmates.

"Chuck [Ed Westwick] is a surly, bourbon-swilling teenager. The perfect face of entitlement. He may be the character I'm most proud of, for introducing stronger menswear on a straight male, [by] wearing a pink suit and ascot and not looking like *Three's Company*'s Mr. Roper. Ed's a Brit, so he had a different understanding of clothes. But I did feel bad, because Ed wore ascots before he was on the *Gossip Girl*, but since it became Chuck's trademark, he can never wear them again."[171]

As is standard with new fashion-driven shows, but especially for a network as small and light on clout as the CW, the first season featured a lot of banging on doors: Century 21, Filene's, and Loehmann's. Borrowing clothes for TV is not the same as calling them in for a photo shoot because, they often have to be held for six weeks, and worn for hours at a time. Runway samples are not made for wear and tear.

But a writers' strike around holiday season in 2007 worked in the show's favor. The network used the time for a publicity blitz, sending the kids wherever there were paparazzi, saturating social media with *Gossip*'s uniformly attractive cast, running the early episodes again. Daman recalls, that "when we came back for season two, Chanel said yes, and that was the key that opened doors. Plus, Anna Wintour's daughter, Bee Shaffer, was a fan of the show. Suddenly, Blake is having lunch with Anna and Karl [Lagerfeld]. Suddenly stuff in boxes from Fendi and Ferragamo would show up. We hadn't even requested it. Young American designers called. That really mattered. *InStyle* magazine was covering us every week, doing full reviews of looks, places to shop, covering where the kids were hanging out. It was really a magical moment in time."[172]

The two main actresses took different approaches to their characters. "From the get-go, Blake was very hungry to learn about style," says Daman. "She knew exactly where the skirt should hit her knee; it was amazing to watch her begin to understand her body. Leighton was more an old-soul actor. I was the designer, and she

wanted me to create Blair for her. Leighton and Blair are very different people. She's a rock singer, much edgier in real life. (And married to Adam Brody, our favorite nerd from *The O.C.*) For Blake as Serena, it was more symbiotic."[173]

Nanette Lepore, Tory Burch, and Anna Sui confirmed that clothes from their collections that were shown on the series sold out or went on back order, but sales have never been part of *Gossip Girl*'s mission. "We just want to share the excitement we feel when we see great clothes."[174]

Daman is the costume designer on the new reboot as well. The clothes are younger, and more casual this time around. "Fashion is in a different place right now. But remember, we're still shooting. We're still here to show off. And we will. Stay tuned."[175]

I want this man's job.

A CONVERSATION WITH ERIC DAMAN

You're now working on the reboot of *Gossip Girl*. Is your approach any different?

Not really. I'm a teen girl at heart, so I want the show to be a living editorial and change the face of network television. (*Sex and the City* was on cable.)

Like so many of your contemporaries, you worked for Patricia Field. What did she teach you that still sticks?

Pat is always pushing limits, and how the illusion is what matters most. I remember modeling in a Calvin Klein campaign for the great stylist Joe McKenna. He put me in an agnès b. suit. I asked, why am I

wearing an agnès b. suit in a Calvin campaign? Joe replied, "Because it's a better suit." And then moved on. It's like how Sarah Jessica Parker knows exactly which size sequin is going to read better on the other side of the camera. Understand the power of your illusions.

Are actors usually as savvy about their costumes?

No. Men are bad about knowing what's best for them. They will come in for fittings, give me their shirt sizes, and I'm like, "No, I shouldn't be able to get three fingers inside your collar." But you have to be gentler with men, make them think they are getting their way. So, you try to be the reed in the river and

not the rock. Try saying no to an actor. You won't get anywhere.

What do you say to critics that deride both editions of *Gossip Girl* for not being realistic?

How can you watch this show and possibly think we are going for realism? When Serena was getting married to Dan at home in the finale of the original *Gossip Girl*, we put her in a gold-drenched Georges Chakra wedding gown. She could barely make it down the staircase. The dress belonged in St. Patrick's Cathedral. But Blake looked amazing. That's all that mattered. And that's all that should. It's not a style seminar. It's entertainment.[176]

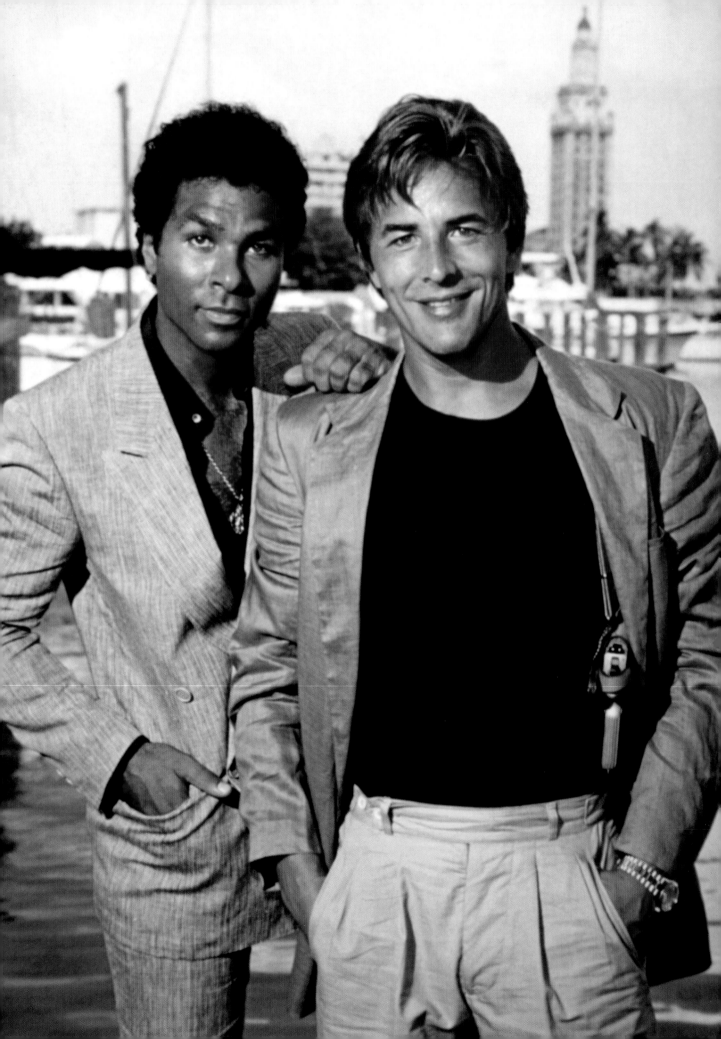

Does This Shoulder Holster Make Me Look Fat?

FIGHTING CRIME, LOOKING SUBLIME

The Avengers

TELECAST *from* **1961–1969** *on* **ABC**

STARRING: Patrick Macnee, Diana Rigg

COSTUME DESIGNER: John Bates

- -

*A pair of British spies. More reserved than Bond.
And more twisted.*

THE *AVENGERS* RAN FOR NINE YEARS IN the UK. The series began with two men in the leads. Then John Steed was joined by Honor Blackman as Dr. Catherine Gale, his first female partner. She left to play Pussy Galore in *Goldfinger*. Linda Thorson was Tara King, Steed's last partner. But it's the woman who came in between Blackman and Thorson who transformed *The Avengers* into the saucy, kinky, racily clad show that fans recall with such fondness. Diana Rigg, the incredibly beautiful, socially iconoclastic, Shakespearean-trained actress instantly implanted Emma Peel as the mythic star of more male fantasies than any brunette since Ava Gardner.

The Avengers was set in a dreamily unreal England where the sun shone often, gardens were bountiful, and every man was perfectly attired for a game of snooker. Threatening this merry old Lewis Carroll dreamscape were

dastardly evil masterminds, each equipped to blow up the entire Commonwealth in minutes, always sure that Steed would be unable to stop them. Steed, however, remained unflappable, able to disarm his foes and be done in time for high tea.

Steed and Peel were a marvelous team. Macnee was the personification of how Americans imagined a cultured Englishman to look and sound, from his precisely tailored suits to his clipped, lilting speech. Rigg, however, was a woman no American had ever seen before on TV. She was even smarter than Steed, resilient, resistant to romantic entanglement (Peel and Steed's flirting never went beyond innuendo), and dressed as fiercely as someone who got a kick out of a little S&M before most Americans knew what the abbreviation meant.

Since England in the mid-sixties was Mod central, designer John Bates dressed Rigg in extremely short

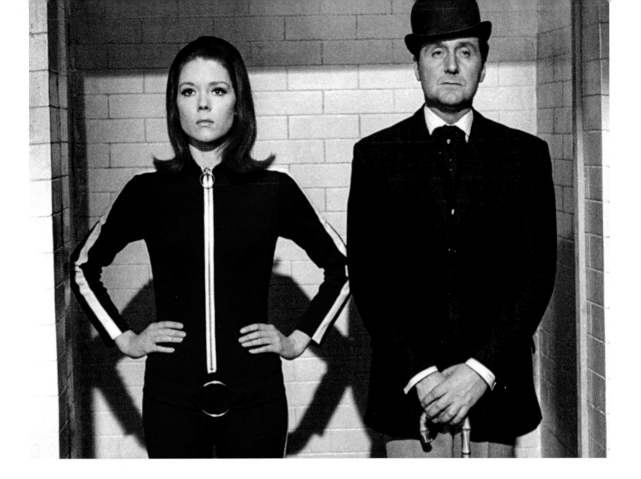

minis before they had become acceptable in the main-stream, deliberately constructing them with no hems so the on-set production team couldn't lengthen them. But Bates raised Rigg to fashion iconography on a par with Mary Quant and Twiggy when the two conspired to outfit her in fetishistic, skintight PVC jumpsuits, low-rise hipster trousers, body-hugging black pullovers with strategic zippers, and ultimately a leather catsuit that fit the definition of dominatrix uniform, though no one ever used the term.

The look had such a startling impact that for her second season, designer Frederick Starke created a complete leather and faux-leather wardrobe that became Peel's go-to look, whether engaging in kung fu or a late-night brandy. Only once did her gear run afoul of the censors: in an episode called "A Touch of Brimstone," Rigg outfitted herself to go undercover at a Hellfire Club as the Queen of Sin, in thigh-high leather boots, a strapless black leather corset with a high-cut leg, a kinky collar of protruding nails, and a long single-lash whip. Rigg did appear on air in the outfit, but when her evil antagonist snatched away the whip and began to use it on her, the censors yelled "cut."

Rigg's own feisty persona was more in concert than in contrast to Emma. When the American press asked her how it felt to be a trendsetter, she replied that she couldn't be having that much impact if men still weren't allowing women in restaurants in pantsuits. She lived with a series of long-term lovers, including one who was married to someone else during her time on *The Avengers*. "No man will ever conquer me or make me his slave," she wrote. "Nobody owns me. Nobody will. I don't yearn for security. Marriage might be fine for many people, but I find its permanence appalling."[177] She got married, once. Divorce was swift. She gave birth to her daughter when she was thirty-eight while living with the child's father, theatrical producer and former Scots Guard Archie Stirling, but no rings were exchanged.

In 1970, Rigg caused a sensation on both sides of the Atlantic when she starred with Keith Michell in a sumptuous, sensual production of *Abelard and Heloise*, the twelfth-century romance between a philosopher and his student, which included a dimly lit but passionate love scene in the nude. This was the first time major stars had disrobed in the West End or on Broadway. Rigg did not take kindly to the press reducing the play's value to a striptease.

"My body is no different than anybody else's," she told talk show host Dick Cavett. "In fact, stepping onstage without your knickers is the most difficult thing in the world. . . . I promise you it is. . . . It's against everything you've ever been taught. And the draft is incredible."[178]

In 1994, TV's first dominatrix became Dame Diana Rigg, a Commander of the Order of the British Empire.

The Man from U.N.C.L.E.

TELECAST *from* 1964–1968 *on* NBC

STARRING: Robert Vaughn, David McCallum, Leo G. Carroll

- -

James Bond, American style: spies who came in from the cold by way of our living rooms.

HEN COMEDIAN MILTON BERLE launched his variety show *Texaco Star Theater* on NBC in 1948, there were only 500,000 television sets in America (mainly in New York City). By the show's end in 1956, the number of screens had risen to 26 million. The network was so sure our Uncle Miltie was the reason for the surge that they signed Mr. Television (another nickname) to an unprecedented, exclusive thirty-year contract. However, after renegotiating his contract to appear on other networks, Berle returned to television in 1966 with another variety show on ABC. Evidently gratitude is even more fleeting than fame in show business, because Berle got trounced in the ratings by a new series on his alma mater network—*The Man from U.N.C.L.E.*

Why was *TMFU* such an instant global hit? Three words explain it: "Bond. James Bond." In 1961, soon after *Life* magazine published a list of President John Kennedy's favorite books that included *From Russia with Love*, Ian Fleming's spy novels became bestsellers in the United States. The first Bond film, *Dr. No*, premiered the next year, riveting viewers' attention to Sean Connery's smoldering gaze, brogue, bottom lip, and Mr. Universe third-runner-up (in 1953) physique. Added drool came courtesy of Ursula Andress's belted white bikini with dangling dagger. In 1963 a better Bond movie, *From Russia with Love*, as well as *The Spy Who Came in from the Cold*, a superb film adaptation of John le Carré's masterful exposé of the dark side of espionage, were box-office hits. By the time *Goldfinger*, one of the best in the Bond

series, premiered early in 1964, Bond was a worldwide phenomenon, and spy films became the favorite new genre of young moviegoers.

How could television resist? Of course, it couldn't. *The Man from U.N.C.L.E.*, the medium's first entry in the genre, was met with immediate rapture. Looking at the series now, with its flat, gray sets accented by boxes studded with blinking Christmas lights meant to evoke the ultimate in computer technology, it's a stretch to believe the United Network Command for Law and Enforcement (the name was invented *after* the acronym was chosen) was a hotbed of international intrigue. As in the Bond films, its heroes battled a SPECTRE-like nemesis called THRUSH. But unlike them, the series was devoid of authentic locations in Greece, Spain, the Soviet Union, and beyond. *U.N.C.L.E.* never left Metro-Goldwyn-Mayer's soundstages number two and three.

And yet viewers were all in for the ride because the one key Bondian element the show got right was the delicate balance of serious intent flecked with flashes of deadpan humor. For that, Ian Fleming deserves credit. *U.N.C.L.E.* can't be dismissed as a rip-off because Fleming, a good friend of series producer Norman Felton, approved *U.N.C.L.E.*'s initial plotlines and even gave the lead character his name: Napoleon Solo.

And to that lead role Robert Vaughn—an actor with a long history of TV credits, though almost always cast as the bad guy—brought the requisite flat, slightly sinister voice, rarely registering emotion yet perfectly pitched for understated sarcasm. Playing opposite him was David McCallum, a British actor cast as a Russian attaché to *U.N.C.L.E.* and bearing the inspired moniker Illya Kuryakin. McCallum started the series as a minor player but was quickly elevated to costar status because his physical stillness amplified the character's mysterious, never explained background or raison d'être as a Cold Warrior working for our side, and because his lean body and distinctive bowl haircut earned him the nickname the Blond Beatle, with the requisite accompanying frenzy.

Unlike Connery's Bond, Solo and Kuryakin were never shirtless, but like Bond, their uncredited wardrobes were sleekly tailored for sleuthing. Vaughn was consistently clad in gray sharkskin and slate blue single-buttoned suits with skinny ties and a Kennedyesque haircut. Kuryakin was often suited in black, alternating white button-downs and skinny black ties with an array of turtlenecks, which traditionally have signaled rebellious iconoclasts (Marlon Brando, Steve Jobs, Steve McQueen, Andy Warhol, Angela Davis) and served as a reminder of Russia's bitter winters. Sales of men's turtlenecks soared,

as did the volume of fan mail for the two *U.N.C.L.E.* stars, who by the second season were receiving seventy thousand pieces of fan mail a month—more than even Clark Gable had ever received when he was the reigning male star at MGM during Hollywood's Golden Age. Vaughn recounts landing at London's Heathrow Airport at midnight, not an hour one would expect to find many fans in waiting. Five thousand women greeted Vaughn when he stepped onto the tarmac.

The reason Vaughn went to London was to test the effectiveness of a new network strategy—visual merchandising. Both stars were sent around the world to promote the series in foreign markets and to drive the sale of lunchboxes, pencil sharpeners, watches, and thermoses. Such items sold in the millions. Unaware of its potential, Vaughn and McCallum never saw a nickel from the merchandising. After *U.N.C.L.E.*, Vaughn continued to appear in other television series. McCallum left Hollywood for good. At the time of this writing, a *Man from U.N.C.L.E.* lunchbox can be bought on eBay for a thousand dollars.

The Wild Wild West

TELECAST *from* 1965–1969 *on* CBS

STARRING: Robert Conrad, Ross Martin

COSTUME DESIGNERS: Jack Muhs, Vou Lee Giokaris, Paula Giokaris

- -

Fighting lawlessness in the territories after the Civil War, armed with fantastical gadgets, a superlative wardrobe, a very cool train, and more than one memorable caboose.

WHEN WRITING ABOUT *BEWITCHED* (see page 79), I stated that for men of my generation, two characters sparked such rabid fascination that the only way to explain the attraction was to realize you were gay. Agnes Moorehead's flamboyant, caftan-clad Endora was the first character I adored. The second object of my projection was Robert Conrad's Jim West.

The Wild Wild West was a clever, handsomely produced amalgam of two TV genres, one waxing, the other waning but still potent. James West and Artemus Gordon (Ross Martin) were Secret Service agents sent by President Ulysses S. Grant to root out and vanquish crime in the American territories. So the fisticuffs and gunfights made the show look like a western, the genre that dominated television in the '60s. But the two men spied on and vanquished their enemies utilizing Gordon's elaborate disguises to go undercover and ingenious gadgeteering that *The Man from U.N.C.L.E.*'s Napoleon Solo and Illya Kuryakin would envy: a bullet-studded belt buckle, a derringer that popped out of West's coat sleeve, a bomb hidden in his boot heel, and a jeweler's case with a carrier pigeon in a secret bottom drawer.

But the show's best visual effect was the star himself. Though only five-foot-eight, Robert Conrad was slyly photographed to appear almost equal in height to his costar, Martin, who was five-eleven. Despite his lack of elevation, Conrad was the handsomest and best-built man on television, with aquamarine eyes, a gleaming shock of pompadoured hair, a rich, raspy baritone that could have afforded him a second career in phone sex, and such a consistent drive to display his virility and dexterity that he is one of the few actors ever to be inducted into Hollywood's Stuntmen's Hall of Fame.

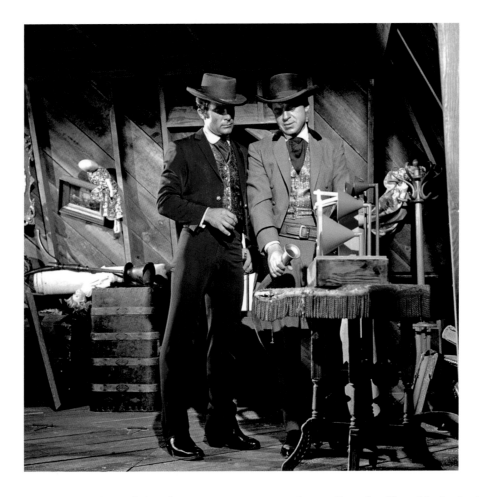

What's more, though he often rode into dusty towns on horseback, Conrad arrived as spotless as if he'd taken an Uber, and never in cowboy attire. Instead, Conrad dressed sensationally in what's now known as steampunk fashion. Steampunk is a subgenre of stylized Victoriana that reflects the machine-driven sense of sophisticated fantasy found in the work of Jules Verne (*20,000 Leagues Under the Sea*) and H. G. Wells (*The Time Machine*). Against the backdrop of his private steam engine, West wore saturated peacock and sapphire blue, lilac, or purple custom-made suits in brushed wool or corduroy, featuring cropped one-button or double-breasted bolero jackets (to add length to his legs) with shawl or peaked collars. These were layered over an intricately brocaded vest and a spread white collar framing a pleated, jewel-tone satin ascot or foulard—often with a stickpin—and topped by a wide black gambler's hat with an upturned brim instead of a Stetson. He was stunning.

Yet somehow, for myriad reasons, Jim West managed to wind up shirtless in almost every episode, and frequently placed in fetishistic bondage. All Conrad would have left on were the tightest high-waisted matador pants any man—no, make that any human—has worn in any medium. The site Urban Dictionary bluntly but accurately pegs Conrad as "famed for having the sexiest butt ever on film."[179]

Conrad's pants were so second skin that rear closeups occasionally reveal a visible panty line. A fight scene early in the series tore the crotch of one pair and exposed an obvious tighty-whitey; subsequently Conrad's underwear was often dyed to match his pants so fight scenes would not have to stop for repairs or reshoots. The high point of Conrad's sanctioned narcissism occurs during a third-season episode called "Night of the Falcon." Suspense is meant to mount as West dashes to dismantle an enormous bird-of-prey-shaped cannon before it blows up Denver, but the race against time is giddily sabotaged by the titillating distraction of Conrad clenching his delts and glutes clad in an extraordinarily high-cut, butt-caressing pair of leather chaps. His strain is so captivating, one is almost sorry to see him succeed.

To his credit, Conrad never feigned innocence about his wardrobe. His producer, who was gay, knew his audience, and the actor was happy to comply. Curiously enough, *The Wild Wild West* was canceled as a scapegoat during an overpublicized panic about excessive violence on television. Funny, I don't remember it that way. But then, I wasn't looking at anyone's fists.

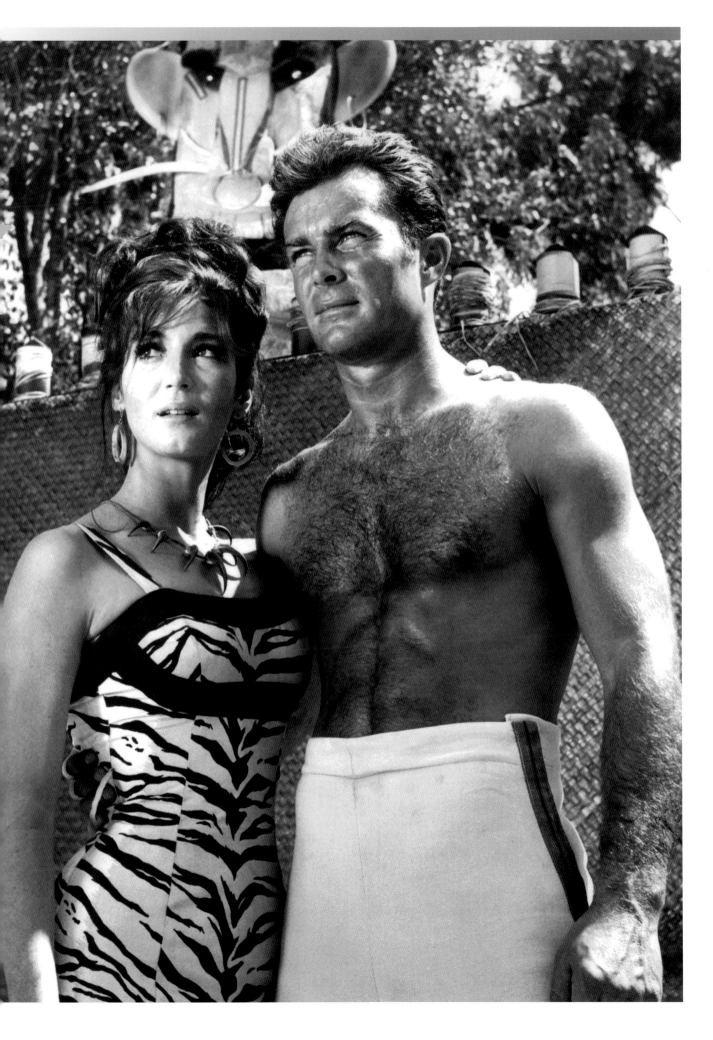

Charlie's Angels

TELECAST *from* 1976–1981 *on* ABC

STARRING: Kate Jackson, Jaclyn Smith, Farrah Fawcett,
Cheryl Ladd, Shelley Hack, Tanya Roberts, David Doyle

COSTUME DESIGNER: Nolan Miller

- -

*A mystery man named Charlie dispatches his three female
detectives' assignments via speakerphone.*

PRODUCERS AARON SPELLING AND LEONard Goldberg brought their idea for a series about three female detectives to Barry Diller, their boss at ABC. Diller's assistant, Michael Eisner (the future CEO of Disney), immediately dismissed the concept, citing the futility of a prime-time action show starring three women, since it was assumed that men controlled the remote at night. Spelling told the Television Academy interviewer that Diller was so turned off by the name of the show, *Alley Cats*, he told the producers "they should be ashamed of themselves."[180]

Diller also griped that since the script offered no clue as to who these women were, the audience wouldn't connect with them. So Spelling made up a backstory on the spot about the trio having graduated from LA's police academy but quitting the force after being assigned menial jobs like meter maid, school crossing guard, and typist.

They were now working as private investigators for a rich, unseen benefactor named Charlie. Placated but still unenthusiastic, Diller greenlit the project based on Spelling and Goldberg's track record (*The Rookies, The Mod Squad, Starsky & Hutch*) but paid scant attention to the show's development—or its casting of *Rookies* veteran Kate Jackson, Breck (shampoo) Girl Jaclyn Smith, and Farrah Fawcett, a young beauty with a rising profile thanks to her presence in multiple national commercials, including the 1973 Noxzema shave cream ad with football star Joe Namath that launched the Superbowl advertising frenzy.

Over 50 percent of America's viewing audience tuned into the opening episode of *Charlie's Angels*. The show was a smash even before anyone donned a bikini. It's important to note that there were none in the opener; all three Angels were dressed in casual ensembles, covered head to toe.

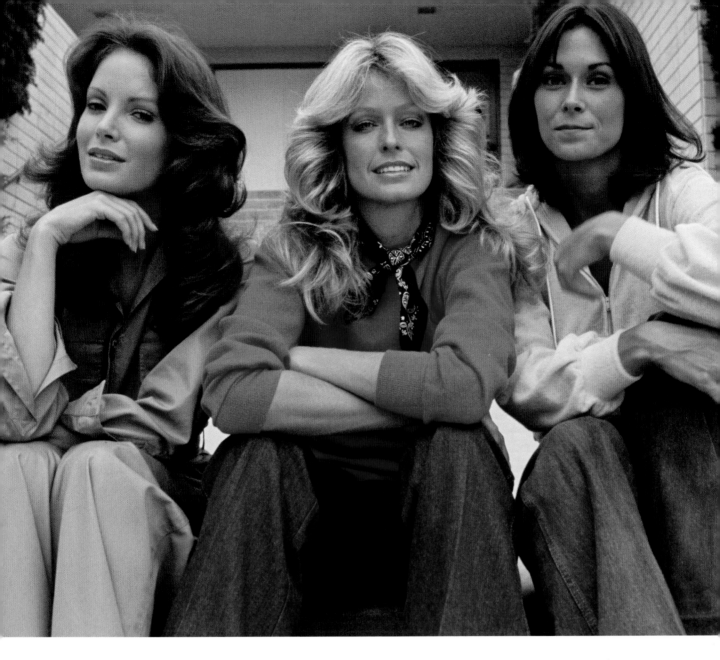

And yet *Charlie's Angels* became one of the most stylistically polarizing series in memory. It was immediately derided by snarky critics as the birth of "jiggle TV." Women's rights groups attacked the format as misogynistic, labeling Charlie a pimp and the women braless Barbies with handguns, which is pretty disingenuous when one recalls that going braless was women's lib's most obvious act of defiance during the '70s. And if jiggling is an implied lead-in to wriggling, how come not one scene in all 115 episodes of *Charlie's Angels* contains an Angel waking up in bed alongside a man?

Though we were midway through the free-love decade, there remained a Calvinist, male-driven double standard regarding who could be sexy on TV. Patrick Duffy was frequently bare-chested on *Man from Atlantis* (1977); Erik Estrada was aiming for the title of most shirtless cop in America on *CHiPs* (1977). Burt Reynolds

enhanced his star power lying bare-ass on a bearskin rug for *Cosmopolitan* in 1972. No one flung the word "objectification" at any of these guys. Yes, the Angels sometimes took on missions to expose mob-run strip clubs, crooked massage parlors, or amoral playboys, all of which would require one or more of the women to dress sexily. But where was the crime in reveling in their inarguable beauty, especially when they were also the smartest people in the room?

"Men can do anything. Women can't," recalls costume designer Nolan Miller. "But we never got one letter about being unfair to women. It just proves that Hollywood doesn't always understand its audience."[181]

Confirming Miller's observation is that the bulk of *Angels'* devoted viewership were prepubescent and teen girls, who immediately embraced Sabrina, Kelly, and Jill as role models based on their astute crime solving,

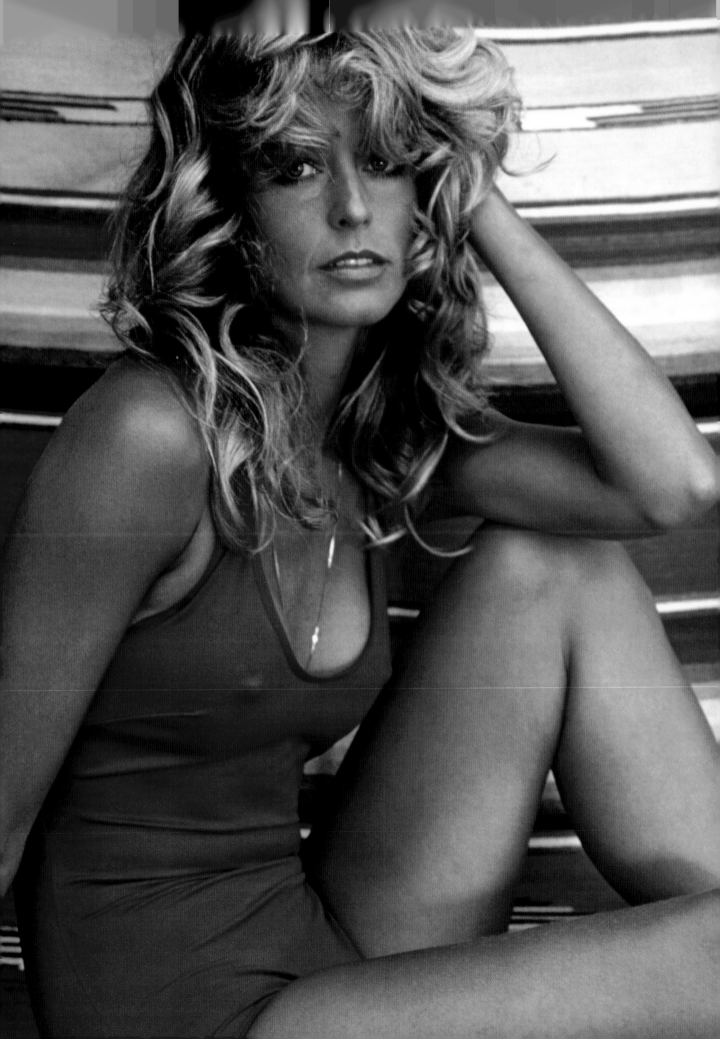

individuality, lack of dependence on men, but most of all their steadfast loyalty to each other. *Charlie's Angels* was the medium's first depiction of women working as a united front.

The Angels weren't interchangeable. "Kate was the leader, the analyst. She also hated clothes," recalls Miller. "Kate always wanted to be casual . . . didn't like wearing heels . . . was constantly telling the cameraman not to shoot her feet. She loved wearing jeans and turtleneck sweaters. Maybe because she had a kind of scrawny neck. But we must have bought her over a hundred black sweaters."[182]

Miller found less resistance dressing the other two Angels. "Jaclyn had such good, classic taste. Not flamboyant at all. That was her niche. Farrah was the eight-by-ten glossy. She loved clothes. She would haunt Rodeo Drive and give me a list of things she wanted on Monday. We'd go way over budget, but then, Farrah was the phenomenon."[183]

Angels' immediate top-ten status took the cast, the producers, even the network by surprise. The actresses' lives were upended. Privacy was impossible, and gossip columns forever hinted at rifts and jealousy. "We were frequently fighting in the *National Enquirer*. None of it was true," says Smith. "We were friends and trusted each other."[184]

But the meteoric obsession with all things Farrah was unlike anything a female star on television had or has ever experienced. Women of every hair color and texture, skin color, and race went in search of the largest hair rollers they could find to reproduce Farrah's cascading feathered shag. In 1978 she released her own line of shampoos produced by Fabergé.

But it was the poster that cemented her first-among-equals fame. It was Fawcett's idea, independent of Spelling, Goldberg, and the network. She was photographed by Bruce McBroom in her home. There was no stylist. Fawcett did her own hair and makeup and posed in clothes chosen from her own closet, but McBroom felt he wasn't capturing the image he wanted. He asked if she had a bikini. Fawcett said no, she never wore them (contrary to insistent belief, she never even wore a bathing suit on *Angels*), adding that she wanted to look more happy than sexy. After another trip to her closet, she came downstairs in a scarlet scoop-neck Norma Kamali tank suit, and McBroom snapped away.

The poster was released midway through the show's first season. Five million copies were sold during the first year. Kamali, who liked Fawcett and regarded her as a good customer, was initially horrified by the poster as she felt the design of the suit was flawed, so she did a quick redesign as thousands of orders amassed in her showroom. (The original is on display at the Smithsonian.) Eventually selling 12 million copies, Fawcett's portrait remains the bestselling poster of all time. She had shrewdly signed on for 10 percent of the profits. Fawcett made five thousand dollars a week on *Angels*. She made four hundred thousand from the poster.

Encouraged by her husband, the actor Lee Majors, and offers galore, Fawcett wanted out of her contract. Spelling and the network filed a seven-million-dollar lawsuit, but they were hoping to negotiate rather than alienate. Eventually they settled with the actress, who agreed to make six more appearances on the show at a then undisclosed salary (it was one million dollars).

After five years and an eventual six Angels, it was time for Charlie to hang up the phone and for Spelling to build an incredible TV empire with shows like *Dynasty* and *Beverly Hills 90210*. Miller claims to have loved all six of his Angels but admits the replacements were nothing like the originals. He cites Bette Davis's claim that you could spot a star because stardust is more discernable than talent. "Look into their windows," Davis said. "If you see a reflection of yourself, no stardust. If you can see into their souls, they have stardust." Well, those girls had it.[185]

Magnum P.I.

TELECAST *from 1980–1988 on* CBS

STARRING: Tom Selleck, John Hillerman

COSTUME DESIGNER: Pacific Clothing Company

He's dressed for a day at the beach, but the guy is a private investigator.

WAS IT JUST ABOUT THE MUSTACHE? True, his is the defining swath of '80s lip foliage, still appropriated by so many males during our current revival of facial hair that Tom Selleck's underbrush has multiple Facebook and Instagram accounts. More than ten websites are devoted to tips on how to grow, style, and maintain its iconic, just-over-the-upper-lip shape, called the chevron (and nicknamed the pornstache because so many '80s male porn stars grew one). But *Magnum P.I.*'s successful eight-year run was fueled by more factors than a burly, hirsute star who knew how to wield mustache wax.

After starring in seven unsold pilots, and a noteworthy story arc on *The Rockford Files* alongside his role model, James Garner, Tom Selleck was offered yet another pilot. *Magnum P.I.* was conceived to make use of the extensive facilities CBS had built on the island of Oahu for its recently canceled series *Hawaii Five-O*. There was only one problem: Selleck hated the script. Magnum was originally a crude riff on James Bond, described by producer/screenwriter Donald P. Bellisario in a Television Academy interview in 2008 as "an ex-CIA, who lived in a house on a cliff, and he had this ferocious killer dog who kept everybody at bay, and he would fly hang gliders with machine guns on the wings."[186]

This Magnum was all swagger, a buxom babe on each arm, joyriding round the island in a flashy car looking for a fight. Selleck contacted Bellisario, whose pilot scripts he had read and admired. The writer recalled that Selleck took issue with the role, saying, "I just don't want to play what I look like."[187] The actor asked Bellisario to rework a script the latter had written about an ex–Navy Seal who had fought in Vietnam and maintained friendships with his members of his platoon after the war.

Though that divisive and demoralizing conflict had ended in 1975, five years later vets were still uniformly depicted in plays and movies and on television as troubled souls, beset by PTSD, often dangerous to themselves and violent toward others. Selleck and Bellisario wanted to change this perception, to represent the millions of vets courageously working through scars and trauma to find productive ways to adapt to civilian life. The network reluctantly agreed to this backstory but asked that scripts refer to the war only tangentially. *Magnum* judiciously employed enough flashbacks to effectively portray the psyches of Thomas Magnum and his best buds, helicopter pilot Theodore "TC" Calvin (Roger Mosley) and Orville "Rick" Wright (Larry Manetti)—but whatever their flaws, they were unequivocally heroes, *Magnum*'s good guys. As Bellisario recalls, "The *Village Voice* did an article which said that they thought it was a seminal moment in television, a changing to an acceptance of Vietnam veterans that had been a long time coming . . . and *Magnum* was doing it."[188]

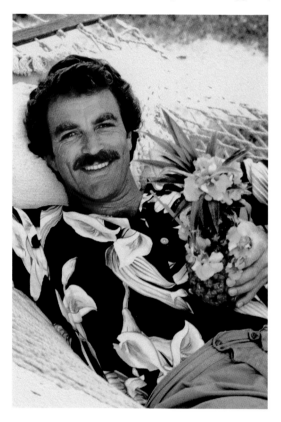

Magnum's visual style was also designed so that Selleck wasn't the series' only irresistible attraction. By 1980 the population of Honolulu was approaching a million. Never having been to the fiftieth state, Bellisario had written the pilot based on a 1955 Fodor's Travel Guide, so he and Selleck were shocked to discover a sprawling building boom crowding Honolulu's shoreline in the shadow of Diamond Head. In order to make it appear as if Magnum was working to preserve tranquility on his island paradise, the decision was made that outside the city center, locations would boast pristine, condo-free landscapes and untrodden beaches, with no structure taller than a palm tree. That's why *Magnum*'s Hawaii looks seductively idyllic, more like Tahiti.

And, like so many other shows in the '80s, *Magnum* beckoned with the advantages of aspirational wealth. With the new president's election in 1980, Reaganomics took hold, and a new strain of humanoids called yuppies began proliferating rapidly; their most notable trait was that they considered wealth and happiness

as synonymous. By 1982, Benjamin Stein in the *Wall Street Journal* calculated "that of the approximately 53 prime-time fictional shows set in the eighties . . . nearly 40 percent featured millionaires or the children of millionaires as primary players. . . . Millionaires (on prime-time TV) are far more common than [in] any other strata of society."[189]

Like *Charlie's Angels*, Magnum worked for an unseen millionaire named Robin Masters (Orson Welles was the disembodied voice) and lived rent free in the guest house of his palatial 8,500-square-foot oceanfront estate. Though Magnum tangled with the property's majordomo, Higgins (John Hillerman), he made full use of the lavish facilities and had keys to Masters's 1984 red Ferrari 308 GTS Quattrovalvole, valued at one hundred thousand dollars in today's market. You can imagine yuppies going limp and breathless at the sight of it, like wandering Jews getting their first glimpse of the Promised Land.

But more important than all of the above: yes, Tom Selleck was adorable, charming, hammy, goofy, funny, and effortlessly winning. As if the mustache and tumbling curls were not heart-quickening enough, Selleck wore a rotating assortment of colorful aloha shirts (the red Jungle Bird, blue Mini Anthurium, black Star Orchid, and purple Calla Lily patterns) from Pacific Clothing Company. The company wound up offering each pattern in ten colors to accommodate the demand. But what really made Selleck's look so striking was pairing the supple shirts with almost comically brief shorts on his six-foot-four frame.

"That's what shorts are," Selleck railed in his defense to Kelly Clarkson on her daytime talk show in 2022. "Shorts are short! And they're coming back up."[190]

Okay. Hawaiian shirts are definitely back. And some stars are hairier than ever. But if you don't have quads as thick as the man who had to turn down the role of Indiana Jones in favor of walking down a deserted beach in what we used to call hot pants, you should stick to Bermudas. Or a sarong.

Miami Vice

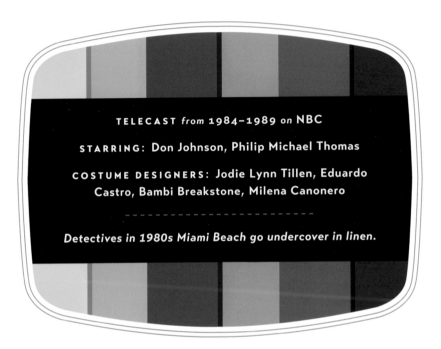

TELECAST *from* 1984–1989 *on* NBC

STARRING: Don Johnson, Philip Michael Thomas

COSTUME DESIGNERS: Jodie Lynn Tillen, Eduardo Castro, Bambi Breakstone, Milena Canonero

- -

Detectives in 1980s Miami Beach go undercover in linen.

WHEN ITS POPULARITY FIRST PEAKED in the mid-fifties, the era of curvaceous ivory palaces like the Fontainebleau, Eden Roc, and Diplomat Hotels, Miami Beach was hailed as the American Riviera. By the mid-eighties, the shoreline had eroded to resemble tundra, and the swinging nightclubbers in white tuxedo jackets and mink stoles had given way to so many seasonal retirees in housecoats and bathrobes that the city's new moniker was "God's waiting room."

Two seismic events came to Miami Beach's rescue. One was planned, the other a fortuitous accident. The planned change was facilitated by the Army Corps of Engineers, who decided to rebuild Miami's entire beachfront in 1985, making it wider and flatter and topping a concrete base with layers of fresh fine white sand.

The happy accident was the release of Brian De Palma's film *Scarface* in 1983. It's a ludicrously unbelievable, thoroughly mesmerizing, floridly operatic saga starring a hot-wired Al Pacino as a penniless Cuban immigrant who rapidly scales the apex of Miami's cocaine-crested mountaintops to become the drug lord of all he surveys. As subtle as a meth overdose, the film was initially trounced by critics (though now revered as a cinematic explosion of excess), but it was an immediate hit with the public. And because it portrayed Miami Beach as a glaring and garish Valhalla of dereliction where unchecked hedonism reigns, *Scarface* also made Miami appear as glamorous as it was volatile.

A year later *Scarface* inspired director Michael Mann to return to the scene of Pacino's crimes and craft a show that could satisfy the two-word mission given to him by Brandon Tartikoff, NBC's president of entertainment: "MTV cops." Mann's *Miami Vice* is an extraordinary and

unprecedented case of life imitating art. It's visuals were fresh and eye-catching, starting with the dashing profiles of Crockett and Tubbs (Don Johnson and Philip Michael Thomas) and their even more distinctive wardrobes. Taking her cue from the visually arresting music channel, costume designer Jodie Lynn Tillen opted for a sartorial palette replete with pale pastel jackets in linen and cotton, substituting soft silk T-shirts for button-downs and striped ties, and resorting to the formality of double-breasted suits only if they were linen in soft lavender, sea green, or taupe. "Though the clothes were dynamic, they were also organic," says costume designer Eduardo Castro, who joined *Vice* in its third season. "Miami can feel like a thousand degrees. So you cringe at the thought of wearing anything too tailored or tight. And in this heat you don't even want to wear shoes, let alone socks."[191]

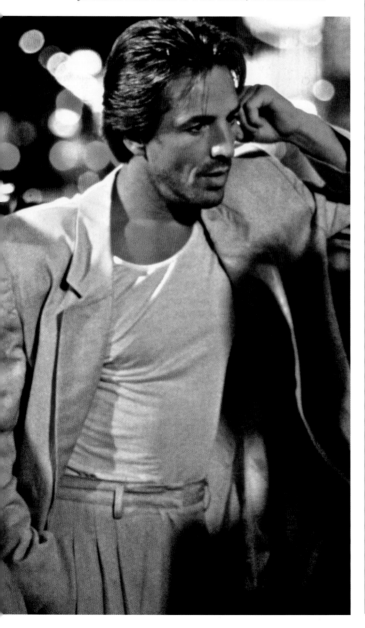

American designers were still focused on dressing President Reagan's titans of industry, so to source the clothes Tillen turned to the easy flow of menswear from such Milanese houses as Gianni Versace, Vittorio Ricci, Etro, and Hugo Boss. The late Kal Ruttenstein, visionary senior vice president of Bloomingdale's in the '80s and '90s, tagged *Vice* as being "the best thing to happen to Italian fashion."[192]

Crockett and Tubbs's wardrobe prompted a boom in linen and unconstructed jackets, colored Ts, slip-on loafers, blazers in every color except navy blue, and quadrupled the sale of Ray-Bans. Johnson can even claim credit for the continued ubiquity of the "stubble."

Though the sherbet-colored suitings proved game changing, they were the show's easy obstacle. Crockett and Tubbs were supposed to chase perps down beachside streets that matched their wardrobes, but the Art Deco–era buildings on Ocean Drive and Collins Avenue had become faded and dingy. So the *Vice* crew began repainting local streetscapes to make them more photogenic.

Just as tourists would pile into Magnolia Bakery because of Carrie Bradshaw's sweet tooth on *Sex and the City*, tourists flocked to Miami to take in the colorful city they savored on *Vice*. There wasn't much of it for those who got there early, but the show's success quickly generated a wave of support from the Miami Design Preservation League started by a driven local activist, Barbara Baer Capitman. She collaborated with inspired designers like Barbara Hulanicki, who created the transformative '60s department store Biba in London but was now a Miami resident, to realize the fantasy created by the series, even changing the locals' mode of dress from Lacoste shirts to hopsack sport jackets with pushed-up sleeves.

Miami Vice's rosy new look also attracted the lenses of high-fashion photographers such as Bruce Weber, Herb Ritts, and Pamela Hanson, whose agents and bookers were not only delighted by the low cost of shooting in Miami Beach but also couldn't resist the seemingly wall-to-wall landscape of hard-bodied, incredibly attractive young men and women whose sultry Latin heritage of sensually charged music, dance, and dress was a driving factor in the city's revitalization.

By the end of the show's run in 1989, every fashion magazine and label were shooting constantly in Miami Beach. As Gianni Versace marveled the first time he sat down and viewed the panorama passing before him at the centrally located News Cafe, "What a view, my darling! I am surrounded by beauty, beauty, beauty. I know where I want to be."[193] Thirty years later the city is still booming. *Miami Vice* made everything nice.

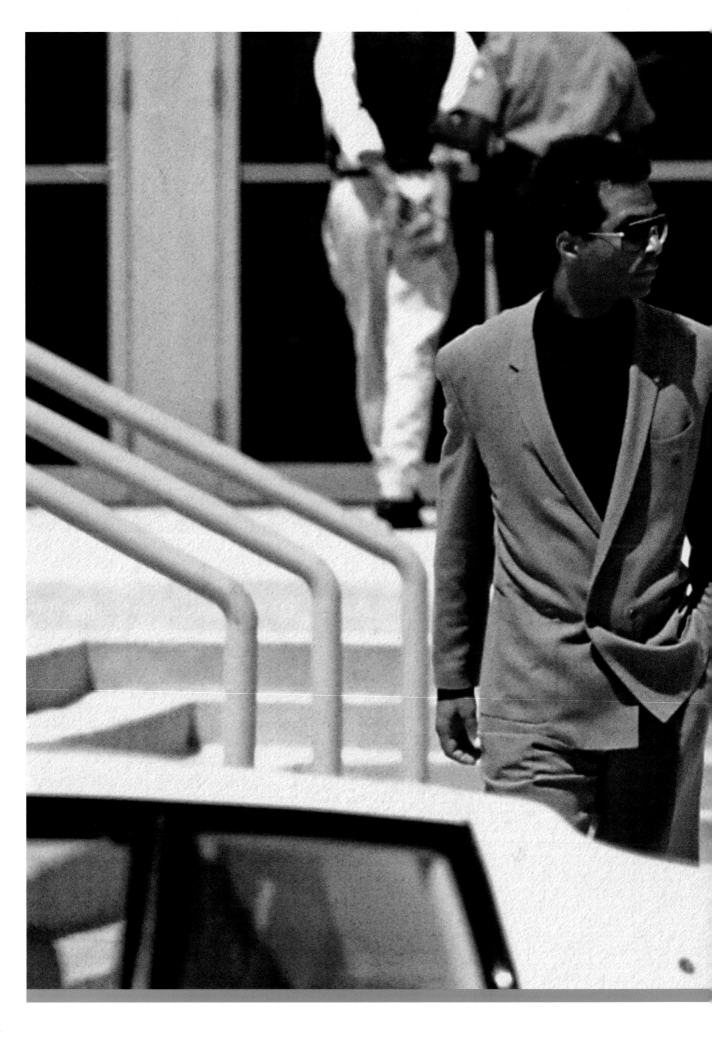

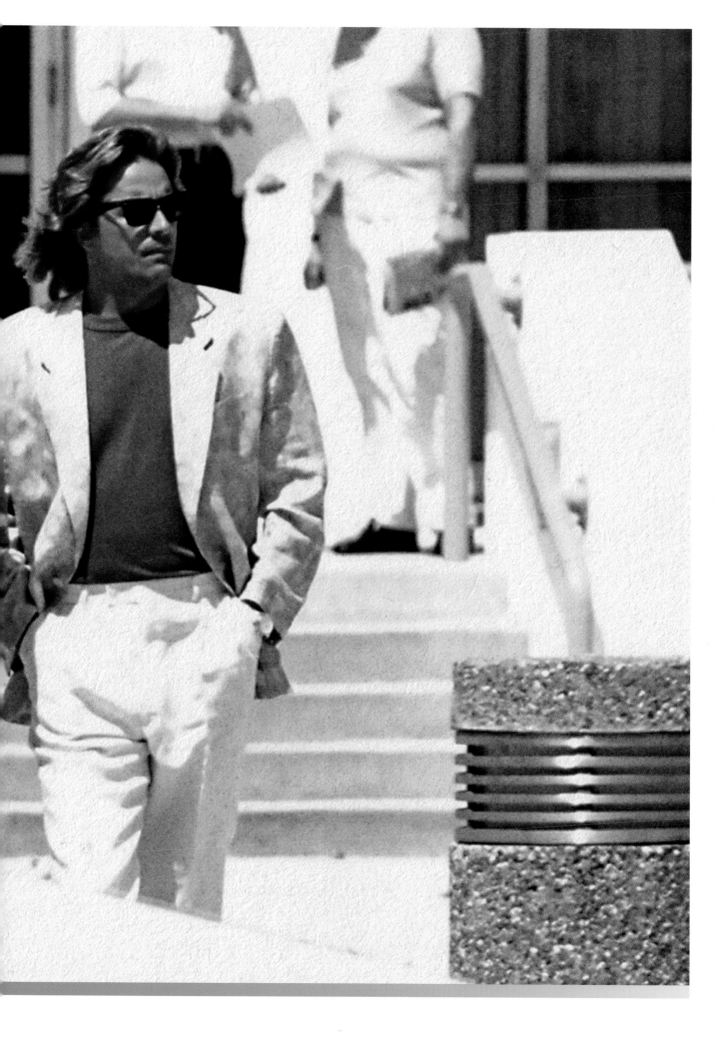

Moonlighting

TELECAST *from* 1985–1989 *on* ABC

STARRING: Cybill Shepherd, Bruce Willis

COSTUME DESIGNER: Robert Turturice

A former model inherits a detective agency run by a smart aleck.

T'S A SHAME THAT, AS OF THIS WRITING, no streaming service offers *Moonlighting* due to the show's failure to secure licensing of the vast cache of '80s music it cleverly employed as emotional underscoring. You can track down some episodes on YouTube, but we are currently denied access to one of the medium's most original, uncategorizable, and cinematically sophisticated productions.

Detectives were so ubiquitous on 1980s television that one might think there were more gumshoes than Billy Joel fans in America: *Miami Vice*; *Hart to Hart*; *Matlock*; *Remington Steele*; *Cagney & Lacey*; *Hunter*; *Hill Street Blues*; *Murder, She Wrote*; *21 Jump Street*; *T.J. Hooker*; *Mike Hammer*; and *Wiseguy* make up only a partial list.

So when ABC informed *Remington Steele* screenwriter Glenn Gordon Caron that they would bankroll a new company of his own if he would just write another

boy/girl private investigator caper, he was both flattered and frustrated. Financing your dream (as long as your dream is the same as ours) wasn't exactly irresistible, yet what Caron did find appealing was the promise that once he had an approved cast and concept, he could "do what you want with it."[194]

What Caron conjured for ABC was a treatment so unfamiliar and unexpected, it was like explaining a slide rule to a millennial. Inspired by a boisterous Shakespeare in the Park production of *The Taming of the Shrew* starring Meryl Streep and the late Raul Julia, Caron dreamed up the Blue Moon Detective Agency, which paired a cool, feisty beauty with a fast-talking smart ass. Together they would solve whodunits less by making use of guns and interrogation rooms and more by relying on crackling repartee filled with pop culture references, delivered at a breathlessly frenetic, staccato

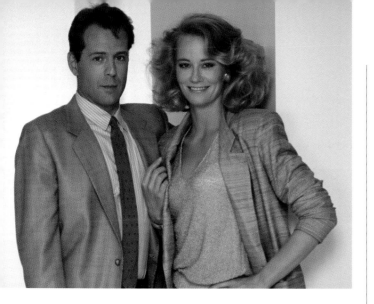

pace that recalled Howard Hawks's dazzling screwball comedies like *Bringing Up Baby* (1938) with Cary Grant and Katharine Hepburn or *His Girl Friday* with Grant and Rosalind Russell (1940).

Caron created his female lead, Maddie Hayes, specifically for Cybill Shepherd, the still radiant former 1968 Model of the Year who made a dynamic screen debut in *The Last Picture Show* (1971), directed by her former mentor and lover, Peter Bogdanovich, but whose career had stalled. And after interviewing more than eleven hundred applicants to play her partner, David Addison, Caron chose the last guy in, an off-Broadway actor with scant credits, a shaved head, two lobes full of earrings, and an attitude as cocky as his profession—a New York club bartender named Bruce Willis.

"There was a jazz about him," said Caron in an interview with the Television Academy. "The part was hard, extremely verbal, so dense. We did ninety-page scripts for a forty-four-minute episode [the average teleplay usually runs a page a minute]. He was one of only three actors who could do the role technically. I also was responding to what I was watching on television . . . this sort of sensitive guy everywhere. Alan Alda was the prototype. . . . But I was in my twenties and that wasn't my experience. Guys aren't sensitive. They want to have fun, and their world was much more sexually charged than that and less nice. And Bruce was this guy."[195]

But every time Caron brought "this guy" to ABC—and he did so eleven times—every male exec insisted he was not leading-man material. There was no way an all-American beauty like Cybill would fall for a guy who was so urban, brash, and flip and nowhere near as handsome and brawny as *Remington*'s chisel-jawed Pierce Brosnan.

Caron remembers persuading Shepherd to screen-test with Willis, and it was obvious they were a fun and feisty match, but the men in the boardroom still insisted that women wouldn't find Willis attractive. Finally Ann Daniel,

ABC's head of prime-time development and one of only two female execs at the network, cleared her throat and announced to Caron and everyone else in the room, "Look, I don't know if he's a TV star or not. I don't know if he's a leading man or not, but he sure looks like a dangerous fuck to me." Willis was hired.[196]

Though the ego clashes grew legendary as the show progressed, Shepherd and Willis generated electrifying chemistry, bantering the multilayered dialogue with delirious screwball swiftness and revealing a sexual attraction that had nothing to do with Caron's terrific screenwriting. Despite their increasing off-camera antipathy, or maybe because of it, Shepherd and Willis were a bewitching couple. In between a recurring motif of slamming doors that punctuated the hotheadedness of these volatile stars, Caron came up with spectacular ways to upend the genre's format. One show was a riff on *The Taming of the Shrew* with the script completely written in iambic pentameter. Another hour featured song and dance sequences staged by Stanley Donen, director of the best movie musical ever, *Singin' in the Rain*. The leads would often break the fourth wall and talk directly to the audience or invade each other's subconscious as animated characters. Orson Welles was brought in to introduce a "he said, she said" tale of murder shot entirely film-noir style in grainy black and white. The shows were dazzling, often taking two weeks to shoot a script and spending more than $1.6 million per episode.

Costume designer Robert Turturice was handed a hefty wardrobe budget, and at first he dressed Willis in Milan's best menswear—Giorgio Armani, Ermenegildo Zegna, and Cerruti—until the constant need for stunt work and outfitting body doubles made it easier to make his clothes from scratch. Turturice went all out for Shepherd, spending thousands per outfit and showcasing her broad-shouldered beauty in a Rose Parade of pale, creamy pastel suits, belted wrap dresses, and strapless gowns always rendered in silk.

By 1989, his role in the movie *Die Hard* had propelled the bartender who didn't have the right stuff into one of the world's biggest box office stars. Shepherd's biological clock sounded the alarm, and she became pregnant with twins. Caron had already quit the series after a fallout with Shepherd. And the film crew grew exhausted trying to keep the feuding stars' trailers far enough apart on the set and replacing the doors that by now were furiously flying off their hinges. Shepherd went on to star in her own successful sitcom, and Willis kept dying harder and harder until finally he could only see dead people (*The Sixth Sense*, 1999).

But nothing else these two did will top the glow they created in the Moonlight.

White Collar

TELECAST *from* 2009–2014 *on the* USA NETWORK

STARRING: Matt Bomer, Tim DeKay

COSTUME DESIGNERS: Stephanie Maslansky,
Karen Malecki

- -

A suave con man is coerced to work for the FBI.

MATT BOMER'S CLOSET IN *WHITE COLLAR* is the nonpareil result of observing the essential word that should be front and center for every man outfitting himself for success and impact: *timelessness*. The return-to-volume and fluid draping that are currently invading vanguard menswear runways like Gucci, Prada, and Louis Vuitton, may command attention now but, just as this silhouette previously dominated the '90s, it's destined to wind up at a resale shop before the buttons come loose. Similarly, the nipped, flashy guise of Sinatra's Rat Pack was once the hallmark of cool, but now registers as amusing vintage costume.

As Neil Caffrey, Bomer's sleek, leanly tailored, understated wardrobe, however, was perfectly pitched to dress this relentless charmer and virtuoso liar who was keenly aware that he had only minutes to secure someone's confidence. Every element of his wardrobe had to radiate flattering, low-frequency, flourish-free harmony, a gentler, less intimidating version of the dynamic suitings adopted by all those *Mad Men*. The result is that though *White Collar* went off the air in 2014, Bomer, who still owns most of the wardrobe, could show up anywhere tonight in one of his onscreen outfits and still be the best dressed guy in the room.

"Men and women look their best when their clothes are perfectly fitted and uncomplicated," states one of *Collar*'s costume designers, Stephanie Maslansky. "Slim suits, which made a welcome return in 2008, not only show off a man's body best, but the subtle patterns and weaves, the high armholes and narrow lapels never take attention away from the face. And when you have a face like Matt Bomer's, why would you put him in anything to distract from it?"[197]

The labels that suited Caffrey best were Paul Smith, Michael Kors, St. Laurent, Hugo Boss, John Varvatos,

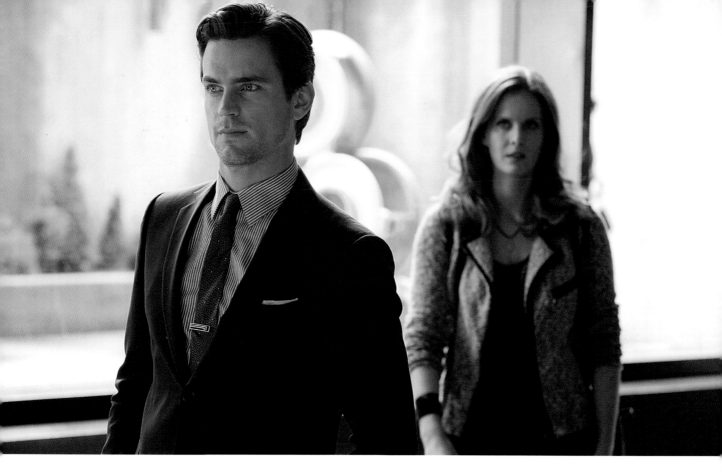

Tom Ford, and bespoke American tailors like Alton Lane and Michael Andress. Bomer admits, "When I got the job, I had about two suits to my name. I was raw clay, I had everything to learn. But trying on the clothing was the key for developing the walk for the character, for holding myself a specific way, standing a step back from the way I would normally behave, so people could take it all in. I knew who this guy was."[198]

"And who he is," says Maslansky, "is a bit of a narcissist. He has no qualms about who he seduces. It's second nature to him. I felt that he would waltz into a store like Paul Smith and work the salesperson until she gave him an amazing discount to get what he wanted."[199]

Though Bomer shares the screen with Tim DeKay as his FBI mentor and warden-without-bars, and with the late Willie Garson as Mozzie, Caffrey's best friend, fellow con, and technological whiz kid, neither the former's Brooks Brothers conservatism or the latter's eccentric East Village–consignment-shop wardrobe hijack the traveling spot, which stays firmly on Bomer. His gratitude is twofold. "*White Collar* was my breakthrough role as an actor," he says, "but it also taught me that, as someone [to whom] looks matter, you really do get what you pay for. I still love to wear the clothes now because they still look so right. And no, I didn't pay for them. But somebody did. So I lucked out."[200]

NOTE: BOMER MAY HAVE LUCK. BUT HE ALSO HAS GUTS. Though it's not a factor in either the show's plot or its wardrobe selection, Matt Bomer is the first openly gay male actor to play a straight romantic lead in an American television drama. It testifies to the actor's histrionics-free but confident self-regard that the raft of right-wing watchdogs, elected and self-proclaimed moralists, and frequently foaming guardians of the social media galaxy stayed silent both during and after Bomer's long stint as an irresistible ladies' man. "I knew it might be a challenge, but I was never hesitant. Now the effect couldn't be more positive."[201] Bomer is currently coproducing and starring in an adaptation of Thomas Mallon's novel *Fellow Travelers*, about two male Washington insiders who fall in love during the McCarthy era's "lavender scare." Bomer's romantic mate will be Jonathan Bailey, the openly gay British actor who fluttered hearts as the straight romantic lead in the second season of *Bridgerton* (see page 40).

Killing Eve

TELECAST *from* **2018–2022** *on* **BBC AMERICA**

STARRING: Sandra Oh, Jodie Comer

COSTUME DESIGNERS: Phoebe De Gaye,
Charlotte Mitchell, Sam Perry

- -

*A brilliant but awkward security operative and a
psychopathic assassin who kills for the sole purpose of
buying more designer clothes become fixated on each other.
Is it a game of catch-me-if-you-can or a courtship?*

NOT EVEN A FULL HEAD OF CORNROWS IS more twisted than the four-season story arc of *Killing Eve*. Why would any sane person become entranced with a woman who kills with less remorse than a chain smoker flinging a lit butt onto the sidewalk? But Sandra Oh's Eve is transfixed. It's bad enough that on a normal day she may vacillate wildly between forsaking all else to track down a hunch, only to suddenly remember (three hours too late) that her husband has been as neglected as her laundry.

The object of Eve's abnormal affection is about five miles past bonkers. Jodie Comer's Villanelle is more poisonous than a cobra kept too long in its basket, and yet you can't resist the urge to pet her. Comer created someone I can't remember meeting before: the most insidiously seductive, unrepentant evil, soulless soul, a woman who smiles beatifically at a cute little girl savoring a dish of ice cream, then as she walks by the child's table, deliberately upends the ice cream into the girl's lap for no other reason than that she wanted to. Villanelle can break into any home, confront her intended victim with serene calm, engage him in conversation as if she might soon invite him to join her for coffee, and then stab him in the eye with a two-foot-long poisoned needle—without getting a drop of blood, sweat, or tears on her outfit for the day, a shirred, baby-blue-printed Burberry smock dress that couldn't radiate more innocence if it was on Maria von Trapp. When asked by her victim why she is doing this, she replies, "I have no idea."

Though unaware of her motivation, Villanelle has crafted a means to an end, and oddly enough her kill fee triggers a compulsive desire to shop for designer clothes. As a consumer even *The Real Housewives of Dubai* grow pale in her shadow. How bizarre that the most terrifying

woman on television is easily its best-dressed inhabitant. The closet that costume designers Phoebe De Gaye, Charlotte Mitchell, and Sam Perry have filled for Comer must have the owners of the RealReal drooling. Bearing no allegiance to any one label, the assortment from two seasons alone is covetous: a black Comme des Garçons tailcoat, an orange La DoubleJ op-art mini, a boldly patterned pantsuit by Halpern, a sumptuously embellished Prince of Wales coat by Y/Project, a Charlotte Knowles green feather jacket worn with matching pants by Gucci, a slouchy charcoal man-tailored suit by Hussein Chalayan, an artist's coat in mustard from Loewe, a red Lanvin trouser suit, a McQueen red blazer and ethereal black gown ensemble. As Villanelle draws closer to her nemesis, she even sends Eve clothes to elevate her drab wardrobe.

Almost everything Comer has worn has sold out on Net-a-Porter and other websites within days, so it's too late to order now. The massive, pink tulle Molly Goddard gown Villanelle wore to a therapy appointment at the end of season one was the look that broke the internet, launched a thousand blogs, boosted the designer's profile, and became the chicest Halloween costume of 2018—provided you could find a knock-off of her massive Balenciaga work boots.

As *Killing Eve* progresses, the story becomes too byzantinely tangled to describe. All good guys vanish, and any that remain earn varying degrees of contempt. The fashion parade never ebbs, but the increasing homoeroticism of Eve and Villanelle's relationship effectively distracts from the fashion parade. As the two stand together on a bridge watching people go by at the end of season three, Eve remarks, "I used to be like them," to which Villanelle replies, "You mean badly dressed?" Recounting all she has lost, Eve bemoans that "when I try to think of my future, I just see your face over and over again." To which Villanelle replies, more matter-of-factly than immodestly, "It's a very beautiful face."

Killing Eve never stops twisting, so be prepared to wind up tied in knots and, against your better nature, wondering if being an assassin has its upside, since evidently you can afford to buy retail at full price.

Talk May Be Cheap, but It's Worth a Fortune

THE UNREAL IMPACT OF REALITY SHOWS

Soul Train

TELECAST *from* 1971–2006 *in* SYNDICATION

STARRING: Don Cornelius

- -

A weekly celebration of African American talent, style, and pride, and the show that taught the rest of us how to dance and dress when everyone is watching.

ECAUSE *SOUL TRAIN* WAS A SYNDICATED show, it played at different times on different channels around the country. But in the '70s, in New York and Los Angeles, anyone I knew who loved to dance (and for me that was everyone I knew) was in front of their television, having moved all extraneous furniture out of the way by Saturday morning at 11:00 a.m. *Soul Train* was don't-you-dare-miss-it television, a sometimes breathless but always inspiring tutorial in how to dance and how to dress. But google the show and discover the unanimity of African American performers, sociologists, civil rights activists, authors, and educators who cite *Soul Train* as the most vital, informative, enriching, and empowering television show in history for African Americans. Every minute it was on, it showcased another positive—make that superlative—aspect about being young, gifted, and Black.

Soul Train declared that the way Black men and women groove, dress, sing, perform, give out, and give back was better than what everyone else was engaged in. As far as host and *Train* conductor Don Cornelius was concerned, no one could be cooler than you. It sounds arrogant, but Cornelius, whose nickname was "the Pope of Soul," delivered his message in such a warm, soothing, amber honey-soaked voice that he left no room for doubt.

And because so many believed in his message, viewers saw beauty in faces they could finally relate to, in ads for Ultra Sheen and Afro Sheen, products created specifically to elevate their presence. Every week was an invitation to experience another great Black artist: Curtis Mayfield, Aretha Franklin, the Staple Singers, James Brown, Gladys Knight and the Pips, Marvin Gaye, Tina Turner, Teddy Pendergrass, Kurtis Blow, Barry White, and a performance by Al Green that can only be described as transformative.

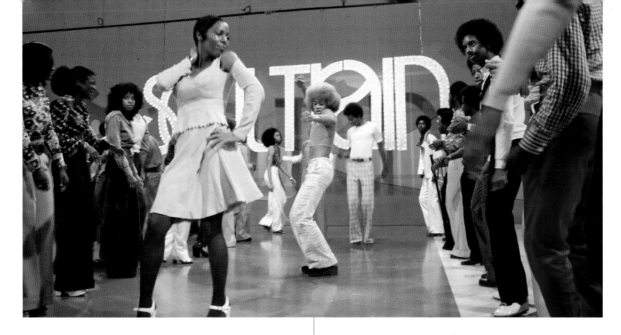

Former radio announcer Cornelius launched the show locally in Chicago in 1971 as an alternative to *American Bandstand*, Dick Clark's dance party institution, which debuted nationally in 1957. While *Bandstand* had integrated its teens four years later, it had never shed its Beach Boys loving, apple cheeked, Crest-white-smile image. Reaction was swift, expanding *Train* to twenty-five markets in a year, In LA, a month's worth of shows were shot quickly and cheaply over the course of one weekend each month. The *Soul Train* dancers were paid with buckets of Kentucky Fried Chicken, but no one was complaining because the food gave them enough energy to introduce popping, locking, the funky chicken, the funky penguin, the robot, the hustle. Where do you think Michael Jackson learned how to moonwalk?

Watching the *Soul Train* line dancers outdo and one-up each other to Whitney Houston's "So Emotional" demanded that you get up and take your first virtual dance class long before Equinox put out their first virtual schedule.

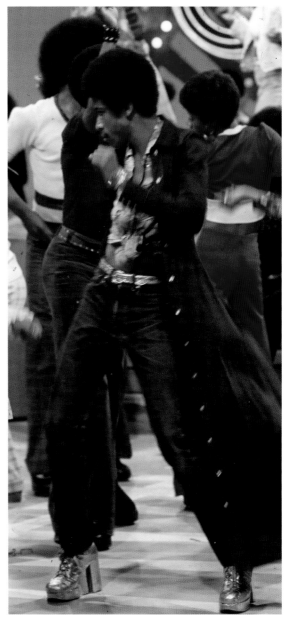

The clothes were spectacular: a black fringed strapless pinwheel gown, double-breasted iridescent blue sharkskin suits, a gold lamé bra with black hot pants and thigh-high boots, quadruple-pleated pants with a patchwork velvet artist's smock, peacock blue silk gowns, gold-embroidered pleated skating skirts, Jenga-stacked platforms, knickers, medallions, massive hoop earrings, a ruched silver cape. And all this is just from one line dance!

Airing from 1971 to 2006, *Soul Train* became the longest-running syndicated show in television history and the most influential show in American music and African American culture. If you were Black, you felt special. If you weren't, Cornelius still offered you love, peace, and soul. I never missed it. Not one week.

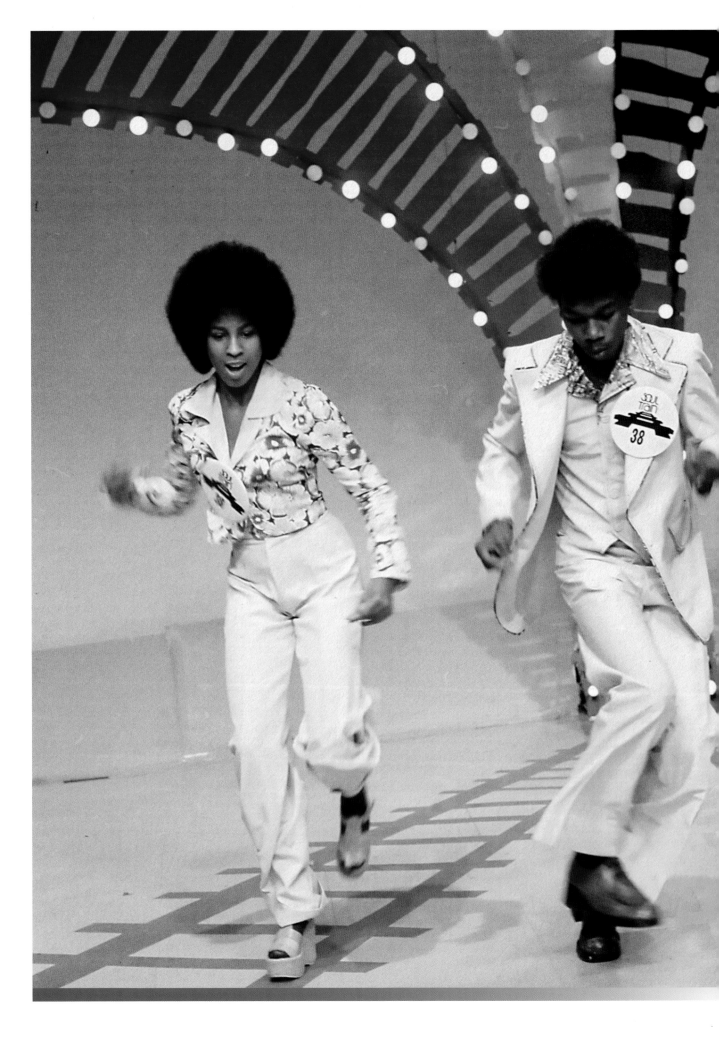

Was your goal to be a *Soul Train* dancer?

No! I was in my first year of college. I think I was nineteen and I was a biochem major, but I wanted to be a marine biologist. We would get together at a nightclub called the Florentine Gardens in Hollywood, where I would change into my club outfit after class.

A talent scout saw us and asked if I would like to be on *Soul Train*, and I figured what the hell. A girl from Brooklyn. Let's go. [202]

So that was it? You were in?

There were over fifty other kids vying for a spot. The one thing I was told was that Don Cornelius didn't like my outfit, which was a cut-off sweatshirt, orange acid-wash skinny jeans, and pink high-tops. I thought I looked cute. Cornelius wanted you looking classier. They told me to come back in a dress and high heels. I thought, how am I gonna dance in high heels? My first day, nobody asked me to dance until Ricky came over and said, "I want to be your partner." I got to do the Scramble Board first time out. That was huge. And then the jealousy started. I laughed about it, which made it worse. It was all pretherapy, and I didn't handle it well.

But you didn't turn down the attention?

Hell, no. They told me it was because I was getting a lot of fan mail. So they put me on a riser. Gave me a spotlight. I went down [to] Melrose and bought lots of tight Spandex. It was a blast.

How did you meet Spike Lee?

Actress Holly Robinson Peete's brother was throwing these parties. They asked for some of the *Soul Train* dancers like me, Rerun, and Jody Watley. Spike was at the party. I got up on the speaker. It was fate. Spike gave me his card and said he wanted to see me. I took the card and threw it in the trash can. My friend went off on me. "You fool!"

That's the director of *She's Gotta Have It*. The next morning he calls me! Says he wants to talk to the girl with the Puerto Rican accent. He asked me to audition for his movie. So I get a ride down to Washington, DC. Next thing I know, I'm in one of Spike's best movies, *Do the Right Thing*. And I never would have gotten it if I hadn't been on a riser on *Soul Train*.

Project Runway

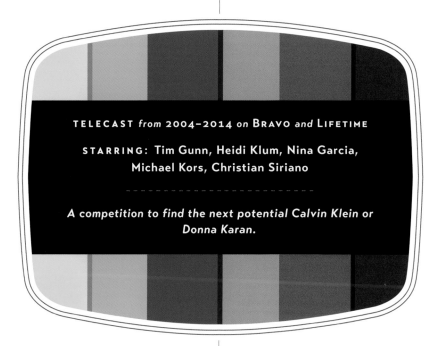

TELECAST *from* 2004–2014 *on* BRAVO *and* LIFETIME

STARRING: Tim Gunn, Heidi Klum, Nina Garcia, Michael Kors, Christian Siriano

A competition to find the next potential Calvin Klein or Donna Karan.

T'S ALWAYS EXCITING TO WATCH SOMEBODY grab the brass ring. But as we've seen with so many competition shows, the excitement that surrounds the winner claiming center stage often doesn't go much beyond the spray of streamers shot from the wings. After twenty seasons of *Project Runway*, can you name one winner besides Christian Siriano? So does that mean the show is a bust? That's an awful lot of time to invest in being disappointed. It might help to shift your perspective on how you can better appreciate what you're watching, and I can't think of a better guide to refocusing your field of vision than a designer whose name everyone does know.

Michael Kors was one of the original judges on *Project Runway*, when few people believed that bestowing a sash on someone with a nimble thimble would be regarded as much more than a stunt. And at first, Kors wasn't

all in either. "I was very cautious at first," he told me, "because I feel protective about how fashion is portrayed on TV and on film. They rarely get it right, because your immediate response to reality television is that someone is going to be eating bugs."[203] It may not be that gross, but making dresses out of material found in a cocktail bar, a dumpster, or even a flower shop doesn't seem likely to take us anyplace where the results will be pragmatic. "And that may have had something to do with why I first said no,"[204] adds Michael.

He wasn't the only one. *Vogue* was the first magazine that turned down an association with *Runway*. *InStyle* was the second. As Julia Roberts says to the Rodeo Drive saleswoman who snubs her at first glance in *Pretty Woman*, "Big mistake. Big. Huge!"

Kors sympathized with their reticence. "I was skeptical at first, too. I didn't see design holding interest long

term. I figured Heidi [Klum]'s fans might watch. Some viewing parties in LA and New York, but this won't make a dent with the general public. Maybe I was being myopic because I was just looking at the mechanics. I didn't consider how entertaining the players could be, or that many people who shop don't stop to consider how clothes first get onto their backs and then into their closets. There is an alchemy to the process. It's always been part of my world.

"But here was a chance to make it part of the viewers', to show the creative process as something that has a start, and a middle, and finally the end. I thought maybe we were onto something. We were on the air for four, maybe five episodes, and I run into Rashida Jones, who tells me, 'My mom and I love watching your show.' Rashida's mom is Peggy Lipton (*The Mod Squad*), fashion royalty. Then she adds, 'Dad too.' Quincy Jones (thirty-time Grammy-winning producer) just *is* royalty! We were definitely onto something."[205]

Kors believes the show's lasting impact is threefold. To begin with, "it was the first time we pulled back the curtain beyond the runway's finished product; like, when you are shopping for a random blouse it may not be crafted by hand, but it still had to be conceptualized, the sleeves needed sizing and proportion, the color made a certain way."[206]

The second is a personal one. "I had never sat in the audience at a fashion show before, in the trenches, and suddenly I became much more empathetic as to what we put an audience through when we are not focused or edited, and the monotony of ninety-five looks sets in so badly you just want to go out for a coffee and come back later. It hammered home that any designer worth his or her salt shouldn't have their name on the wall behind the backdrop when they show. People should know who you are by the distinction of your clothes. You should have a point of view, tell your story quickly. ABCD, gotta go. Done. These are essentials that I think Nina [Garcia] and I have imparted to the kids each season."[207]

The final factor that heightened *Runway*'s impact is the medium itself. "When fashion is presented in a vacuum, we don't even know if Ralph Lauren or Tommy [Hilfiger] even exist. It's just a brand. Social media has changed that but when *Runway* started, we didn't have it. But with television, the brand becomes people whom you know and hang out with. People know me. They know what I designed and hear why I did it that way. The fact that this awareness occurred at a time that coincided with me having product at a more affordable price meant my reality was no longer confined to the runway. It made all the difference in how I spoke to the young designers on the show. So even if you are designing dresses out of some era, you still want to excite people with how you did it. I'm really proud that on *Runway* we pulled together as a team to tell that story. And that's why the show still works."[208]

Keeping Up with the Kardashians

TELECAST *from 2007–2021 on* BRAVO

STARRING: Kim, Kourtney, and Khloé Kardashian;
Kris, Kendall, and Kylie Jenner

*The family is an undeniable, unavoidable, and unstoppable
force in our culture.*

ET'S DISPENSE WITH THIS AS SWIFTLY and painlessly as possible. On one hand, the level of vitriol still lobbed at the Kardashian/Jenner clan is both wailing into the wind and fairly disingenuous. Meanwhile, the valuation of Kim's shapewear company, Skims, has just been upped to $3.2 billion because no store can keep the merchandise in stock. Kylie Cosmetics is valued at a mere $900 million. *Keeping Up with the Kardashians* ended what seemed like a seventy-year run on E! in 2021. But evidently plenty of viewers weren't satiated, because the subsequent launch of their new series, now shortened to *The Kardashians*, caused Hulu to crash. And yet no sooner was the streamer up and running than social media was inundated with scathing denunciations: all we were being offered was more of the

same. Why is anyone surprised? Exactly what did you think the new series would have that the old one didn't? Musical numbers? Stand-up? In-depth, woman-on-the-street interviews hosted by Caitlyn?

However, they achieved their silhouettes, there is no denying that the Kardashian women have altered how we perceive beauty and style, sometimes for the better. But as they continue to increase their influence, one reason for the sustained enmity may be that the more this tight-knit, very insular troupe commands the spotlight, the more apparent it is that, though they are incredibly successful, self-possessed, and even loyal, all that Lorraine Schwartz jewelry can't hide the fact that the Kardashians lack luster. Big on presence. Small on substance.

Their dullness is not meant to be a criticism. It's merely a statement of fact. Yes, they have embarked on some provocative and bizarre relationships with men, and Mom's wicked marketing skills might make for an intriguing Master Class, but in their studied positions around an array of beige sofas, the tenor of conversation is never witty or passionate. In fact, if your monthly bills are paid and you've figured out today's Wordle, watch any five episodes of *Keeping Up* in random order, then watch them again consecutively (alcohol is encouraged), and you will find no perceptible difference. For their last episode of *Keeping Up*, the women sat with Andy Cohen, whose impish curiosity guarantees that he can talk to anyone. But Cohen would get three questions into a fresh conversation and hit dead air. He must have said, "Switching gears . . ." so many times that I thought he was riding uphill on a ten-speed. Which probably would have been less of a strain on everyone. The problem is not *Keeping Up with the Kardashians*. It's that they're exactly where they want to be. And you really need to move on.

The Real Housewives of...

TELECAST *from* 2006– *on* BRAVO

STARRING: We don't have the space to list them all.

Desperate Housewives *for real, around the globe.*

THERE ARE SO MANY ITERATIONS OF *The Real Housewives*, it's hard to imagine throwing a dart at a map and not hitting at least one that's in play within fifty miles. With varying production schedules, recasting, and impending deals, it's difficult to determine exactly how many editions are in circulation, but as of this writing there are eleven American conclaves, nineteen international assemblages, and twenty-one spinoffs. The first champagne-brunch bunch was stationed in Orange County in 2006. (I told you *The O.C.* had sway!) But after however many thousands of cocktails and millions of miles slogged, executive producer Andy Cohen still manages to keep these bastions of buoyant and bubbling attitude distinct in his mind, balancing his enthusiastic P. T. Barnum showmanship with the darting focus of a plate spinner.

"I was an enormous soap opera fan as a kid," Andy recalls. "And then when I saw *Desperate Housewives*, I thought, what if we could find real housewives who bonded over shared circumstances and maybe some conflicting motives? We really didn't have a grand plan. We just went out there looking for a sociological time capsule, a slice of how the other half lives."[209]

But the moment he sat down and started interviewing women, he realized that the secret to building the intrigue and chemistry he was looking for was "going to be in the casting. It's the only thing that counts. The women we pick are exactly as they appear. They think what they think. We have never told them how to behave. If something happened at the party last night, it will come up in the conversation. We aren't looking for

DRESSING THE PART

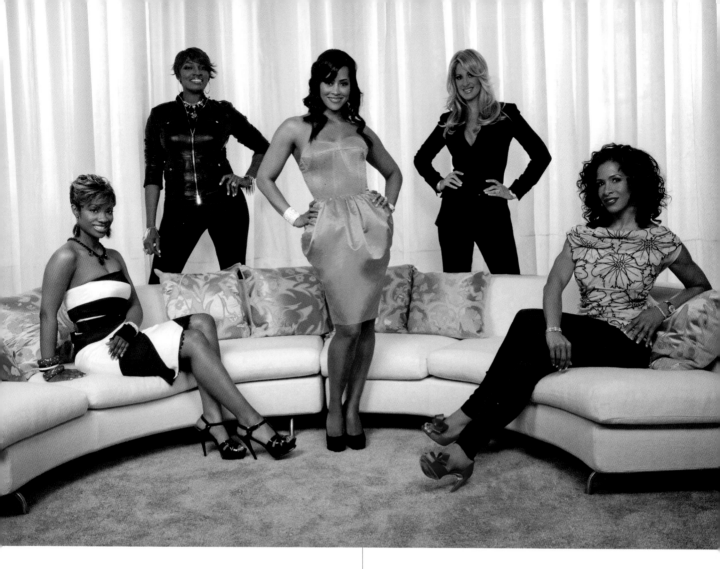

women who keep things to themselves. It doesn't have to be conflict. But we're sure hoping for a story. In fact, some of the most successful seasons are the ones [that] kept conflict to a minimum."[210]

However, lots of the episodes fans watch over and over are those featuring the overturned tables; Teresa and Joe going to jail; Tamra divorcing her controlling husband; Kyle Richards's fallout with her sister, Kim. But Cohen is not altogether wrong. There is also Lisa Rinna's sass, Cynthia Bailey's beauty, the Countess Luann's earthiness and her burgeoning nightclub career.

Cohen believes that fans see the geographical distinctions. "The cities are not interchangeable. The Atlanta women are the most consistent. Doesn't matter what they're wearing. There are always boobs in Atlanta. My Beverly Hills ladies may be the best dressed. It's a label contest with them, but each has their own style. Dorit and Erika lead that charge. And Jersey is so . . . well, it's Jersey. Hey, you cross the river, you get a lot of leopard. But one of my favorite looks and one that really threw me was in the early seasons of *Orange County*. It was all about this blouse; they all wore it. It was their uniform, and it gathered at the center

of the chest and was usually bejeweled, and it showed off their bosom. And at the first reunion I asked them, what is that thing you're wearing? And they called it a 'sky top.'"[211]

Cohen is most partial to the women who have been with him the longest: "Kyle, Luann, who has the most effortless style, Teresa, Carole Radziwill in New York, Lisa Vanderpump. These women just know who they are. It's why the audience loves them and keeps coming back.[212]

And just when I thought several cities on the shows had run their course, I discovered *The Real Housewives of Dubai*. Like the ludicrously garish display of wealth that is the defining image of this city that's all radiance, where license plates with single digits cost more than the Rolls they are affixed to, its *Wives* have conjured a social hierarchy that is equally towering and poised to shatter. Their wardrobes are too spectacular to be vulgar, and they are worth their weight in filler. From Ayan: "They don't hate me because I'm beautiful. They hate me because they are basic." And from Lesa: "The only thing you can take from me . . . are notes."

I tell Cohen I can't wait for their reunion. He replies quietly, "You may have to bring a bodyguard and a gun."[213]

RuPaul's Drag Race

TELECAST *from* 2009–2016 *on* LOGO,
from 2017–2022 *on* VH1, 2023– *on* MTV *and* PARAMOUNT+

STARRING: **RuPaul, Michelle Visage, Santino Rice,
Ross Mathews, Carson Kressley, Trixie Mattel, Shangela,
Sasha Velour, and Jinkx Monsoon**

COSTUME DESIGNER: **Zaldy**

- -

*A fabulous group of drag queens vie for this season's
crown and scepter.*

ROBIN WILLIAMS IN *MRS. DOUBTFIRE*, Flip Wilson as Geraldine, Nathan Lane as Starina in *The Birdcage*, Dustin Hoffman in *Tootsie*, Tom Hanks in *Bosom Buddies*, Tony Curtis in *Some Like It Hot*, Tyler Perry as Madea, Patrick Swayze in *To Wong Foo, Thanks for Everything!, Julie Newmar*. An actor doing drag hasn't been that big a deal for a long time. The difference between these guys and Sasha, Trixie, Shangela, and Jinkx is that at the end of the day the famous actors take their performing drag off and move on. In or out of costume, however, Sasha and friends are always drag queens.

And a lot more people used to have a problem with that. I don't know if RuPaul set out to make his series a platform for change. My guess is that when *RuPaul's Drag Race* was first pitched to Logo, a gay channel with the depth of a bugle bead, the show was going to be all about outrageous performances and a lot of finger-snapping shade.

But like so many other shows that are based on competition, when the camera follows the contestant off stage we get to hear a person yearning for something better, watch them fight to contain nervousness, try to stifle their insecurity, deal with a backstory that makes you twitch, reach out for encouragement, latch onto a stranger they hope might become a friend. And after all, these feelings are not theirs alone.

We turned on *Drag Race* for a snark and a lark, and then these unique, vulnerable, talented men got under our skin. By the time the show moved to VH1, not only had the production values become more polished, but also RuPaul and his executive producers Fenton Bailey and Randy Barbato adjusted the dynamics to take on a hunch that we wanted to know more about these contestants.

Their stories may have contained more extreme highs and lows than a lot of ours, but all minorities and the marginalized know what it's like to be judged unfairly or by standards that should have been retired long ago.

Ru & Co. embraced these queens and offered us the opportunity to do the same. And we did. And the moment that happened, the drag artists became people worth rooting for as well as performers who entertained the crap out of us. We cheered them on, and then others started hearing the cheers: unexpected fans like Lady Gaga, Cardi B, Ricky Martin, Whoopi Goldberg, Miley Cyrus, Demi Lovato, Neil Patrick Harris, Ariana Grande, Lizzo, and U.S. Representative Alexandria Ocasio-Cortez came on the show as judges. As seasons progressed, the contestants looked prouder. Their makeup rivaled Kabuki theater for intensity. The costumes, many made by a marvelously talented ex-club-kid named Zaldy, rivaled the best of Ziegfeld.

Drag Race has now watched its contagious flamboyance spread beyond its mirrored runway and onto red carpets and bigger stages. Harry Styles's Gucci-designed sequin jumpsuits, Jared Leto's Met Ball outfits, straight Black country singer Jimmie Allen's pink velvet vest and pants at the CMA Awards, Timothée Chalamet's red satin backless jumpsuit by Haider Ackermann, Brad Pitt's olive skirt, and Dwayne Johnson's ballet pink satin tuxedo jacket by Dolce & Gabbana at the 2023 Oscars aren't coincidental. Fashion and drag have always had a strong connection. No one is hiding it anymore.

But the most positive change wrought by *Drag Race*, according to Frank DeCaro, author of *Drag: Combing through the Big Wigs of Show Business*, is that "Drag as entertainment has become a valid pursuit in show business, and one can be famous and earn a living. Drag artists get to be people, not freaks, unless they want to be. People now line up around the country for drag brunches. The caliber of drag has elevated as its advocates follow Ru's advice to 'step your pussy up.' Phrases like that and 'serving face' are entering mainstream vernacular. You also don't have to do drag to be emboldened by it. You watch the reaction of young gays to the growing hate of the right. Instead of cowering, their response is, I'm going to be even gayer, even louder. Try and stop me."[214]

As I'm writing this paragraph, RuPaul Charles has won his eleventh Emmy, the most ever won by an African American performer. *RuPaul's Drag Race* doesn't succeed because it's a terrific drag show—which it is—but because it is great reality television. And it is further proof of the undiminished power of the medium. One afternoon you're with the Crawleys, having tea. The next day, oh look, RuPaul drops by, spilling tea. Everyone comes to you. What an amazing way to meet the world.

NOTES

1. Aurelie Corinthios, "The story behind Mary Tyler Moore's hat toss," *Entertainment Weekly*, January 25, 2017, https://www.ew.com

2. Thomas Vinciguerra, "30 Years Later, Revisiting 'Brideshead,'" *New York Times*, December 30, 2011, https://www.nytimes.com

3. John Dunn, Interview with the Author, July 18, 2022

4. Janie Bryant, Interview with the Author, June 29, 2022

5. Ibid.

6. Ibid.

7. Ibid.

8. Ibid.

9. Ibid.

10. Virginia Bates, Interview with the Author, August 16, 2022

11. Ibid.

12. Karla Adam and Annabelle Timsit, "Epic Queue for Queen Elizabeth II's coffin had more than 250,000 people," *Washington Post*, September 20, 2022, https://www.washingtonpost.com

13. Jon Jackson, "More than 4.1 Billion Watch Queen's Funeral, Surpassing Every Royal Wedding," *Newsweek*, September 19, 2022, https://www.newsweek.com

14. Diane Clehane, "Queen Elizabeth Has Only Allowed One Person to Read Her 'Secret' Diary," *BestLife*, September 11, 2020, https://www.bestlifeonline.com

15. Donna Zakowska, Interview with the Author, May 22, 2022

16. Ibid.

17. Ibid.

18. Ibid.

19 Ibid.

20. Ibid.

21. Ibid.

22. Ibid.

23. Crystal George, "*Stranger Things* and the 9 most expensive Netflix shows," NetflixLife, April, 2022, https://netflixlife.com/2022/04/22/stranger-things-most-expensive-netflix-shows/

24. Ellen Mirojnick, Interview with the Author, June 20, 2020

25. Ibid.

26. Ibid.

27. Ibid.

28. Ibid.

29. Héloise Salessy, "Bridgerton: 8 fashion trends from the series we are going to see everywhere," *Vogue France*, February 1, 2021, https://www.vogue.fr/fashion/article/bridgerton-fashion-trends-netflix-series/amp

30. Conchita Widjojo, "Fashion Searches Spike After Premiere of 'Bridgerton' Season Two, *Women's Wear Daily*, March 22, 2022, https://www.wwd.com

31. Television Academy Foundation, *The Interviews—25 Years*, Interview with Marlo Thomas (March 26, 2002), https://www. interviews.televisionacademy.com

32. Ibid.

33. Ibid.

34. Marlo Thomas, *Television Academy*

35. Ibid.

36. Marlo Thomas to Jennifer Ferrise, "How That Girl Star Marlo Thomas Found Success on Her Own Terms," *Instyle,*July 19, 2019, https://www.instyle.com/celebrity/marlo-thomas-that-girl

37. Television Academy, Interview with Marlo Thomas.

38. Ibid.

39. Ibid.

40. Ibid.

41. Jennifer Keishin Armstrong, *Mary and Lou and Rhoda and Ted* (New York: Simon & Schuster Paperbacks, 2013), 33

42. Ibid., 35

43. Ibid., 36

44. Ibid., 45

45. Ibid., 101

46. Ibid., 132

47. India Robey, "The Micro-Mini Skirt was a Celebrity Favorite in the Early 2000s," *Nylon*, December 15, 2021, https://www.nylon.com

48. Rachel Stanley, Interview with the Author, June 20, 2022

49. Ibid.

50. Lyn Paolo, Interview with the Author, July 12, 2022

51. Ibid.

52. Ibid.

53. Christi Carras, "Mindy Kaling 'had a reckoning' after a 'devastating' remark from another writers room," *Los Angeles Times*, August 19, 2021, https://www.latimes.com/entertainment-arts/tv/story/2021-08-19/mindy-kaling-the-office-body-positivity

54. Salvador Perez Jr., Interview with the Author, May 18, 2022

55. Ibid.

56. Ibid.

57. Ibid.

58. Robert Jay, "Number of Television Sets in 1952," Television Obscurities, August 6, 2009, https://www.tvobscurities.com

59. Donna McCroban, *Prime Time, Our Time: America's Life and Times through the Prism of Television* (Rocklin, California: Prima Publishing & Communications, 1990), 51, 52

60. Tim Brooks and Earle Marsh, *The Complete Directory to Prime Time Network and Cable TV Shows 1946–Present*, (New York: Ballantine Books, 2007), 652

61. Allan Glaser and Rick Carl, *The Official "I Love Lucy" Paper Dolls* (Philadelphia: Running Press, 2004), [introduction]

62. Ibid.

63. Ibid.

64. Rick Carl, Interview with the Author, July 20, 2022

65. Hal Rubenstein, *The Looks of Love: 50 Moments in Fashion That Inspired Romance* (New York: Harper Design, 2015), 193

66. McCroban, *Prime Time, Our Time*, 53

67. "Ibid., 36

68. Ibid., 36

69. Post Editors, "Donna Reed: Fire and Ice," *Saturday Evening Post*, March 28, 1964, 22

70. Meredith B. Kile, "EXCLUSIVE: Dick Van Dyke says he and Mary Tyler Moore Had a 'Teenage Crush' on each other," ET website, January 22, 2016, https://www.etonline.com

71. Television Academy Foundation, *The Interviews—25 Years*, Interview with Mary Tyler Moore (October 23, 1997), https://www.interviews .televisionacademy.com

72. Ibid.

73. Breanna Hare, "Sitcom wives wore dresses. Then came Mary Tyler Moore in a pair of capri pants," CNN Style, July 10, 2021, https://www.cnn.com/style/article /mary-tyler-moore-capri-pants/index.html

74. MeTV staff, "Why Mary Tyler Moore's pants were such a big deal in the 1960s," MeTV, January 30, 2017, https://www .metv.com/stories/why-mary-tyler -moores-pants-were-a-big-deal

75. "Ibid.

76. Matt Baume, "Bewitched: It was Gay All Along?" YouTube, March 1, 2021, https://www.youtube.com

77. "Bob Mackie, Interview with the Author, May 25, 2022

78. Ibid.

79. Ibid.

80. Ibid.

81. Ibid.

82. Ibid.

83. Ibid.

84. YouTube, "Katey Sagal on *The Talk*," YouTube, May 7, 2013, https://www .youtube.com

85. Colette Shade, "The Trashy, Expensive, Contradictory Reputation of Leopard Print," Racked, March 7, 2018, https://www.racked.com

86. Ashley Riegle, Aude Soichet, Lauren Effron, "Katey Sagal talks explosive new memoir, past drug addiction and how she met and dated Kiss' Gene Simmons," ABCNews, March 23, 2017, https:// abcnews.go.com/Entertainment /katey-sagal-talks-explosive-memoir -past-drug-addiction/story?id=46336304

87. Television Academy Foundation, *The Interviews—25 Years*, Interview with Nolan Miller (April 8, 2003), https://www .interviews.televisionacademy.com

88. Ibid.

89. Ibid.

90. Ibid.

91. Ibid.

92. Ibid.

93. Ibid.

94. Helen Jackson, "Jennifer Saunders Says Her Dream 'Absolutely Fabulous' Prequel Would Star Amy Schumer and Lena Dunham," *Variety*, June 29, 2016, https://www.variety.com

95. Jamie Roberts, "Jennifer Saunders says AbFab wouldn't be made today due to 'sensitive viewers,' *The Mirror*, June 16, 2021, https://www.mirror.co.uk.com

96. America Ferrera, "My identity is a superpower—not an obstacle," TED talk, May 19, 2019, https://www.ted.com

97. Ibid.

98. Ibid.

99. Ibid.

100. Ibid.

101. Ibid.

102. Eduardo Castro, Interview with the Author, May 19, 2022

103. Ibid.

104. Ferrera, "My Identity is a Superpower"

105. Jonathan van Meter, "Why We're All Glued to 'Empire': Behind the Scenes of TV's Runaway Hit," Vogue.com, August 14, 2015, https://www.vogue.com/article /empire-cast-the-weekend-lee-daniels

106. Nicola Fumo, "'Empire' is Changing What TV Merchandise Means," Racked, December 1, 2015, https://www.racked .com/ search?q=Empire+is+Changing +what+TV+Merchandise+Means

107. Kenya Hunt, "Empire: How Cookie's Wardrobe has redefined fashion on TV," *The Guardian*, October 7, 2015, https:// www.theguardian.com

108. Ibid.

109. Lara Zarum, "The Rise of 'Schitt's Creek,'" *New York Times*, January 7, 2020, https://www.nytimes.com

110. Debra Hanson, Interview with the Author, April 22, 2022

111. Ibid.

112. Ibid.

113. Abid Rahman, "'Embarrassing': Netflix's 'Emily in Paris' Blasted by French Critics," *Hollywood Reporter*, October 5, 2020, https://www .thehollywoodreporter.com

114. Ibid.

115. "Kyle Chayka, "'Emily in Paris: and the Rise of Ambient TV," *The New Yorker*, November 16, 2020, https://www .thenewyorker.com

116. Patricia Field, Interview with the Author, June 18, 2020

117. Ibid.

118. Ibid.

119. Ibid.

120. Jim Colucci, Interview with the Author, August 5, 2022

121. Jim Colucci, *Golden Girls Forever* (New York: Harper Design, 2016), 333

122. Claire Sewell, "A Brief History of Sophia's Purse," The Golden Girls Fashion Corner, August 31, 2018, https:// www.goldengirlsfashion.com

123. Jim Colucci interview

124. Patricia Field interview

125. Ibid.

126. Ibid.

127. Ibid.

128. Ibid.

129. Ibid.

130. Ibid.

131. The Clicker and Susan C. Young, "Ladies of 'Desperate Housewives' changed the face of television," *Today*, May 11, 2012, https://www.today.com /popculture/ladies-desperate-housewives -changed-face-television-766742

132. Catherine Adair, Interview with the Author, May 25, 2022

133. Ibid

134. Ibid.

135. Ibid.

136. Ibid.

137. Ibid.

138. Ned Zeman, "Beds, Burbs, and Beyond," *Vanity Fair*, May 2005, cover, https://archive.vanityfair.com /article/2005/5/bed-burbs-and-beyond

139. Catherine Adair interview 2

140. Jenn Rogien, Interview with the Author, July 14, 2022

141. Ibid.

142. Ibid.

143. Ibid.

144. Ibid.

145. Dhani Mau, "'Girls' Costume Designer Talks Season 4 and Why Hannah's Clothes Fit So Badly," *Fashionista*, January 8, 2015, https://www.fashionista.com

146. Jane Wagner, *The Search for Signs of Intelligent Life in the Universe* (New York: Harper & Row, 1986)

147. Max Kalnitz, "12 of the longest-lasting friendships in Hollywood," *Insider*, updated February 13, 2022, https://www.insider.com

148. Allyson Fanger, Interview with the Author, May 26, 2022

149. Ibid.

150. Ibid.

151. Ibid.

152. McCrohan, *Prime Time, Our Time*, 348

153. Ceci, Interview with the Author, August 5, 2022

154. Ibid.

155. Ibid

156. Ibid.

157. Winnie Holzman, Interview with the Author, August 11, 2022

158. Patrick Norris, Interview with the Author, August 2, 2022

159. Winnie Holzman interview

160. Patrick Norris interview 2

161. Debra McGuire, Interview with the Author, May 19, 2022

162. Ibid.

163. Ibid.

164. Ibid.

165. Ibid.

166. Ibid.

167. Ibid.

168. Kim Renfro, "Low-rise jeans, checkered Vans, and that iconic leather necklace: How 'The O.C.' costume designer accidentally became a '00s trendsetter," *Insider*, August 7, 2021, https://www.insider.com

169. Eric Daman, Interview with the Author, May 20, 2022

170. Ibid.

171. Ibid.

172. Ibid.

173. Ibid.

174. Ibid.

175. Ibid.

176. Ibid.

177. Ronald L. Smith, *Sweethearts of '60s TV*, (New York: St. Martin's Press, 1989), 167

178. Ibid., 171

179. Wrong-side-of-the-tracks, "Robert Conrad," *Urban Dictionary*, July 21, 2008, https://www.urbandictionary.com/define.php?term=Robert%20Conrad

180. Television Academy Foundation, *The Interviews—25 Years*, Interview with Aaron Spelling (November 18 and 24, 1999), https://www.interviews.televisionacademy.com

181. Television Academy, Interview with Nolan Miller

182. Ibid.

183. Ibid.

184. Television Academy Foundation, *The Interviews—25 Years*, Interview with Jaclyn Smith (November 12, 2012), https://www.interviews.televisionacademy.com

185. Aaron Spelling, *Television Academy*

186. Television Academy Foundation, *The Interviews—25 Years*, Interview with Donald P. Bellisario (April 28, 2008), https://www.interviews.televisionacademy.com

187. Ibid.

188. Ibid.

189. McCrohan, *Prime Time, Our Time*, 291–292

190. Tom Selleck on *The Kelly Clarkson Show*, "Tom Selleck Defends His 'Magnum P.I.' Short Shorts," YouTube, April 27, 2022, https://www.youtube.com

191. Eduardo Castro interview

192. Kal Ruttenstein, Interview with the Author, October 3, 1993

193. Gianni Versace, Interview with the Author, January 28, 199

194. Television Academy Foundation, *The Interviews—25 Years*, Interview with Glenn Gordon Caron (September 19, 2007), https://www.interviews.televisionacademy.com

195. Ibid.

196. Ibid.

197. Stephanie Maslansky, Interview with the Author, July 25, 2022

198. Matt Bomer, Interview with the Author, August 11, 2022

199. Stephanie Maslansky interview 2

200. Matt Bomer interview

201. Ibid.

202. Rosie Perez, Interview with the Author, July 21, 2022

203. Michael Kors, Interview with the Author, July 28, 2022

204. Ibid.

205. Ibid.

206. Ibid.

207. Ibid.

208. Ibid.

209. Andy Cohen, Interview with the Author, August 2, 2022

210. Ibid.

211. Ibid.

212. Ibid.

213. Ibid.

214. Frank DeCaro, Interview with the Author, August 25, 2022

PHOTOGRAPHIC CREDITS

The publisher would like to thank the following for permission to reproduce copyrighted material:

FRONT COVER: James Devaney/ WireImage/Getty Images

BACK COVER: From Left: Liam Daniel/Netflix/courtesy Everett Collection, JAX MEDIA/Album/ Alamy Stock Photo, Pictorial Press Ltd/Alamy Stock Photo; mptvimages.com

ALAMY STOCK PHOTO ALBUM: 10, 26, 44, 105, 113, 137; RGR Collection: 12, 15; Moviestore Collection Ltd: 14; Pictorial Press Ltd: 29, 147, 168, 173; INSTAR Images LLC: 34; TCD/Prod.DB: 36, 194; United Archives GmbH: 87; Moviestore Collection Ltd: 16–17, 91, 155 bl; Photo 12: 32–33, 97, 166, 134–135, 158-159; PictureLux: 103, 108, 112, 128; AJ Pics: 152; Collection Christophel: 185; WENN Rights Ltd: 22–23, 196, 198.

CBS ARCHIVE: 46.

ELLEN MIROJNICK: 43 tl, 43 ml, 43 b, 45, 46.

EVERETT COLLECTION: 50, 55, 73, 84 b, 95, 149, 171, 175, 178, 179, 187; AMC: 19; Focus Features: 24; Jason Bell/Focus Features: 27; Alex Bailey/Netflix: 30; Des Willie/Netflix: 31; Liam Daniel/ Netflix: 41, 43 tr; Netflix: 42; Greg Gorman/Fox Network: 57; Vivian Zink/ABC: 52; Jordin Althaus/ Hulu: 66; Aaron Rapoport/Fox Network: 68; Gene Trindl/TV Guide: 75; Ron Thal/TV Guide: 80; Mario Casilli/TV Guide/ ABC: 88; Andrew Eccles/ABC: 99; Chuck Hodes/Fox Network: 100, 102; CBC: 106–107; Ian Watson/CBC/POP: 109; Stephanie Branchu/Netflix: 112–113; Marie Etchegoyen/Netflix: 114–115; HBO: 129, 130; Ron Tom/ABC: 133; Jojo Whilden/HBO: 138; Craig Blankenhorn/HBO: 139 t; Jessica Miglio/HBO: 139 b; Ali Goldstein/ Netflix: 141; Melissa Moseley/ Netflix: 142; Saeed Adyani/ Netflix: 143; NBC Productions: 151; ABC: 155 tr; Andrew Eccles/ Warner Brothers: 157; WB: 161; Andrew Eccles/The CW: 164–165; Giovanni Rufino/The CW: 167; Universal Television: 188–189; David Giesbrecht/USA Network: 193; BBC America: 197; Barbara Nitke/Bravo: 205, 206–207; Wilford Harewood/Bravo: 211.

GETTY IMAGES ABC PHOTO ARCHIVES: 49, 78, 92, 125, 155 tl, 155 br; CBS Photo Archive: 52, 54, 71, 72, 77 l, 82, 176; Craig Sjodin/ Disney General Entertainment Content: 58; Giovanni Rufino/ Disney General Entertainment Content: 60; Adam Taylor/ Disney General Entertainment Content: 61; Richard Forman/ Disney General Entertainment Content: 63; FOX Image Collection: 64; Bettmann: 77 r; Steve Schapiro/Corbis Premium Historical: 92; James Devaney/ WireImage: 116, 163; New York Daily News Archive: 127; Bill Davila/FilmMagic: 131; Arnaldo Magnani: 144; Soul Train: 201, 202, 203; Dia Dipasupil/ FilmMagic: 209.

JANIE BRYANT: 20–21.

MPTVIMAGES.COM: 51, 81, 84 t, 85, 118, 181; Mario Casilli: 94, 122, 191; Gunther: 121; Gene Trindl: 174; Bruce McBroom: 182.

NETFLIX: 111.

VH1: 213, 214–215.

DONNA ZAKOWSKA: 37, 38, 39.

SALVADOR PÉREZ: 67.

While every effort has been made to credit photographers, HarperCollins would like to apologize for any omissions or errors and would be pleased to make the appropriate correction for future editions of the book.

ACKNOWLEDGMENTS

THE DECLARATION "I HATE WRITING, BUT I LOVE HAVING WRITTEN" HAS been attributed to a diverse array of authors: Dorothy Parker, Frank Norris, Mark Twain, Neil Simon, even Nobel Prize–winner Ernest Hemingway. Its sentiment applies to every writer I know.

That's because it doesn't take a village to write a book. All it requires is one person, willing to duct tape him- or herself to a chair, arch one's fingers over a laptop, and totally shut out the rest of the world. However, that isolating constraint is so daunting I always begin writing with an arsenal of distractions: scanning the fridge for a new treat that has magically appeared since my last search twenty minutes earlier, watching four episodes of *Frasier* back to back for "inspiration," paying my utilities early, ironing pillowcases, refolding sweaters. Avoiding writing does wonders for housekeeping.

But something unexpected happened not long after I started my research for *Dressing the Part* at New York's Paley Center for Media, where a gem of a librarian named Jane Klain generously helped me set up shop. Though I knew no book had yet focused on the impact of television costume design on either our closets or our culture, I was unprepared for the instantaneous enthusiasm and unbridled support from the talented artists who have outfitted more than seven decades of video crushes, idols, role models, and heroes.

Not only did every costume designer I approached agree to an interview, but John Dunn, Janie Bryant, Donna Zakowska, Ellen Mirojnick, Lyn Paolo, Salvador Pérez Jr., Bob Mackie, Patricia Field, Eduardo Castro, Paolo Nieddu, Debra Hanson, Catherine Adair, Jenn Rogien, Allyson Fanger, Ceci, Patrick Norris, Debra McGuire, Eric Daman, and Stephanie Maslansky captivated me with tales of sublime ingenuity, twinkle-eyed gossip, and resourceful invention, opening their closets, sending me sketches, and sharing secrets both on the record and off. Other contributors, including writer/producer Winnie Holzman, acclaimed designer Michael Kors, reality producer Andy Cohen, actors Matt Bomer and Rosie Perez, also chatted as breezily as if I'd been hosting a pool party in July featuring an irresistible frozen negroni machine.

Why were all these artists so engaged and sure I would do them proud? I'd like to think it was all due to my irresistible charm and insatiable curiosity, and hopefully those qualities did factor in, but it turns out I got myself an invaluable guardian angel: Deborah Nadoolman Landis is an award-winning designer (*Indiana Jones and the Raiders of the Lost Ark*, Michael Jackson's "Thriller" music video), and a distinguished professor, founding director, and chair of UCLA's David C. Copley Center for the Study of Costume Design. She has also produced a feast of a book, *Dressed: A Century of Hollywood Costume Design*.

Professor Landis's love for her craft and colleagues is both boisterous and boundless. The moment I told her about *Dressing the Part*, she began beaming and announced her mission to connect me with every designer on my wish list, in addition to other artisans she felt I should know. It's a lot easier to tap into an artist's openness and trust when someone has preceded you with a line of introduction that figuratively covers you in roses. Ms. Landis proved to be an invaluable matchmaker, advisor, historian, and cheerleader. Best of all, she is now my friend.

Writing is a solo endeavor but producing a handsome, desirable book requires numerous sets of eyes and perspectives. Book publishers are not alike. They don't all automatically provide the structure and taste a writer needs to polish a tome until it radiates as a source of pride. So, I'm grateful to HarperCollins for pairing me with my editor, Maddie Pilari, whose youthful verve is beautifully balanced by her skill at clarifying a narrative, her unwavering desire for fairness, her disdain for careless snark, her ability to get the joke, and most importantly, for always keeping in mind that a winning book should intrigue the reader to become as excited as the writer.

Dressing the Part is a chronicle of happy times, so it shouldn't be merely fun to read, but should boast a look that is equally playful. Thanks to design director Lynne Yeamans and her team headed by book designer Raphael Geroni for such a lively and uplifting framing of our memories. And I am once again indebted to Nicole Hyatt and Rebecca Karamehmedovic of Sway NY for the tireless and exacting pursuit of the right photographs to amplify the narrative. As you can see, because of these two design teams, *Dressing the Part*'s pages are a delight to peruse, as welcoming as a cherished scrapbook, and as irresistible as the ruby bright square of cherry cobbler that was always at the center of my favorite Swanson Turkey TV dinner.

Finally, I am thrilled to have been responsible to a commander who never wavered in her boosterdom for *Dressing the Part*. Lisa Sharkey, HarperCollins senior vice president of Creative Development, let me know this was a book she couldn't wait to read, envisioning the work as clearly as I did, constantly coming up with sharp ideas that refined and elevated the book's intention and direction, goading me on for more story, more intimacy, more exuberance, more takeaway, more seductive pictures, and always so appreciative of each effort to make things better.

I love having written *Dressing the Part*. But for once, armed with dozens of delicious stories and confidential details, the collaborative gusto of so much talent, and memories gleaned from a medium that has afforded a lifetime of pleasure and sartorial inspiration, I have to differ with that withering statement credited to either Dorothy Parker or Neil Simon. I didn't hate writing *Dressing the Part*. In fact, I had the best time with this book. I hope you did, too.

ABOUT THE AUTHOR

HAL RUBENSTEIN'S LIFELONG MISSION HAS BEEN TO LIVE WELL, discover the best of what's fresh and new, and convince everyone to savor the same. Consequently, the writer, designer, lecturer, consultant, podcaster, and pop culture obsessive has had a busy career. Rubenstein was one of the founding editors of the award-winning *InStyle* magazine, and its fashion director for fifteen years. Simultaneously, Rubenstein was chief restaurant critic for *New York* magazine. Prior to that, Rubenstein was men's style editor of the *New York Times Magazine*, a founding editor of *Details*, *POZ*, and *7 Days* magazines, in addition to creating and editing the cult classic *Egg*, which gave Annette Bening, Liam Neeson, and Vanessa Williams their first magazine covers.

Rubenstein is the author of seven books, including the bestselling *Paisley Goes with Nothing* and *100 Unforgettable Dresses*. He designed an eponymous clothing line sold on HSN, has lectured at art museums in Chicago, New York, Los Angeles, Phoenix, and Vero Beach, the Fashion Institute of Technology, Parsons School of Design, the Savannah College of Art and Design, on the *Queen Mary 2*, and at the California Governors Conference on Women and Children.

A design consultant for such diverse brands as DKNY, Tod's, BR Guest restaurants, Todd English, Gabriel & Co. Fine Jewelry, Rubenstein has been an on-air commentator for the *Today* show, *Good Morning America*, *Top Chef*, *The View*, *Iron Chef*, *Oprah*, *Dateline*, and *Extra*.

Among numerous accolades, Rubenstein is proudest of his Founder's Award from the Council of Fashion Designers of America (CFDA) for his lifetime contribution to fashion.

In addition to *Dressing the Part*, Rubenstein is excited about the launch of his next act, The Happy Grownup (www.thehappygrownup.com), a multimedia platform celebrating the opportunities, challenges, and joy to be found in life after fifty.

Rubenstein lives in upstate New York with his husband, David Nickle, and the world's most adorably needy goldendoodle, Murray.